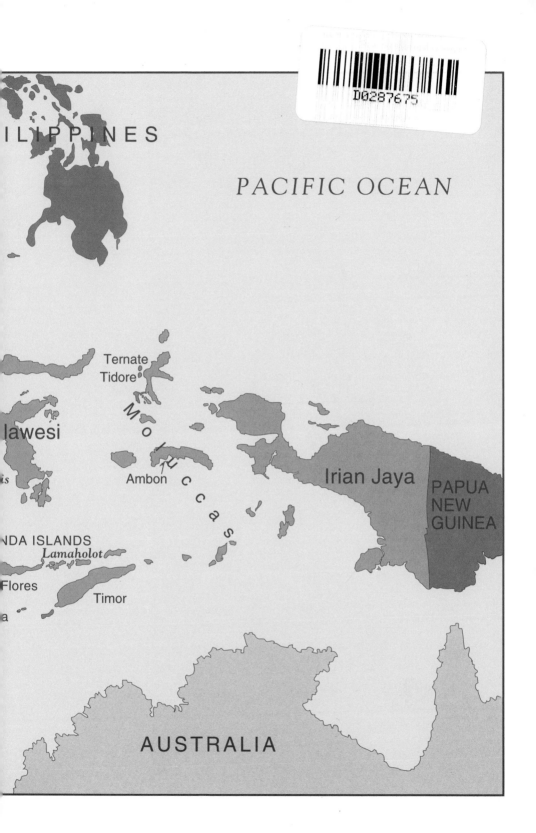

ILIPPINES

PACIFIC OCEAN

Ternate
Tidore

lawesi

Moluccas

Ambon

Irian Jaya

PAPUA
NEW
GUINEA

NDA ISLANDS
Lamaholot

Flores

Timor

AUSTRALIA

FRAGILE TRADITIONS

Fragile Traditions

INDONESIAN ART IN JEOPARDY

Edited by

Paul Michael Taylor

UNIVERSITY OF HAWAII PRESS
HONOLULU

© 1994 University of Hawaii Press

All rights reserved

Printed in the United States of America

99 98 97 96 95 94 5 4 3 2 1

Library of Congress Cataloging-in-Publication Data

Fragile traditions : Indonesian art in jeopardy / edited by Paul
 Michael Taylor.
 p. cm.
 Includes bibliographical references and index.
 ISBN 0-8248-1533-5
 1. Ethnic art—Indonesia. 2. Cultural property, Protection of—
Indonesia. I. Taylor, Paul Michael.
N7326.F73 1994
709'.598—dc20 94–6320
 CIP

University of Hawaii Press books are printed on acid-free paper
and meet the guidelines for permanence and durability of the
Council on Library Resources

Designed by Paula Newcomb

Contents

Foreword

The treasures of Indonesia's patrimony constitute historical evidence and reflect refined artistic values. They have been preserved because they fulfill material and spiritual needs: as ceremonial objects they relate to beliefs and religion, and as prestige objects they reinforce social position. These heirlooms may also be viewed as art on the basis of their expressive style, color and rhythm in composition, and alluring lines. Such characteristics are appealing and visually gratifying not only to the objects' owners but to other viewers as well.

These objects, which result from a people's creative force, cannot be separated from any aspect of that people's culture or environment. Much Indonesian material culture—from textiles and everyday objects to the architecture of houses, palaces, religious sites, Hindu or Balinese temples, mosques, and churches—has been enriched by contact among Indonesia's various ethnic groups and by encounters with foreigners. Throughout the history of Indonesia, its material culture has been constantly influenced by foreign objects brought by Chinese and Indian immigrants, Arab pilgrims, scientific explorers, and European missionaries. Foreign influences spurred new creativity; many new styles were incorporated, resulting in great art produced by the people of Indonesia.

In the fourth century A.D., Hinduism began to have its greatest influence. During the classical period, which ended with the collapse of the Majapahit empire, local kings withdrew one by one as Islamic influences began to permeate in the fifteenth and sixteenth centuries. Islamic kingdoms began to appear along the coasts, starting with the northern coast of Java. The arts thrived under the influence of these kings of Java, Sumatra, and other areas. Then came the arrival of the Europeans and the appearance of the Dutch VOC (United East Indies Company) in the seventeenth century. They began to take over the pockets of indigenous power on the coasts, and eventually the Dutch government controlled the Indonesian people.

During that time, European intellectuals observing the varied Indonesian cultures on the coast and in the interior took note of their unique ceremonial objects. These were all the more remarkable because the Indonesian aesthetic led to the creation of objects that differed greatly from those of the Europeans. The Indonesian sense of aesthetics, however, was considered "lower" than the "higher" aesthetics of Europeans, who at that time were influenced by the theory of evolution. Other European reactions to Indone-

sian cultures included the desire to possess items that had been created with traditional technology; even though this technology was considered lower, it was still interesting as a forerunner of modern technology. Those who appreciated Indonesian cultures thought that gathering collections and doing research could provide important data for the history of the development of culture in general. The Dutch government for its part ordered research and collection primarily in order to better understand Indonesian culture, through which it could approach the people.

During the eighteenth century many European intellectuals sought more knowledge of the sciences and the arts in general. Science lovers in Holland founded a science institute in Haarlem in 1752, and on April 24, 1778, an association for the arts and sciences was formed in Batavia (now Jakarta, Indonesia's capital). Called Bataviaasch Genootschap van Kunsten en Wetenschappen (Batavia Society for the Arts and Sciences), its motto was, "For the benefit of the general public." This association then established the museum that became the National Museum of Indonesia. The association carried out research in the fields of biology, natural science, archaeology, literature, ethnology, and history. The fruits of that research are now housed in the National Museum.

Christian missionaries arrived in Indonesia in the seventeenth and eighteenth centuries. Preaching that ancestor worship was at odds with the teaching of the church, they attacked artwork in the form of ancestor figures and objects used to praise the ancestors. Figures such as the *adu* of Nias, which were then stored in the *adat* (traditional) houses, eventually disappeared. The objects stopped being made as their religious or ceremonial significance began to change. Many objects, including *adu*, were taken from their native lands. This is happening to other types of artwork as well, such as textiles, which are associated with the cultural spheres of marriage and status.

Among the elements of culture that have been lost, some can no longer be traced, while others can. Members of the older generation who could have served as informants about this material are almost gone, and those who follow no longer fully understand the traditions. At present, although some people do still follow them, these traditions are becoming weak from pervasive neglect.

Cultural changes often occur because values have changed as a result of new influences. Hopefully the value changes that Indonesians are experiencing will not completely destabilize and bury the identity of each ethnic group. On the other hand, some objects of material culture are no longer relevant to the development of our people. Such objects truly do not need to be preserved any longer. A developing people needs to choose honestly

what is necessary and what is not. We are faced with a clear challenge: deciding what method of selection to employ so that cultural objects exemplifying the uniqueness of our people survive. It is like rediscovering the value of pearls sunk in mud.

In relation to Indonesia's cultural heritage, the role of the National Museum is to collect, preserve, and provide information about these items of Indonesia's patrimony so that they can be understood, appreciated, and enjoyed by all Indonesians. We are now aware that many items of Indonesian material culture have almost died as a result of development. All organizations that are aware of this fact can help provide the stimulus for excavating and revitalizing those elements of culture that once thrived in our land. These objects can enhance and enrich Indonesian identity.

SUWATI KARTIWA
Director, National Museum of Indonesia

Acknowledgments

The editor gratefully acknowledges the patience and professionalism of each of this volume's contributors, the helpful suggestions of two anonymous reviewers for the University of Hawaii Press, the preliminary copyediting assistance of Diane Della-Loggia, and the help of Lorraine Jakoby in rechecking several authors' bibliographic citations. Photo credits are given in figure captions; many thanks to Marcia Bakry for the map. At the University of Hawaii Press, thanks are due editor Pamela Kelley, managing editor Sally Serafim, and copy editor Patricia Draher.

1 Introduction

PAUL MICHAEL TAYLOR

This volume brings together a unique group of case studies about several endangered forms of Indonesian art. The essays assess the effects on this artistic heritage of certain national and international phenomena, especially the primitive art market and various kinds of private and institutional collecting. The authors, who have extensive experience in Indonesian communities, find that many vibrant art traditions in this region are threatened by these forces.[1]

Collections of indigenous art and material culture have always been recognized as sources of information about the people who produced the objects. Increasingly, collections and collecting institutions are also being analyzed as expressions of the cultural presumptions of the societies that are marketing or assembling the collections. This book, by contrast, investigates the effects of the market in collectible art on the small, indigenous communities where traditional artworks are produced.

A collection of essays, like a collection of objects, has an origin in a particular historical context and can be examined for evidence of the presumptions held by the contributors and editor. This volume originated in a panel of papers presented at an annual meeting of the Association for Asian Studies in San Francisco. The panel included papers by three of this volume's contributors (Barnes, Crystal, and Taylor) and comments by two others (Kartiwa, Errington). It brought together anthropologists, museum specialists, and art historians concerned particularly with those Indonesian art traditions that had been labeled "primitive art," though no panelists used that label. After the original conference, several other scholars were invited to add important new perspectives to this topic. The additional contributors included people who have significant effects on these same trends and markets, as collectors, museum directors, or "cultural resource" planners and consultants (Barbier, Moss, Heppel), as well as one art historian who brings to the discussion a much longer-term view of transformations within a single indigenous tradition (Feldman).

These studies contribute to the growing recent assessment and thoughtful critique of institutions that collect, sell, exhibit, appraise, restore, fake, and study art. As such, this book of perspectives from Indonesian anthropology, art history, market development, tourism consulting, and museology proba-

bly constitutes one of the most succinct yet broad-ranging examinations available, for any single country, of the current transformation of indigenous art forms within communities where artworks are created.

One important characteristic of the essays in this collection is their authors' long experience among particular Indonesian societies, such as the Nias, Batak, Iban, Toraja, or Lamaholot peoples. Previous publications on Indonesian art (including those listed in the references of each chapter) have surveyed the history and meanings of indigenous art forms from many perspectives, and have undoubtedly contributed to the growing popularity of the field. But no publication has attempted to assess the effect on those art-producing communities of that same popularity, or of the market (or rather the many markets) that has been created. Compared to the sellable artifacts of Africa or Meso-America, Indonesian material culture was "discovered" quite recently. The contributors to this volume have been able to study the effects firsthand as they were happening. Yet Jerome Feldman's essay also serves to remind us that the influence of the Western market on Nias Island art long predated the promotion of such works to "primitive art."

Our primary concern is the impact of the international art market, though many other aspects of the Indonesian historical context are explored insofar as they affect indigenous art traditions. The massive effects of the introduction of popular education, and the accompanying religious conversions and reformations, have obviously been crucial in the transformations documented here.

Another extremely influential phenomenon is the transformation of Indonesia's colonial government into a national government with many postcolonial characteristics. Since Indonesia's independence in 1945, the Indonesian nation-state has increasingly influenced local traditions. It does this directly, by claiming and supporting some forms of artistic expression under the rubric of national identity while discouraging others as irrelevant to progress. It also influences indirectly, as, for example, when centrally planned economic development offers alternative careers to Lamaholot girls who might have become textile weavers.

Forging a single national identity has been a central concern for Indonesia, as for any new nation. This is certainly a goal of the governmental apparatuses, regulations, and institutions that might collectively be called Indonesia's "cultural resource policy." The diverse components of that policy seem to reflect some of the basic contradictions in the country's national motto: *Bhinneka Tunggal Ika* (Sanskrit for "Unity in Diversity"). First, the motto's obvious contradiction between the unity of a national culture and the diversity of local indigenous traditions reflects policies that sometimes crush and sometimes encourage local traditions. Second, the motto's more

subtle contradiction between history that really happened and the rewriting of history to validate the present (the motto is in Sanskrit though its actual antiquity is questionable) reflects the pervasive official and unofficial reinterpretations that traditions are undergoing throughout Indonesia today. Third, the motto, as the national slogan, reveals a contradiction between quintessential Indonesian-ness and the purposeful use of imported culture, represented by Sanskrit, thereby paralleling the dilemma of Indonesia's most vital indigenous traditions, which have always adapted to and incorporated outside influences. In this respect, the situation and even the national motto parallel America's own *E Pluribus Unum*.

To this constellation of problems affecting Indonesia's indigenous art traditions the authors bring a variety of perspectives. In fact, given the diversity of the our backgrounds, it is remarkable that we have so many concerns and perceptions in common, along with a shared sense that this topic is of real immediacy and relevance. Although we share certain vocabulary, and we all write in English,[2] many of us sense the semantic ground shifting beneath our feet as we speak of "traditional" arts or cultures, or use even the now-accepted designation "art" for selected material culture of "tribal" Indonesian societies.

Yet despite any differences of opinion or ambiguities within our discussions of these issues, we all believe that this is a part of the world where traditional arts, however defined, are still very much alive but under heavy pressure from a variety of sources. The art market, which only recently "discovered" Indonesia as a new source of sellable artworks, seems voracious and is rapidly expanding. Its operations have complex, reverberating effects of many kinds—effects unknown to the new "end users" of the decontextualized objects appearing in galleries and showrooms. One is reminded of the former "huge" market (by Tibetan village standards) in the tails of now-endangered yaks, sent to become the primary component of American Santa Claus beards in the last century. Tibetan villagers had no idea why their yaks' tails were needed in such quantity, nor did the families supplicating Santa Clauses in American stores have any idea what the beards were made of, let alone ponder the effects of Santa-Claus-beard production on Tibetan village life.

Just as this book's contributors represent a diversity of viewpoints, we hope its conclusions are pertinent to anthropologists, art historians, museum professionals, and, ideally, to development workers and government planners. The phenomena observed in Indonesia are not unique to that country but can be found, mutatis mutandis, throughout Southeast Asia and much of the rest of the third world. Thus we hope our conclusions will find audiences not only among Indonesianists but also among those

who are interested in the contemporary art world, particularly those who are professionally involved in "primitive art"—from dealers and collectors to museum curators and art historians. Anthropologists concerned with social change will hopefully find this book to be a source of ideas and information.

Before considering the backgrounds and perspectives of the authors, we should assume a broader perspective on "tribal" art of Indonesia in relation to the rest of Indonesian art, and in relation to the continuum of artifacts and arts from other regions. This topic is considered especially in my essay and by Laurence Moss, Jean-Paul Barbier, and Shelly Errington in the chapters below, but we might first distinguish here between several different framing discourses, or ways of conceptualizing, assessing, and discussing the range of phenomena that cosmopolitan readers, including those in Indonesia, now classify as Indonesian visual art. Three such framing discourses are especially pertinent to the discussion: (1) the discourse of the Western art market; (2) the discourses of the various indigenous traditions (as explored especially for Lamaholot in Ruth Barnes' essay); then finally (3) the discourse of analysts and nonindigenous scholars as expressed within this volume.

Each of these discourses has both complex presuppositions (what Errington in her essay calls "stories") and internal variants. These discourse frames, with the exception of the indigenous Indonesian ones, employ the English term "art"—but because the word is so vague, speakers appear to be talking about the same thing but are not. This volume's contributors all seem to desire the continued production of objects of "art" (whatever the writer's own criteria are). But there is ample evidence, as documented especially in Barbier's essay, that those who speak within the indigenous local traditional discourses do not necessarily share this desire. Most of the essays here in fact deal with the tensions that arise not just when "the market" enters a village, but when people speaking from within very different discourses come into contact.

The convergence of alternative discourses about this book's subject has, in fact, left us with an aggressively problematic, even confrontational, title, each component of which is intentionally polemical: *Fragile Traditions: Indonesian Art in Jeopardy.*

It might seem that the only unproblematic term in our title is "Indonesian." But are these case studies from Indonesia really about Indonesian art? We in fact do not consider the full historic range of the visual arts produced within the boundaries of present-day Indonesia. Our shared emphasis is instead on exemplary "outer-island" Indonesian communities that have

been considered creators of "primitive art" by the art market, and on what has been happening to them since they were so identified. The examples we use are for the most part from groups that have in the past been termed "tribal," "archaic," and "primitive." Moss, however, includes examples of "court arts," derived from courts or sultanates of the Lesser Sunda Islands; and my essay includes examples from the sultanate of Ternate and one illustration from Bali. Java and Bali constitute Indonesia's two "inner islands," which are generally ignored in this volume, as in the primitive art market, though they contain the majority of Indonesia's population. The most important category of material culture under consideration remains that termed "primitive art" in the art-market discourse, though we also occasionally speak of what has been called (in Western discourses) "court art," "folk art," "oriental art," "tourist art," and "popular art." The indigenous discourses may not recognize any of these categories, and indeed the distinctions are only problematic for museums, collectors, appraisers, exhibitors, and the like. They are of no importance whatsoever to the makers of these art forms—who do, after all, share the trait that they live or lived in the modern Indonesian nation-state.

Yet we could also cite the cogent examples given in my essay or in Errington's to further object that the art traditions in question are "Indonesian" only in the sense of being *claimed* by that modern nation-state. In many cases, such claims are contested, ignored, or not even fully understood by the creators of those traditions. Some peoples seem to use their art traditions to actively resist a national identity. However, this is a pan-Indonesian, not a local, phenomenon—one found within the borders of many other nations that provide ample precedents for incorporating this tumultuous phenomenon into discussions of their "national" traditions. Really, then, nothing could be more Indonesian.

Yet another polemic in our title is that the "traditions" described are not necessarily "fragile": as Suwati Kartiwa contends in the Foreword, they are already much changed from the recent past, and have probably regularly changed throughout history. This is a topic that requires much more study. Indonesia has proved very fertile ground for contemporary anthropology fieldworkers, but the essays in this volume reflect the broader lack of historical perspective and detailed historical study that is frequently cited as a fundamental problem within Indonesian studies. The fact that art traditions disappear is not unique to the last five decades of postcolonial development, or even the colonial period. As Kartiwa notes, cultural change and assimilation of foreign forms have always been Indonesian phenomena. Feldman's case study from Nias Island is the only one in this volume that documents

the uninterrupted effects of a long history of Western acquisition of indigenous artifacts on one society's production of those artifacts. How does this fit into the larger discussion?

We find that the relative absence of historically documented case studies leaves us several open questions: Are the despoiling effects of recent changes fundamentally different from changes in past centuries? Are they the same kind of changes that have taken place elsewhere but are now occurring in more remote areas as those areas are "discovered," allowing today's observers to record the changes firsthand? Or have changes steadily been taking place everywhere with such force that we waste our grief in mourning the loss of remote and untouched traditions—since there are none. At the very least, the firsthand case studies gathered here will help those concerned with these issues (including indigenous artists themselves) to explore answers.

Of course, it is difficult to draw testable hypotheses that would resolve these questions, in the absence of identifiable units of change or quantifiable measures of how much change constitutes the loss of a tradition versus the creative adaptation of a traditional form. Yet when we consider the alternative presuppositions underlying modes of discourse about traditional arts, it is clear that whole fields of endeavor are premised on answers to these questions, though those answers are necessarily subjective.

First, consider the framing discourse of the primitive art market. An important element in the art market's valuation of these objects has precisely been their "fragility." Modernization is seen as spoiling the communities' creativity, and thus bringing about scarcity and wonderful high prices. Hence the strong stress on "antique" objects. This is an ideological underpinning of the success of the primitive art market.

The premise of fragility explains the supposedly inevitable "jeopardy" in which these traditions find themselves. Yet this is too simple an explanation for change, and it belies the complexity that is presented in the essays below. While by some definitions Indonesian art is in jeopardy, by other definitions it is booming. The thriving forms of Indonesian "art," such as Balinese painting and sculpture, Flores ikat-weave clothing and accessories, Toraja handicrafts, are often precisely those that have changed in such a way as to make them *not* saleable in the international art market except as "folk arts" or "tourist arts." These modified forms are often, from the point of view of the primitive art market, hopelessly transformed by Western influences—though they may be considered icons of tradition by the people who make and use them. Note that when Western artists find inspiration in "primitive" forms, they are praised for bringing new dynamism and power to their work, not pitied for having abandoned their traditions. Yet indige-

nous people influenced by modern forms are accused of losing their "fragile" traditions; their products are demoted from the art market to the tourist trade. It might seem from these observations that "fragile traditions" is a fictional construct, invented by a voracious art market whose ideology of disappearing traditions maintains high prices for the few "authentic" objects that can be obtained.

Yet we cannot so easily dismiss the notion of traditions, and their fragility, when we discover that the indigenous frames of discourse used by Indonesian peoples themselves also regularly employ such concepts, though the same tangible objects recognized as traditional by them might not be so considered in the art market. Very interesting phenomena occur when these framing discourses collide, as when the art market, with its immensely unequal access to capital, reaches a Lamaholot village and buys up (thus making unavailable) the traditional ikat bridal sarongs used in wedding ceremonies. As Barnes describes in her essay, new, inexpensive textiles are produced that satisfy all the Lamaholot requirements of authenticity but not those of the art market. The Lamaholot elders' concern (their fear of fragility) seems to be not with the modification of form but with the potential loss of the meaning and importance conveyed by the tangible object; they are concerned, too, that the weaving craft that embodies their traditional values will be lost as young women find careers elsewhere. Happily, the exploration of this subject in further case studies should provide new insights into the resilience of the people who produce Indonesian art, perhaps showing us exactly what Indonesian artists consider most important to maintain in the face of all other transformations.

By these and other criteria, many of Indonesia's traditions are indeed fragile and in jeopardy—though we cannot seem to agree on what exactly is endangered, why this is so, or what needs to be done. Each contributor to this volume brings a unique perspective to the discussion.

Suwati Kartiwa, who received her training in anthropology at the University of Pennsylvania, is the director of the National Museum of Indonesia, Jakarta, and author of several monographs and articles on Indonesian textiles. In her Foreword, she briefly surveys the long history of foreign-influenced changes in Indonesian art traditions. She then poses the question of how Indonesians today should decide which of their traditional arts should be abandoned and which should be reinterpreted and revitalized in the name of development. She also considers the role Indonesia's museums should play in that process of selection.

Ruth Barnes, an art historian in the Department of Eastern Art, Ashmolean Museum, Oxford, has done field research on the island of Lembata, eastern Indonesia. The results were published in her book *The Ikat Textiles*

of Lamalera: A Study of an Eastern Indonesian Weaving Tradition (1991) and in several articles. She has coedited, with Joanne Eicher, *Dress and Gender: Making and Meaning in Cultural Contexts* (1992) and currently is working on a collection of Indian block-printed textiles at the Ashmolean Museum. Her interests are in both ethnographic material and the role of textiles in the pre-European Indian Ocean trade.

Barnes' essay in this volume provides a moving account of the indigenous discourse regarding textiles among the Lamaholot people of the Lesser Sunda Islands (or Nusa Tenggara). The chapter shows the author's sensitivity to the importance and multiple meanings of heirloom textiles in the ceremonies, social relations, and identity of Lamaholot communities. It also documents how different communities have reacted as their heirloom bridal cloths have disappeared into the international art market. Barnes introduces a dilemma facing art historians, whose studies of the social context of these artworks will invariably fuel the market for them. That market is ultimately one reason for the art historian's employment, yet its growth—even as a result of studies such as these—can negatively affect the regional traditions that are the subject of study.

Cultural anthropologist Eric Crystal is coordinator of the Center for Southeast Asian Studies of the University of California at Berkeley. He first worked in the Toraja region of Indonesia in 1968–1969 for his dissertation research. Crystal has visited the area many times since then, documenting traditional belief and culture in the context of dramatic social change. He is particularly concerned with the rights of indigenous peoples and with issues of equity in development. His professional contributions have appeared in print, video, film, and audio form.

Crystal's essay forcefully and emotionally describes the tragic loss to indigenous communities resulting from the international art market's relatively new access to the magnificent life-size ancestral statues (*tau tau*) of the Toraja people of Sulawesi. Although Crystal does not investigate in detail issues of legal title to these statues and relevant local laws, he finds that in practice Indonesian legal remedies are inadequate to prevent the disappearance of the *tau tau*. He emphatically urges collectors and museums to become aware of the consequences on Toraja villages of this potentially illegal trade in ancestral imagery, and thus refrain from encouraging it.

Jerome Feldman is professor of Art History at Hawaii Pacific University, Hawaii Loa Campus, in Kaneohe, Oahu, where he specializes in Southeast Asian and Oceanic art. He received his Ph.D. from Columbia University in 1977 on the architecture of Nias Island, Indonesia. He has lectured widely and published numerous articles on the art and architecture of the region.

His extensive research of public and private collections in the United States, Europe, and Asia is evident in his contribution to this volume.

Focusing especially on the sculpture of Nias Island, whose renowned artistic traditions fill museums of the world, Feldman identifies changes that allowed the plastic modes of expression to survive amid missionization so long as the original religious purposes of the sculptures were disguised. Secular versions of formerly religious objects were also created to satisfy diverse Western buyers (including both curio-seekers and buyers with more discriminating taste). Some artifacts, such as sword handles or houses, survived partly because they were never associated with "idolatry." Among such artifacts, which serve the same function today as in the past, Feldman finds late twentieth-century workmanship very similar to that seen in the earliest collections. By contrast, Nias ancestral sculpture was closely linked to the religious beliefs that Christian missionaries found most threatening. Yet it was the form most in demand by the art and curio market. Feldman's study of early collections provides a unique historical record of how indigenous sculptural forms became modified in response to these push-and-pull forces: by disguising the meaning of religious statuary and by creating modified, secular, collectible versions of ancestral statues for the art and curio markets.

Jean-Paul Barbier brings to this discussion his informed perspective as a museum director and a leading active collector of Indonesian primitive art. He is also a scholar and has published his studies of art objects and accounts of field studies undertaken in North Sumatra and elsewhere, including *Tobaland: The Shreds of Tradition* (1983). Barbier is a bibliophile (and collector especially of sixteenth-century French poetry), a trained jurist, and the founder and president of a Geneva management association. In 1977 he founded the Barbier-Müller Museum, Geneva, which has assembled over five thousand works of "ancient and primitive art" from Africa, Oceania, Indonesia, and pre-Columbian America. These collections have been featured in numerous traveling exhibitions seen in Europe, Asia, and America.

Barbier's essay illustrates his sensitivity to the local cultural context of artworks and his concern about the effects of alienating artworks from communities in which they were created. He correctly points to many cases, in the history of Indonesia and elsewhere, in which people themselves decide that certain traditions have lost their meaningfulness and can be abandoned, and he emphasizes the important role of collections as a responsible alternative to destruction and loss.

In addition to editing this volume, I offer an essay on the *nusantara* (archipelago) concept in Indonesia's museums. As a research anthropologist and

the director of the Asian Cultural History Program at the Smithsonian Institution, I organized the recent exhibition *Beyond the Java Sea: Art of Indonesia's Outer Islands*, seen in the United States, the Netherlands, and Australia; with Lorraine V. Aragon I wrote the accompanying book of the same name (1991).

My essay discusses the role of national, provincial, and local museums in the preservation and interpretation of local art traditions. I point to potential progress in maintaining local art traditions through museums and to the serious problems those museums face in effectiveness due to a lack of resources. I also give examples of the appropriation of the once-independent local cultural traditions by the central powers of the nation-state, and of the silent resistence against that process.

Laurence A. G. Moss, a change-and-development consultant, provides another important perspective, focusing on market-based methods of maintaining traditional art and craft forms. He is coordinator for the Natural Resources and Environment Program of the Asian Institute of Technology, Bangkok, and is currently advising the Lao People's Democratic Republic on tourism strategy. He teaches and advises in planning and managing environmental and cultural resources, and has carried out assignments in environmental and cultural resource management and development in eighteen countries. He has also organized exhibitions and authored the catalogue *Art of the Lesser Sunda Islands: A Cultural Resource at Risk* (1986).

Moss' thought-provoking essay briefly surveys the history of the collection of what today's art market labels "primitive art." His summary particularly emphasizes recent developments, as is appropriate from an Indonesianist's perspective (since Africa, for example, was "discovered" earlier). Moss proffers the term "tribal," rather than "primitive," art, though many of the societies he describes had court traditions or were strongly connected to outer-island courts. Then, drawing on his long field experience in the Lesser Sunda Islands, he provides a broad-ranging summary of the factors relating to the maintenance or disappearance of tribal art traditions, including markets, tourism, and other sources of social change in the villages that produce artworks. Moss' provocative conclusion outlines several practical options for sustaining or revitalizing traditional craft industries to create a classic situation of "sustainable yield." He especially emphasizes the importance of properly targeting development aid and of organizing craft production to respond to market demands.

The contribution of anthropologist Michael Heppell reflects his long field experience among interior peoples of the island of Borneo (the world's third largest island, politically divided between the nations of Malaysia, Indonesia, and Brunei). Heppel makes a detailed case study of three types of craft

(woodcarving, textiles, and mask making), providing rich ethnographic information about the past and current status of each. For each craft form he assesses the likelihood of reversing the "slow terminal illness" of Dayak art, and suggests ways of helping villagers to adjust to market demands and to utilize modern methods of distribution. Thus Iban villagers, who immediately chose to switch from soft natural dyes to bright aniline dyes when the latter became available, should adjust their own aesthetic to that of the art market. Threads dyed with natural dyes could easily be mass-produced and distributed, as alternatives to manufactured colored thread, for weaving cloths that would look more "traditional" and thus be easier to sell.

To this wide range of voices, Shelly Errington, professor of anthropology at the University of California, Santa Cruz, contributes a final word—an independent reading of this book's case studies. Her essay deconstructs the texts collected here by first asking the question, Why and how did the objects of concern in this book come to be considered "art"? She examines the "stories" or sets of presuppositions various users of this term hold. She also examines the processes by which indigenous artworks and traditions become pressed into the service of the Indonesian nation-state, which in turn asserts its own set of presuppositions about those traditions and their role within national public culture. She includes in this regard some examples from her extensive fieldwork in southern Sulawesi Island, Indonesia. Errington's frequent allusions to Indonesia's forms of public culture, as they are played out in local contexts, reflect her firsthand familiarity with that country.

Clearly, all the authors share a sense of urgency and feel that Indonesian "traditional arts" are threatened by many forces. Some of us also proffer suggestions about what can be done. We are all learning the fluidity of our terms of discourse and our analytical constructs—including our modes of classifying visual art and material culture. More information about historical changes in visual art traditions, and more interaction among people of varying expertise in this area, will undoubtedly engender dissatisfaction with the current distinction between primitive or tribal art (authentic) and tourist art (inauthentic), and other such distinctions. To fill the void that would be created in the art market's means of evaluating Indonesian "art" and distinguishing it from nonart, we shall still need criteria of quality. As with the art produced in our own culture, we might even come to recognize the value of artists' creations that are "timeless" not because they are somehow primeval or authentic, but because they are exceptionally appropriate and meaningful both to the artist's historic context and more generally to the human condition.

So, like most collections, this group of essays could be expanded in scope —it invites more essays at every turn. More could be written on the art market's ideology, for example, and its philosophical underpinnings. Since many of us question the premises of the primitive art ideology that nevertheless seems to define our field of study, we might seek more essays from regions primarily affected by other kinds of markets. But our collection rests here, emphasizing the complex effects of the processes governed by that ideology (and also by international economic forces) on indigenous communities where artworks are produced. In the name of the art market, several different modes of extracting artworks have been used. Some resemble strip-mining; others are like cash cropping, with dangers of overspecialization and loss due to whimsical changes in market demand. Perhaps we shall find ways to make the means of extraction resemble the efficient forms of deep mining, which disturb the land's surface very little.

Notes

1. This introduction is much indebted to the comments of two anonymous reviewers of this book for the University of Hawaii Press, one of whom provided the "mining" metaphors for extraction of artworks from indigenous communities with which the Introduction closes.

2. Suwati Kartiwa approved the editor's translation of her Foreword from the original Indonesian.

2 "Without Cloth We Cannot Marry": The Textiles of Lamaholot in Transition

RUTH BARNES

In the study of Indonesian textiles, the exhibition *Splendid Symbols: Textiles and Tradition in Indonesia* was a benchmark. It initiated the first international symposium on Indonesian textile research (Gittinger 1980). It also brought the textile arts of Southeast Asia to the attention of the general public (Gittinger 1979). Six years later, by the time of the second scholarly conference in Cologne, Germany, two important developments in the field were apparent. The first, in scholarship, seemed most encouraging. Microstudies in specific locations were adding to the general understanding of the position of textiles in Indonesia, their history, their designs, and their function in the context of particular societies. The second development consisted of the response from outside academic circles, and it was distressing to experience. Numerous art dealers were in the audience at Cologne. As contributors read their papers, there was ample note taking when so-called traditional cloth was mentioned, usually a reference to a textile with complex designs, dyed with natural dyes. The writing became especially feverish when place-names came up. The presenters were taken aback when members of the audience even made flash copies of the slides being shown.

I was due to speak about the importance of Indian silk trade cloths, or *patola*, for a particular textile-producing area in eastern Indonesia. These cloths, which are decorated in the complex technique of double ikat and carefully dyed in almost luminescent colors, were in the 1980s still found in some parts of Indonesia, where they were first brought by Indian, Arab, or European traders as early as the sixteenth century. The local adaptation of Indian designs and the relationship between Indonesian textiles and the Indian silk cloths were the topics of my interpretation (R. Barnes 1991).

Before my talk I was approached by a man who had read the outline of my paper and took a surprising interest in very specific matters: Where was the village I was talking about located, and how did one get there? How old were the silk *patola*? Where were they kept in the village, and who owned them? Whose house were they in, and how many had I seen? I began to feel a great concern on behalf of my friends in the village, and for the safety of treasures in their possession, which they regard as sacred and essential to

the community's well-being. For the first time I had severe doubts about the appropriateness of my research and its presentation. Of course I gave the paper, but I did not show slides of the imported Indian silk cloths or the finest of the locally made textiles.

The boom in Indonesian textiles experienced on the ethnographic art market has, of course, numerous repercussions on different levels. Only two will be considered here. First, there are the reactions it may cause in the textile scholar. Second, of greater importance, is the effect on the communities that produce the objects in demand. This discussion will present the example of the Lamaholot region, in the eastern Indonesian province of Nusa Tenggara Timur, and outline the significance textiles have to the people living there.

Textiles in Lamaholot Society

The Lamaholot are a culturally and linguistically united people who live on the islands of Solor, Lembata, Adonara, and in East Flores. They and the people of Kédang, on the eastern tip of Lembata, who speak a different language, make up the East Flores regency (Kabupaten Flores Timur). The current political unity has no indigenous historical tradition but was established early in the twentieth century under the administration of the Dutch colonial government. It was, in fact, not successfully completed until local rulers, who considered themselves to be of aristocratic standing, had been brought under control. The language of the area is divided into distinct dialects (see Keraf 1977, 1978). Warfare between villages has been frequent in the past, and may flare up again even nowadays, especially on Adonara and in parts of East Flores. This traditional fragmentation explains the surprising variations in the area's textiles, seen in their color and designs (R. Barnes 1987).

The region has produced some of the finest cloths decorated in the ikat tradition, a technique in which the patterns are tied into the threads and then dyed prior to weaving.[1] Particularly accomplished versions of these textiles are made in six geographical areas among the Lamaholot: Ili Mandiri and Lobe Tobi on East Flores, the western part of Solor, and the districts of Ili Api and Lerek and the village of Lamalera on Lembata. In addition, there are economically important weaving centers in coastal Adonara and in the village of Kalikur in Kédang, but they produce an entirely different cloth, not of the same color and with less skillful ikat (R. Barnes 1989a). This essay will concentrate on the first type, a textile that has specific meaning to the communities that produce it. Needless to say, this kind of cloth also has the greatest value on the international art market. Most of the

description and interpretation are based on the situation found in one location, the village of Lamalera on the south coast of Lembata.[2]

Throughout rural Indonesia, weaving is primarily a female task, and the women of Lamalera have turned it into a particularly accomplished art (fig. 1). The village traditionally has few fields and must barter for staple goods such as maize, rice, and vegetables. The men of the community go to sea on most days of the dry season, in big, clan-owned boats that are locally built. They hunt large sea animals, sperm whale and giant manta ray in particular, but also porpoise and shark. The meat is dried, and the women carry it inland to the mountain villages, where they exchange this major source of protein for the staples needed in Lamalera. In addition to the dried fish and whale meat, the women trade their own cloth. Weaving, thus, is an important traditional economic factor in their community's survival.[3]

The textiles are woven first of all to be worn, and they take the shape of tubular, untailored skirts, or sarongs, characteristic of eastern Indonesia. The women also make a cloth that resembles a woman's sarong but has a meaning and function beyond the mundane. It becomes part of an elaborate exchange of gifts at, or following, a marriage and is passed from the bride's family to the lineage of her husband. His side in return gives an elephant tusk. These presentations are only one part of the exchange of gifts

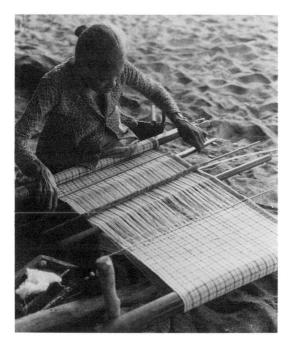

Fig. 1. A Lamalera woman weaving a man's sarong, 1979. Photo: Ruth Barnes.

associated with establishing ties between the two lineages, but they are the most conspicuous, and also the least materially functional. Although the tusk can be cut up and the ivory made into bracelets or other ornaments, and certain of these bracelets used in the gift exchange (fig. 2), the tusk has to be complete to be acceptable as a marriage presentation. The cloths are certainly wearable, and in many parts of the Lamaholot region, older women wear similar cloths at important community feasts or celebrations. However, in Lamalera in the 1980s they were rarely worn possibly because the cloths still in the village were used exclusively for bridewealth.

The Lamaholot loom, a version of the common Indonesian back-strap loom, uses a circular warp; that is, the threads are wound continuously from warp beam to cloth beam and back. As the textile is woven, the beginning and the end of the cloth finally come close together. However, it is impossible to close the gap between the two by inserting weft threads, unless the heddle and shed-stick are removed. The final part could be closed, laboriously, by inserting the weft manually, but instead the open warp threads are cut, and the cloth is sewn together. Yet if it is a bridewealth textile, the warp is left open as it comes off the loom; the unwoven part is called *ratā* (hair), and it may not be cut. In East Flores, where the same prohibition exists, the continuous warp preserved in the "hair" of the cloth is sometimes referred to as the threads of kinship and descent (R. Barnes 1989b:57). A cloth with an uncut warp-fringe is not worn, because it is not yet a proper dress.

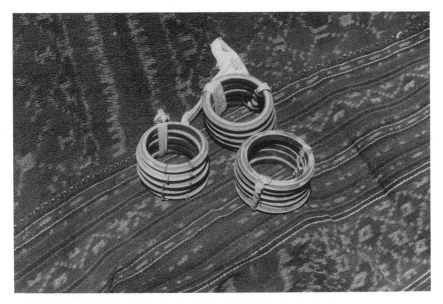

Fig. 2. Textiles and bracelets are part of the Lamaholot marriage presentations, 1979. Photo: Ruth Barnes.

The very fabric of the bridewealth cloth, then, is set aside from everyday dress. So are the design and especially the color (R. Barnes 1989b:49–51). In all those parts of Lamaholot where there is a strong ikat-patterning tradition, the bridewealth cloth *must* be red. The brownish-red tone is achieved by dyeing the yarn with the chopped roots of the *Morinda citrifolia* shrub. The other dominant dye used is indigo. The red Lamaholot bridewealth cloth has to be made entirely from indigenous products: locally grown and hand-spun cotton, dyed with plant dyes only.

The word *méan* (red) seems to have a meaning that goes beyond the description of a color. This becomes evident when one asks for the name of the reddish-brown thread that dominates the color scheme of the cloth: it is called *nubar*; *méan* describes the complete cloth. The word seems to refer to extraordinary powers and wealth, not only among the Lamaholot but also among other eastern Indonesian groups. Vroklage (1953, vol. 1:576) translates the Belu word *mean* as "golden, red, strong, healthy; God himself may be called *mean*." Closer to the Lamaholot, among the Lio of Central Flores, *méa* means "to grow" (Arndt 1933:243). And for the neighbors of the Lamaholot, the Kédang, the term *matan-méan* indicates "all forms of extraordinary wealth of which gold objects are particularly representative" (R. H. Barnes 1974:106). It also describes the manifestation of the snake guardian spirit of the village, which is said to emit a rainbow, reflecting the gold it keeps inside. Therefore, it seems that the cloth that is referred to as *méan* has a meaning in local context that relates it to unusual spiritual power.

Making the red cloth can be a dangerous undertaking. The very nature of making a textile is a state of transition, rather than permanence. The raw cotton is spun; the thread is transformed from its original color into a dyed pattern; the yarn is woven to become a fabric—textiles are created through change. In Laboya on Sumba, the process of spinning and winding cotton thread on a swift has been linked to concepts of procreation and to the former practice of headhunting. The process is also likened to a passage from death, or nonliving, to life, and from wilderness to society (Geirnaert 1990). Only women can manipulate the transformation in Laboya and among the Lamaholot. In Lamalera, a woman of child-bearing age is considered to be "hot" (*pelate*), and she may not yet make a red cloth of her own. That is left to older women, who are "cool" (*gelate*). The color *méan* is of course also associated with blood and warfare. It may take the "cool" state of an older woman to handle the powerful, strong force that is manipulated when a red cloth is made. To ignore the prescription will cause a woman to go insane.[4]

Becoming responsible for making a bridewealth cloth is a gradual process. Young women will be partially involved for years. But occasionally an illness, especially if it involves mental confusion, is said to be caused by the

woman working on a red cloth while her children are still young. The completed textiles, as evidence of the successful transition, are associated with women. For that reason a textile of the finest sort—strong, shining, red—is presented with the woman when she makes the transition from one clan (her own) to another (her future husband's).

The gift is essential to the marriage, as it confirms the particular relationship between the two clans, the wife-giver and the wife-taker. When asked what they would do if they had no cloth appropriate for bridewealth, people would shake their heads in astonishment: "Without cloth we cannot marry!" By implication they meant that the community as they knew it would come to an end.

The Loss of Traditional Textiles

What happens when the cloth *does* disappear? Already in the 1920s, the German ethnographer Ernst Vatter had difficulty finding the weavers of the best pieces, who were by then elderly or dead. "Along with the old women the ikat technique slowly dies" (Vatter 1932:222). At that time the danger was not the outsiders coming to buy up all the best local cloths, but the change experienced by the Lamaholot themselves (fig. 3).

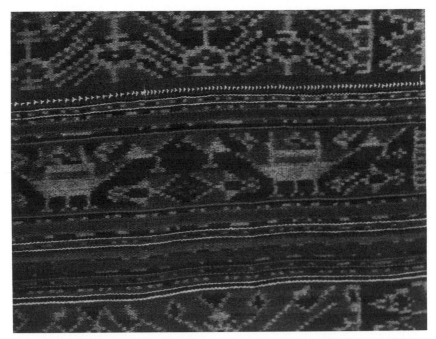

Fig. 3. A Lamalera bridewealth cloth, *kewatek nai telo*, collected in 1929 by E. Vatter. Museum für Völkerkunde, Frankfurt am Main, NS 27997.

The area has been in contact with Europeans since the early sixteenth century, and Indian, Arab, and Chinese traders had visited these islands before them. Conversions to Islam and Roman Catholicism go back to the sixteenth and seventeenth centuries, but it was only in the early years of the twentieth century that European missionaries made attempts at large-scale Christianization. Conversion went hand in hand with schooling, and to some degree with training in new professions. Lamalera was one of the first villages to take full advantage of the new opportunities. As both men and women are affected, it is inevitable that traditional skills will be less prominent, especially if they involve the long-term planning that is required for the making of a red bridewealth cloth. The tying, dyeing, and retying of the patterns require many years, as the roots of the morinda tree should only be dug up in August and September, at the height of the dry season. The source for blue and black, the *Indigofera tinctoria* bush, however, flourishes only in the rainy season. Occasionally, ikat patterns that have been prepared over decades, by different generations of women, are assembled into one cloth.

In the 1970s many Lamaholot women, especially older ones, were still working on fine ikat cloths, using the natural dyes required for certain textiles. However, between 1971 and 1982 outside visitors, obviously dealers in art objects, had appeared in all the weaving centers of the Lamaholot. Their advent led to drastic and surprisingly fast changes in some areas.

Especially in the villages of East Flores and on Solor, certain categories of cloth have disappeared altogether. In 1970, at the Ili Mandiri village of Wailolong, the cloth was entirely comparable to textiles collected by Vatter four decades earlier. Much of it appeared to have a family resemblance to his cloth, as though one saw mother and daughter at work. The same could be said of the textiles of Lamalera. In 1982, however, the situation had certainly changed. Ili Mandiri has (or had) three different types of bridewealth cloth—the proper red cloth, or *kewatek mean*, and two versions with less complex ikat designs and far more indigo-dyed threads. The proper red cloth had virtually disappeared, and the lesser versions of bridewealth cloth had become an accepted gift instead.

In western Solor by then, a *kewatek mean* could hardly be found at all. Only two were still in existence in the area around Ritaebang (fig. 4), where the extreme situation has brought about an interesting change. The two cloths may no longer be used as bridewealth, but instead have become lineage treasures. Lamaholot villages are divided into lineages that trace their origin to the same ancestor, and each lineage has as its focus a house, the *lango bélā* ('big house', as it is called in Lamalera), where all ceremonies and special occasions concerning the lineage are celebrated. The communally owned valuables or treasures (Indonesian: *harta pusaka*) are also stored

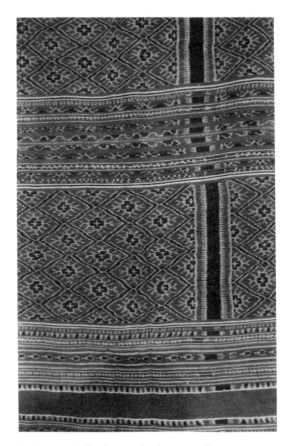

Fig. 4. The *kewatek mean* of western Solor, formerly used as bridewealth, Ritaebang, Solor, 1982. Photo: Ruth Barnes.

there. Lineage treasures include especially large elephant tusks, gongs, or Indian silk *patola*, but they may also be stones or other found objects. Although originally made to be circulated as a gift, the Solor textiles, like the other treasures stored in the lineage house, must never leave it, as they represent the spiritual and physical well-being of the group.

The women of Solor, however, still need cloths to bring into their husbands' clans. Instead of the elaborate version, they are producing a much more modest type of textile (fig. 5), which nevertheless has certain features in common with the cloth previously used. It is, again, a red cloth, and it incorporates a wide border with patterns suitable to the bridewealth cloth. The design is dyed with both indigo and morinda; the over-dyeing process, called *belapit* in Lamaholot, is a prerequisite for a gift textile.

At present, the effects of the rapid departure of traditional bridewealth cloth is felt most strongly in East Flores and western Solor. On Lembata, all three ikat-producing traditions still use the red cloth in its old form (fig. 6), and production continues. However, it is only a matter of a few years at

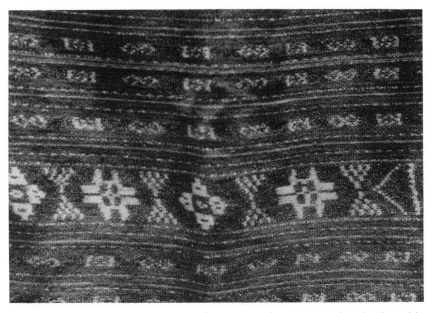

Fig. 5. The *kewatek temodol belapit* of western Solor, now used as bridewealth, Ritaebang, Solor, 1982. Photo: Ruth Barnes.

most until the situation will be similar to East Flores and Solor: the weavers simply cannot produce cloth at the rate at which it is leaving the villages.

In Lewoleba, the island's administrative center and market town, a part-Chinese merchant with family ties in Ili Api and Lerek has bought up what must be several villages' supplies of bridewealth cloth, and he is sought out by dealers who visit the island. One of his customers, whom I met at the Cologne conference, insisted that the cloths he had bought were examples of an art form now long since dead: to him something was only valuable, both aesthetically and commercially, if it was no longer alive and therefore not to be recreated.

For some time to come, cloths will retain their importance to the Lamaholot, as something that may take on a meaning different from mundane clothing. Under the onslaught of an expanding art market, however, the traditional ikat textiles with their complex designs will almost certainly disappear locally, to reappear in galleries and the homes of so-called connoisseurs. Inevitably, to display the full size of the textile, the large bridewealth cloths will be cut at the *ratā* section, where the "thread of life," as expressed in the warp, is exposed. Thus literally made lifeless, the cloth has become no more than a beautiful object. Made once to be part of an elaborate exchange of gifts and presentations and imbued with social and spiritual

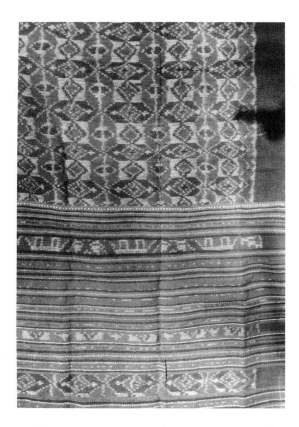

Fig. 6. The *kewatek nai telo* of Lamalera, still used as bridewealth in 1982. Photo: Ruth Barnes.

meaning, it now has lost its ability to carry a message that is quite specific. Instead, it is transformed and "refined" as a work of art. The aesthetic appeal of the textile is certainly familiar to the Lamaholot, as well, and qualitative distinctions are made by the weavers themselves. But the bridewealth cloth is also always seen in the context of the community, and potentially as part of the circulation of gifts that is an essential aspect of the lineage's continuity. To someone familiar with this dimension of the textile's role it seems inappropriate to have it transformed into an object of purely aesthetic appeal.

The textiles thus exported from villages are usually legitimately acquired. They are also being replaced by cloths admittedly less spectacular, but in essence acceptable to the Lamaholot. What is *not* acceptable, and what even brings a sense of devastation to the people, is the loss of clan treasures. They are known to have monetary value, but to the Lamaholot their value is of a mystic nature. The cloths, like all other clan treasures, manifest the lineage's well-being in every sense, and for such an object to leave the clan house, or to be sold, is disastrous. The loss is believed to bring illness and misfortune to the entire group. In 1982, a whole series of unfortunate events

that befell one clan in Lamalera was put down to the fact that an old school teacher, who was not living in the village at the time, rather than properly looking after such a treasure, a large piece of ambergris (fig. 7), had instead sold it to a Chinese merchant.

A village south of Larantuka in East Flores once possessed as a lineage treasure the bronze figure of a weaver seated at a back strap loom and nursing a child (fig. 8). The representation is so far unique, although stylistic links may be established to wood carving traditions from various parts of Southeast Asia some of them as close by as Central Flores and even Solor. However, the figure is likely to be much older. The loom represented is a foot-braced type, which has become rare now, but may still be found in some regions marginal to maritime Southeast Asia. In an archaeological context it appears on the lid of a cowrie container at Shizhaishan, a site identified with the royal cemetery of the kingdom of Dian, a Bronze Age culture that flourished on the southwestern frontier of the Western Han empire (206 B.C.–A.D. 8) (Vollmer 1979).

The figure was discussed by M. J. Adams in *Asian Perspectives* (1977). The publication of the volume was in fact delayed until 1979; three years later, in 1982, the bronze statue had disappeared from the village. Rumors about its appearance on the art market were heard in Jakarta circles in the summer of the same year. Shortly after, the metal of the figure was analyzed for dating at the Research Laboratory for Archaeology and the History of Art

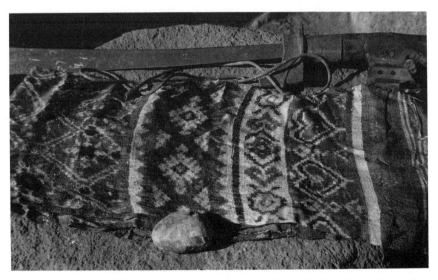

Fig. 7. Treasures of a Lamalera clan: a sword, metal chain, Indian silk cloth (*patola*), and a piece of ambergris. The latter was sold at some time between 1979 and 1982. Photo: Ruth Barnes.

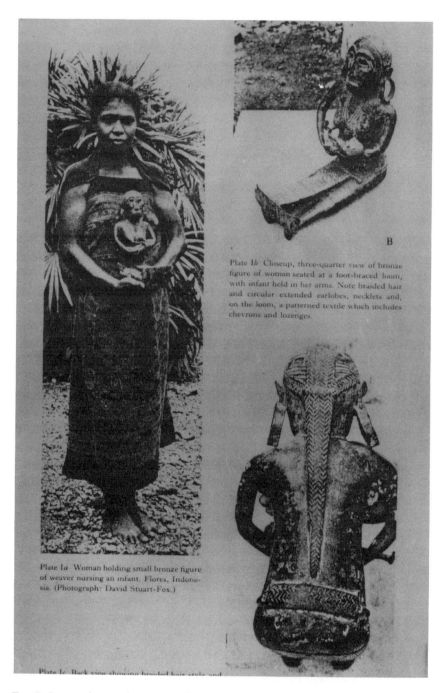

Plate 1b Closeup, three-quarter view of bronze figure of woman seated at a foot-braced loom, with infant held in her arms. Note braided hair and circular extended earlobes, necklets and, on the loom, a patterned textile which includes chevrons and lozenges.

Plate 1a Woman holding small bronze figure of weaver nursing an infant. Flores, Indonesia. (Photograph: David Stuart-Fox.)

Plate 1c Back view showing braided hair style and

Fig. 8. Bronze figure of a weaver, formerly a sacred heirloom, East Flores, present whereabouts unknown. Photo: David Stuart-Fox, published in M. J. Adams 1977.

at Oxford University. Needless to say, this was not done to make the information accessible to interested scholars but was part of a consultancy contract that was to give legitimacy to the art market price sought by the dealer involved. The figure was finally purchased by a private collector; its whereabouts are uncertain, although the author has been told that it is now owned by a collector of South American origin who lives in Switzerland.

It is not to be implied that the statue was acquired by unethical methods. However, the fact that it was once a treasure of outstanding symbolic value should make us at least cautious about the sales transactions involved. A purchase legitimate in law is not necessarily morally beyond reproach. The buyer may exert considerable pressure, whether of offering what may seem in local context vast sums of money or by calling upon a relationship of obligations. The latter is possibly the most difficult to refuse and is effectively used by local middlemen. If an object like the bronze weaver had lost its particular meaning within the village community, it should certainly then have become, as a treasure, part of the national heritage of Indonesia. It is a tragedy that it not only has left the country but could disappear into the obscurity of a private collection.

The situation at present puts scholars working with contemporary "traditional" Indonesian art in an impossible position. We feel committed to people whose craftsmanship and mastery of their environment we appreciate. They have given us much, and we perhaps feel that we can only repay them by passing on what we have learned from them. There, however, we are caught; with our publications, we inadvertently threaten the cultural heritage of those to whom we owe so much. In light of this, the familiar poem by William Butler Yeats (1899) takes on new meaning:

> Had I the heavens' embroidered cloths,
> Enwrought with golden and silver light,
> The blue and the dim and the dark cloths
> Of night and light and the half light,
> I would spread the cloths under your feet:
> But I, being poor, have only my dreams;
> I have spread my dreams under your feet;
> Tread softly because you tread on my dreams.

Notes and References

1. In eastern Indonesia it is always the warp that is tied.

2. From 1969 to 1971 I visited the village briefly while my husband and I were living in the Kédang district (R. H. Barnes 1974). I returned in 1979 and 1982, and spent altogether nine months in Lamalera. The first return was funded by the Brit-

ish Department of Education; the second in 1982 was supported by the Social Science Research Council of Great Britain. All visits were carried out under the auspices of the Indonesian Institute of Sciences (LIPI).

3. In the 1980s the village had means of support apart from the traditional ones. Early in the twentieth century, European missionaries brought Western education, and the professional advantages were quickly realized and successfully accepted by the people of Lamalera (R. H. Barnes 1986).

4. Insanity for a woman is often said to be caused by her having had close contact or sexual intercourse with a spirit. This may happen to her unintentionally if she sits down too long near the spirit's place of habitation, which may be a large rock or a big tree.

Adams, Marie Jeanne
1977 "A 'Forgotten' Bronze Ship and a Recently Discovered Bronze Weaver from Eastern Indonesia: A Problem Paper." *Asian Perspectives* 20 (1): 87–109.
Arndt, Paul
1933 *Li'onesisch-Deutsches Wörterbuch*. Ende, Flores: Arnoldus.
Barnes, Robert H.
1974 *Kédang: A Study of the Collective Thought of an Eastern Indonesian People*. Oxford: Clarendon Press.
1986 "Educated Fishermen: Social Consequences of Development in an Indonesian Whaling Community." *Bulletin de l'Ecole Française de l'Extrême-Orient* 75:295–314.
Barnes, Ruth
1987 "Weaving and Non-Weaving among the Lamaholot." *Indonesia Circle* 42 (March):16–31.
1989a *The Ikat Textiles of Lamalera: A Study of an Eastern Indonesian Weaving Tradition*. Leiden: E. J. Brill.
1989b "The Bridewealth Cloth of Lamalera, Lembata." In *To Speak With Cloth: Studies in Indonesian Textiles*, 43–55, edited by Mattiebelle Gittinger. Washington, D.C.: The Textile Museum.
1991 "Patola in Southern Lembata." In *Indonesian Textiles: Symposium 1985*, edited by Gisela Völger and Karin v. Welck, 11–17. Cologne: Rautenstrauch-Joest-Museum.
Geirnaert, Danielle
1990 "Kijora: A Thing for Lost Souls." In *The Language of Things: Studies in Ethnocommunication: In Honour of Professor Adrian A. Gerbrands*, 131–146, edited by Pieter ter Keurs and Dirk Smidt. Leiden: Mededelingen van het Rijksmuseum voor Volkenkunde.
Gittinger, Mattiebelle, ed.
1979 *Splendid Symbols: Textiles and Tradition in Indonesia*. Washington, D.C.: Textile Museum.
1980 *Indonesian Textiles: Irene Emery Roundtable on Museum Textiles, 1979 Proceedings*. Washington, D.C.: Textile Museum.

Keraf, Gregorius

1977 "Status Bahasa-Bahasa di Flores-Timur." *Dian* 4 (7): 18; (8): 12; (9): 14–15; (13): 6.

1978 *Morfologi Dialek Lamalera.* Ende, Flores: Percatakan Offset Arnoldus.

Vatter, Ernst

1932 *Ata Kiwan: unbekannte Bergvölker im tropischen Holland.* Leipzig: Bibliographisches Institut.

Vollmer, John E.

1979 "Archaeological Evidence for Loom from Yunnan." In *Looms and Their Products*, 78–89, edited by Irene Emery and Patricia Fiske. Washington, D.C.: Textile Museum.

Vroklage, B. A. G.

1953 *Ethnographie der Belu in Zentral-Timor.* 3 vols. Leiden: E. J. Brill.

Yeats, William Butler

1899 "Aedh Wishes for the Cloths of Heaven." From *The Wind Among the Reeds*, p. 60. London: John Lane.

3 Rape of the Ancestors: Discovery, Display, and Destruction of the Ancestral Statuary of Tana Toraja

Eric Crystal

Shadow of Death, Image of Life

Continuity with the ancestral past, solidarity with kinsfolk of the present, and an affirmation of cultural and social integrity of future generations invest much of Southeast Asian art with the vitality of religious symbolism and the power of ethnic identity. Ancestral images have figured prominently in the monumental architecture of the Hindu-Buddhist era in Southeast Asia, which often presents images of deceased god-kings in Java and Cambodia as symbols of social continuity and incarnate sacral power on earth. In writing of the god-kings of Angkor, Coedes (1964:26) notes that "by erecting an idol . . . or 'lord of the universe', which was the 'holy image' [urah rupa] of a king or a prince or a dignitary . . . the Khmers thought they could perpetuate in stone the essence of the person that they wanted to worship."

The indigenous religious traditions of Southeast Asia have similarly invested considerable religious commitment, ceremonial grandeur, and artistic talent in the creation and display of images of the prominent deceased. Among Malayo-Polynesian speaking peoples of Southeast Asia, such nearly life-size images, carved in wood, are known from widely dispersed locales, such as Rhade villages in the southern cordillera of Vietnam, the Batak area in Sumatra, Sumba in the Lesser Sunda Islands, and the Sa'dan Toraja area of southern Sulawesi, Indonesia. The wooden images found in the late twentieth century in villages of eastern Indonesia are probably similar in form and meaning to their prehistoric counterparts. In fact, most of them are less than two hundred years old. Despite stylistic variations, "they convey a common feeling about the magical potency of supernatural or deified human beings" (Holt 1967:26).

The wooden statuary of outer-island Indonesia, and of highland minority regions of mainland Southeast Asia as well, reflects the oldest of representational artistic traditions of tropical Asia. Such neolithic artistic traditions are "characterized by conventionalized frontal-type figures of ancestors,

often of startling realism, as well as by magic symbols such as buffalo horns, human heads, various animals, renderings of the so-called tree of life, etc." (Wagner 1967:33).

Geographically and culturally distinct from the Muslim lowlands, the Toraja region did not come under colonial administration until about 1900. Dutch Protestant missionaries intervened to check the spread of Islam into the region after establishment of the Pax Neerlandica in 1905. In the post–World War II era, geographical and political isolation from contemporary Indonesia continued as the Darul Islam insurrection engulfed surrounding districts from 1951 to 1965. Thus Toraja traditional culture remained largely intact in 1968, at which time half the population adhered to the ancestral religion, *aluk to dolo*, while the other half adhered to Christianity.

Toraja ancestral statuary, or *tau tau*, reflects essential indigenous concepts concerning status, the disposition of the soul, and the solidarity of present generations with those of the past. *Aluk to dolo*, literally "rituals of the ancestors," is oriented to ancient "principles" of ritual and social action. *Tau tau* statues stand in limestone cliff galleries, manifesting the social status of the deceased, intergenerational continuity, and ethnic identity of this minority mountain people. They project both the shadow of death, as the image escorts the soul of the deceased to the burial site, and the image of life, as genitalia are prominently carved although discreetly hidden under formal dress (see Crystal 1985: fig. 164).

Only Toraja of high rank and standing, whose survivors are able to finance a large death ceremony, usually of five or seven nights' duration, merit the construction of a *tau tau* image. There are two *tau tau* fabrication techniques: lesser and major. In the lesser, and more evanescent tradition, for those of modest rank and means, an image is crafted of bamboo and cloth (fig. 1). This image is discarded at the close of the funeral ritual prior to the transport of the remains to the burial cave. The major *tau tau* tradition commands the preparation of a statue from durable jackfruit wood. Sacralization of this image commences with the sacrifice of a pig at the first felling of the jackfruit tree. Normally carved for those receiving the elaborate two-stage *rapa'i* funeral, the image is prepared before the final seven-night ritual and shortly before the funeral commences is placed prostrate alongside the remains in the house of the deceased. "During the manufacture of the doll, the woodcarver sleeps near (or even under) the house where the deceased lies on view. . . . When the image is completed it is placed beside the dead. Just like the deceased, the *tau-tau* receives food to eat." (Nooy-Palm 1979:262). Body and *tau tau* image are "awakened" as one as the funeral begins. During the rite they are moved together in procession from house to rice granary to ceremonial field, and placed on display at the

Fig. 1. Widow with bamboo and cloth *tau tau* statue of late husband, Rindingallo, 1985. Photo: Eric Crystal.

ritual center atop a large catafalque. As the wooden statue is carried, the head is often swiveled on its detachable base, and the arms and hands are manipulated by the specialist who bears it. A lifelike wooden puppet, the *tau tau* statue represents the hidden soul of the deceased, which resides in the vicinity of the ceremony until several weeks after interment. Ultimately the body is deposited in a chiseled cave vault, and the image is placed in an adjacent gallery of ancestral statues.

In 1968 the eighty-three villages of Tana Toraja maintained thousands of such statues, many of them hundreds of years old. Displayed for all to see, the statues symbolized for the Toraja the individual status of the deceased, the collective powers and prescience of the ancestors, and the conscious ethnic identity of a minority mountain cultural tradition.

Display

Toraja burial traditions have been radically altered in historic times due to incursions from without. Arung Pulacca, the lowland Bugis warlord who assisted the Dutch in the conquest of southern Sulawesi in the seventeenth

century, is said to have invaded Tana Toraja in early colonial times. Burying the deceased with precious textiles, beads, and metals inside elaborately carved wooden sarcophagi was the Toraja rule at the time. Over the centuries, multiple burials in large wooden vessels placed at the base of limestone cliffs accumulated irresistible treasure troves of heirloom goods and precious metals across much of Tana Toraja. Arung Pulacca looted the region and occupied it for seven years until he was expelled in a major insurrection. As a result of the seventeenth-century Bugis occupation, Toraja burial practices radically changed. Cave burial vaults began to be carved in high, inaccessible cliff faces. It appears that the *tau tau* carving tradition also commenced at this time, although that is not certain.

For at least the last twelve generations the Toraja have been marking major funerals with the commissioning of ancestral statues. Such statues have been displayed in dramatic limestone galleries of assembled figures adjacent to burial grottoes or hand-hewn caves. The soul of the deceased is not thought to reside in such statues but is believed to travel alongside them to the burial place before final dispatch to the land of the dead somewhere in the south. Images are owned, named, and cared for by successive generations of descendants. "The *tau tau*, are dressed in fine suits of clothes and set in little alcoves in the cliff walls, there to look down on the activities of their living descendants. These effigies . . . represent men or women of high status, destined to become godlike ancestors in due time" (Barbier 1984: 102). At twenty-year intervals the images are traditionally refurbished, reclothed, and consecrated en masse in a ritual termed *ma'nene'*. At such times offerings are made to the ancestors, and family members attend to the statues of prominent relatives. Normally, access to the statue galleries is forbidden except in the event of large funerals, when a new statue is emplaced.

The belief system that invests Toraja statuary with such power and meaning remains very much alive. In 1990, at least 50,000 Toraja continued to practice the *aluk to dolo* religion. For those who have embraced Christianity, allegiance to the family line (ramage) and respect for deceased ancestors remained strong and uncompromised. *Tau tau* statues bear the names of the deceased and are the exclusive property of those family members who have organized and financed the death ritual. Relatives very frequently recall not only the year of interment but also the precise number of water buffalo and pigs sacrificed at the time. Such statues are objects of family pride as well as symbols of status. They reflect an archaic religious system and late neolithic artistic tradition once characteristic of many peoples of highland Southeast Asia.

International Attention

Regional peace returned to South Sulawesi with the conclusion of the Darul
Islam insurrection in February 1965. In 1966, the government was headed
by President Suharto, who subsequently opened Indonesia to foreign
investment, international development assistance, and expanded tourism.
In 1968 the term "tourist" was unknown in Tana Toraja; a decade later the
word *turis* had supplanted *belanda* (Dutchman) as a synonym for Western
visitors. A trickle of tourists appeared in the area in 1969 and 1970, prompt-
ing local government initiatives to develop two spectacular traditional
burial sites at Londa and Rantelemo near the principal Toraja town of Ran-
tepao in 1971. Access roads were built, and welcoming signs and formal
gateways were constructed, in the first manifestation of infrastructure devel-
opment in Tana Toraja directly relating to cultural tourism.

The first recorded theft of a *tau tau* statue occurred in 1971, in the west-
ern Toraja district of Saluputti. A British antiquities dealer spirited a cave
burial door and at least one statue out of the area with the connivance
of the son of a village leader. Within a decade no burial site in the eighty-
three villages of Tana Toraja would be free of the threats of looting and
destruction.

At the conclusion of the Pacific Area Travel Association annual meeting
in Jakarta in 1973, scores of travel agents were escorted on tours through
Tana Toraja. International art dealers quickly seized the opportunities pre-
sented by the opening of the area to survey and sell on commission Toraja
funerary statues. Some European dealers assigned agents with telephoto
lenses to survey the many burial sites in the region. Customers in Europe
could subsequently select their preferred statue from photographic albums.
As Toraja ancestral statues have for centuries been placed on public display
for all to regard and respect, no obstacles were confronted by those intent
on surveying objects for subsequent theft. In the minds of many Toraja vil-
lagers, the coming of the tourists and the destruction of their ancestral stat-
uary are inextricably linked. This is not to say, of course, that legitimate
tour operators were directly involved in the looting of Tana Toraja. Simply,
the opening of the area to outside contact and the legitimization of tourist
interest in burial sites greatly facilitated the work of international art
thieves.

Local, provincial, and national government reaction to the attack upon
Toraja burial sites and statue galleries has been weak and ineffective, if
noticeable at all. Such statues are invariably stolen with the connivance and
active participation of Toraja accomplices. The sums of money involved are

not inconsequential. In 1985 Toraja statues were selling in Los Angeles for about $6,000 each. Indonesian accomplices operate at night, use four-wheel-drive motor vehicles, and have little to fear in terms of legal retribution: although thieves have been apprehended, the most severe sentence meted out in local courts has been three months in prison. The Toraja are linguistically, ethnically, and religiously distinct from the Bugis and Makassar lowland majority in this province, and little sympathy for highland traditional arts and culture has been registered by provincial authorities.

As the national government has vigorously promoted tourism since the 1970s, Tana Toraja has moved to a position of prominence. In 1968 the area was virtually unknown, never cited in provincial or national press, and at best considered a backwater of embarrassing cultural conservatism. By 1990, Tana Toraja had become the second focus of national tourist development after internationally renowned Bali. A fine all-weather road links the formerly semi-isolated Tana Toraja region to the provincial capital; thrice-weekly air service is in operation. A Toraja house adorns Indonesian currency, and Toraja handicrafts are well known throughout the archipelago. Yet the Ministry of Education and Culture has never engaged the significant issues posed by the explosive development of international tourism in Tana Toraja. In the 1980s, 40,000 foreign visitors annually made their way to the Toraja region. Yet Indonesian authorities have employed few measures to assess, survey, and safeguard the ancestral statues and archaic burial sites that constitute the most important physical attractions of the region. Indeed, the Ministry of Education and Culture has taken no role in planning for tourism or protecting antiquities in the Toraja region, but instead has left the field to national and provincial officials concerned exclusively with the development of tourist enterprise.

Destruction

For Western art dealers to commission the theft of but one ancestral image from Tana Toraja would be a crime of serious magnitude. By 1988, however, almost all traditional burial sites had been disturbed by thieves, and hundreds of intact statues had been taken from Tana Toraja. Some museum directors and gallery curators justify their removal by saying that such fine works of art are so valuable a part of the artistic inventory of Southeast Asia that leaving them exposed to the elements in Tana Toraja would be negligent. Others say that the statues are no longer significant or meaningful to the Toraja and are willingly sold by villagers who have new personal and family concerns in a changing world.

Such obfuscations cannot mask the terrible rape of the Toraja ancestors

that has occurred since the mid-1970s. So brazen has been this attack on ancestral tradition that even the two famous Toraja tourist sites, the burial caves and gallery at Londa and the great gallery at Rantelemo, have been looted of practically all their precious statues. At Londa, in July 1987, an empty gallery greeted visitors as they strode down the massive concrete stairway that tourist development funds had recently financed. That year five of the eleven statues that had remained two years earlier were spirited away into hiding, and six were stolen.

At Rantelemo the last refurbishing ceremony took place in 1971 (figs. 2–5). In 1987 eleven statues remained from approximately seventy that had been in place a decade and a half before. Here, again, an all-weather access road built for tourists' convenience facilitated the theft of the statues.

Tau tau statues are often constructed so that the heads and forearms are detachable. This not only allows the manipulation of the statue during the funerary procession but also helps in the emplacement in the high, narrow statue gallery. For this reason heads alone are often stolen when thieves hastily exit burial sites to avoid discovery (fig. 6). In Sangallangi district thieves used axes to free the most desired statues from the galleries in which they had been placed perhaps a century before. Dismembered torsos and limbs littered the burial site.

Elsewhere villagers used an obscure cave to hide approximately sixty statues, removed there by Toraja farmers who feared that thieves would

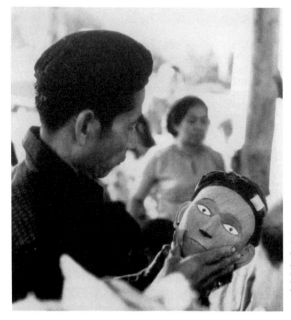

Fig. 2. Refurbishing the head of a statue, Rantelemo, 1971. Photo: Eric Crystal.

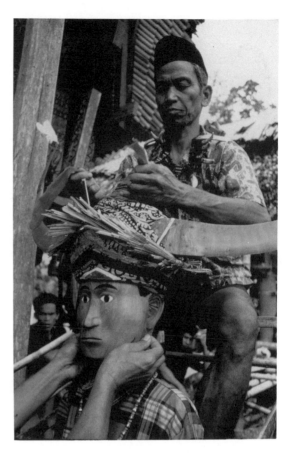

Fig. 3. Ceremonial deco-
ration of wooden *tau tau*
shortly before funeral
procession to ceremonial
field, Rembon, 1971.
Photo: Eric Crystal.

steal or destroy them. In Tana Toraja, fear of theft and destruction sur-
rounds all traditional burial places. Many villagers hide their statues, await-
ing the funeral of a relative so that they may place *tau tau* inside burial
caves, sealing them from public view.

The rape of Tana Toraja's ancestors has occurred in every district and at
almost every burial site, save one, which is guarded around the clock by
former serfs of the nobles of Sangalla. Not only have hundreds of sacred
objects been stolen intact, but many more have been destroyed in the fran-
tic rush to extract them from the region, from the province, and from the
country. One of the first thefts occurred in 1971, in Ulusalu district to the
west of the Toraja administrative capital of Makale. Photographs of appar-
ently stolen *tau tau* and a carved tomb door appear in an exhibition cata-
logue published by the Museum of Cultural History at the University of
California at Los Angeles (Feldman 1985: 27 [pl. 16], 133 [fig. 160a]). The
objects, which were included in the museum's exhibit, are said by villagers

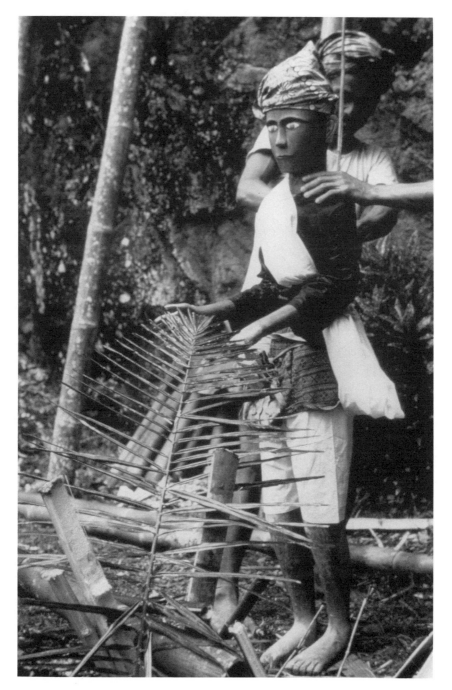

Fig. 4. Carrying a refurbished statue up to gallery, Rantelemo, 1971. Photo: Eric Crystal.

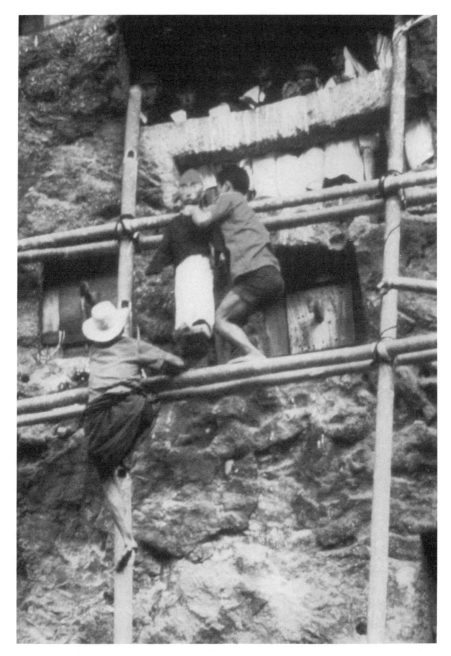

Fig. 5. Placing statues in gallery, Rantelemo, 1971. Photo: Eric Crystal.

Fig. 6. Man with disfigured wooden *tau tau*. The head has been sawed off by thieves for sale in the West, Saluputti, 1985. Photo: Eric Crystal.

to have been procured by a dealer in primitive antiquities directly from an Ulusalu village in 1971. Not only are in situ photographs and ownership of the items linked to the same individual, but Ulusalu villagers identified both the object in the book and the dealer in interviews in July 1985. The publication of such photographs and display of such objects represent an atypically brazen flouting of UNESCO codes and common decency.

The bitter experience of the Toraja is cause for serious reflection among those concerned with the preservation of fragile material culture traditions of Indonesia. The rape of the ancestors has occurred over an extended period in close collaboration with external sources of finance and demand, in an area that has become a focus of international tourist attention. Scores of *tau tau* statues have been accepted as donations by museums across the United States. Dealers anxious to increase public knowledge and appreciation of Toraja ancestral statuary have not proffered these pieces out of a sense of altruistic community service. On the contrary, with each donated piece (usually of secondary value as assessed by art dealers), the corresponding value of artifacts sold either in galleries or to private parties will rise accordingly. The theft of these statues may be traced precisely to demand emanating from the West. The responsibility for surveying traditional sites and taking measures to protect them obviously rests with the authorities in Indonesia. But in 1985 the senior civil administrator of Tana Toraja, the chief prosecutor, and the chief of police did not comprehend the dimensions

of the problem. Yet, in terms of prospective tourist development, it is diffi-
cult to imagine why tourists would want to visit a famous burial site in
Toraja when all the statues have been excised. Paradoxically, just at the time
when cultural tourism has directed the attention of a dozen anthropolo-
gists, 40,000 annual foreign visitors, and national development planners to
Tana Toraja, the fragile material culture of the region is rapidly disappearing
from Indonesian national territory.

In a similar plight are sacred Toraja textiles, such as blue and white *sarita*
batiks and hand-drawn *mawa* (shaman's cloths). Never once displayed in
national or regional museums, precious unrecorded artifacts of a living
Toraja culture have been taken from Sulawesi to be hung in far off locales.

Christian or *aluk to dolo*, rich or poor, from north or south, residents of
Tana Toraja remain confused and angered at what has happened to their
ancestral images. Government officials in the 1980s announced that they
would commission new statues to replace the stolen ones. No comment
could more concisely summarize the tragedy of the rape of the Toraja ances-
tors. Sacred images, invested with the power of belief and consecrated in
the context of great funeral rituals, tested by the winds for centuries in open
limestone cliff galleries, may be replaced by newly carved objects produced
on contract for local authorities. Named for individuals and known for the
great ceremonies that ushered them into the land of souls, many such
ancestral statues either lie strewn like so much firewood about desecrated
burial sites or perhaps form the centerpiece of private art collections in Los
Angeles, Brussels, or New York. Other Toraja *tau tau* remain hidden by
fearful Toraja awaiting the opportunity to seal them behind burial vault
doors forever.

If museum curators and antiquarians in the West were to recognize that
each statue from Tana Toraja was indeed stolen property, illicitly obtained,
the continuing assault on traditional statuary in highland Sulawesi would
slow significantly. If the studied ignorance that permits the looting of ances-
tral burial sites in Tana Toraja continues much longer, a significant element
of Indonesia's, and the world's, ancestral tradition will have been totally
destroyed in little more than two decades.

References

Barbier, Jean-Paul
1984 *Indonesian Primitive Art: Indonesia, Malaysia, the Philippines, from the Collection of the Barbier-Müller Museum, Geneva.* Dallas: Dallas Museum of Art.
Coedes, George
1964 *Angkor, An Introduction.* New York: Oxford University Press.
Crystal, Eric
1985 "The Soul That Is Seen: The *Tau Tau* as Shadow of Death, Reflection of Life in Toraja Tradition." In *The Eloquent Dead: Ancestral Sculpture of Indonesia and Southeast Asia,* edited by Jerome Feldman, 129–146. Los Angeles: Museum of Cultural History, University of California.
Feldman, Jerome, ed.
1985 *The Eloquent Dead: Ancestral Sculpture of Indonesia and Southeast Asia.* Los Angeles: Museum of Cultural History, University of California.
Holt, Claire
1967 *Art in Indonesia: Continuities and Change.* Ithaca, N.Y.: Cornell University Press.
Nooy-Palm, Hetty
1979 *The Sa'dan Toraja: A Study of Their Social Life and Religion.* Vol. 1, *Organization, Symbols and Beliefs.* Verhandelingen van het Koninklijk Instituut voor Taal-, Land- en Volkenkunde, 87. The Hague: Martinus Nijhoff.
Wagner, Frits A.
1967 *Indonesia: The Art of an Island Group.* Rev. ed. New York: Greystone Press.

4 The Adaptation of Indigenous Forms to Western Taste: The Case of Nias

Jerome Feldman

The Indonesian island of Nias has earned an international reputation for its dramatic forms of indigenous visual arts. The islanders produced some of the most spectacular examples of architecture, stone work, wooden sculpture, gold work, and costumes seen anywhere in the archipelago. Remainders of this once-vibrant tradition fill the museums of Europe, America, and Indonesia. In Nias, the cultural inspiration that fueled the traditional arts is being supplanted by a market economy. The result is a necessary change in the stylistic norms that guided the arts in the past.[1]

The most abundant and perhaps interesting form of art in the island consists of wooden images (*adu*) produced originally for the propitiation of the spirits of ancestors. These effigies could range in form from simple sticks or twigs to finely finished statues, fulfilling a multiplicity of functions in the traditional religious system (*moloche adu*).

Missionization and Dutch policing effectively ended the production of images for religious purposes by 1920. Whatever was not collected by museums, confiscated, or purchased as curiosities by missionaries and civil servants was either destroyed or hidden. Often the sacred objects were destroyed by the Nias people themselves, either to prove their conversion or to prevent the sacred objects from falling into the hands of foreigners. As early as 1902, controversy arose among concerned Westerners over the role of foreigners in the artistic destruction taking place on the island (see H. S. 1902:179; Mundle 1902:280).

In an island such as Nias, where sculpture is a high and respected art form, the extinction of talent or, even less likely, of the urge to carve seems improbable. A number of processes have taken place that allow the plastic mode of expression to survive within the traditional Nias cultural context. The original form of an object could be retained if deemed suitable or noncontroversial. The form also could be disguised so that the purpose, or even the presence, of a religious object would not be detected by those who would object to it. Alternatively, a style could be changed to conform to prevailing requirements while retaining the original ideas; such carving could likewise be a form of disguise.

Sculpture could also find expression within the context of the Western market economy. Here forms are adapted to conform to the taste of consumers. These products must maintain something about them that is distinctly Nias in origin, but they need not conform to ritual requirements. This has resulted either in simplified, doll-like objects for the curio market or in objects of refinement for those of discriminating taste.

The Survival of Traditional Forms

Certain items, such as sword handles and houses, do not have the obvious onus of idolatry and hence could continue to be produced. In many cases one can find workmanship in the late twentieth century that is, in these categories, comparable to many fine old collections. Although the function of swords has changed from use in warfare to ceremonial purpose, traditional swords are still clearly understood to be potent weapons. The monsters comprising the sword handles come from the old Nias context. The *lasara*, the dragonlike royal protective creature of South Nias, is most commonly found on swords *(telögu)*, along with elaborate amulet bundles *(ragö)* of animal teeth, stones, and other items believed to be potent protection. This type of sword has its origin in South Nias and was intended for the warriors under the direct command of the village ruler. Similar swords were also found in certain parts of Central Nias. In 1990 *telögu* were found in all regions of the island, not necessarily in royal contexts, although association with nobility added prestige to the bearer. Other regional sword types serving diverse functions have largely vanished from the contemporary repertoire because they are considered either less attractive or less prestigious.

Traditional houses *(omo hada)* are still preferred by conservative islanders in South Nias, although the enormous expense of the feasts required upon their construction makes this ideal unattainable for most individuals. Conceivably the feasting could be eliminated, but in Nias one typically does not compromise tradition; one either follows it or adopts an entirely different way.

The South Nias *omo hada* is an abbreviated version of the chief's house, or *omo sebua*. Evidence suggests that design elements of these houses were influenced by contact with Dutch galleons at the turn of the nineteenth century, a period of intense slave trade and increased wealth for the rulers of South Nias. The magnificent gilded galleons provided an excellent model for a harmonious transformation of the basic house style that reflected the newly gained affluence. The result of this interaction between two vital cultures was a grand style of palace and a level of magnificence unusual in tribal domestic architecture (Feldman 1984). Because *omo sebua* require

human heads for their consecration, and enormous feasts for their construction, these grand homes are no longer made.

In other regions of Nias, *omo hada* are becoming a thing of the past. North and Central Nias have had a longer period of intensive Western contact than the South, and traditional houses there tend to be smaller and less precisely built than their southern counterparts—two reasons why *omo hada* were rarely built in the 1980s. A contemporary chief's house near the capital of Gunung Sitoli shows an unusual amalgam of a typical North Nias oval house form with an appended Batak-style gable typical of Sumatra (fig. 1). This abrupt mixture of styles, which contrasts greatly with the merging of style elements in the south, perhaps results from the intense contact between North Sumatra and Gunung Sitoli that dates to the establishment of the town as the Dutch headquarters in 1840.

In Gunung Sitoli, the indigenous architecture styles of both areas have also been used in nontraditional contexts. A concrete government building has the oval form of a North Nias building, and a bank has a miniature South Nias building decorating the roof. Here the original intent of the architecture has been subordinated to a decorative regional reference.[2]

Fig. 1. North Nias chief's house showing the inclusion of a Batak-style gable, 1974. Photo: Jerome Feldman.

Stone monuments are still erected in some areas as testimonials to great feasts given by the nobility. In South Nias vertical stones *(batu wa'ulu)* commemorate feasts called *fa'ulu* (upwards), which celebrate the acquisition of wealth and power. A comparison of old and new versions of these stones shows an interesting aesthetic change toward Western modes of representation. A fine old example in the village of Bawömataluo in South Nias is decorated with a complicated abstract design (fig. 2). The monument honors the ruler Alawaföna, and the decoration depicts elements of his head ornaments. He in fact never wore headgear exactly like this; the carving is not so much an illustration of his actual ornaments as it is a metaphorical reference to his qualities. The plant motifs signify that he is a person who has achieved very high status; that is, he is complete as the world is complete, indicated by the presence of wild plants and animals. His stature is therefore likened to the total cosmos. The hook shapes, protruding on the right and left below the horizontal element, represent the teeth of a tiger, an animal

Fig. 2. Vertical stone monument commemorating a feast for Alawaföna, Bawömataluo village, South Nias, 1974. Photo: Jerome Feldman.

not found in Nias but symbolic of a ruler. The animal's bravery, ferocity, and exotic qualities are implicit in the carving. Such teeth are also found on the amulet bundles of the oldest royal swords, where they indicate the ability of the ruler to command the use of foreign products. The only obviously representational element is the necklace; even this is not just a necklace, but a *kalabubu*, a type of costume element indicating a great warrior.

A contemporary stone monument from Bötöhilitanö village, South Nias, provides an interesting aesthetic contrast (fig. 3). A frame, a new device, causes the central elements to be perceived as a picture or illustration. Indeed, the items here are clearly identifiable to any person familiar with Nias material culture. In the center there is a scale *(bulu gana'a)* above two items used for the measurement of rice, the cuplike *jumba* and the larger *töwa*. The horizontal line is a ruler *(afore)*, for measuring pigs. These refer to the norms and standards of society (Suzuki 1959:128). On the periphery are a spear, a shield, and a sword, elements of protection. It is a rule that protective symbols always surround the protected.

Although the elements depicted here are traditional, and their ultimate origins are embodied in rich mythology, in this monument symbolism is present but metaphor is not (Roth 1985:131–184). The objects and their arrangement symbolize society, but nothing is indicated about the qualities of the ruler or his village. The completeness of nature, the strength of the tiger, wealth, and status are not alluded to through the qualities of an animal or plant. It is in fact a picture of society, utilizing traditional material culture as symbols placed within a picture frame. The subtle artistry of the Bawömataluo example has been replaced with simpler outlines.

Disguising Traditional Forms

Images in human form are no longer produced in Nias as sacred items associated with traditional religion. This does not mean that elements of the ancient belief system do not survive, but in a nearly totally Christian social context, images are seen as inappropriate. Even elderly people disparage them with Indonesian exclamations such as *hormati kayu* (giving honor to wood). Given this context, it is not surprising to find that no images are in use; it is difficult to get the elders to even speak about them. If questions refer to customs of the past, however, informants are able to explain much about the images.

An interesting case demonstrating a possible survival of the use of images was observed in the village of Hilinawalö in the Mazingö district of South Nias. An important offering intended to protect the household of the ruler from disease used to be positioned in front of the chief's house. This

Fig. 3. Vertical stone monument, Bötöhilitanö village, South Nias, 1988. Photo: Gary Schidler.

be'elösöu, or *famalua*, consisted of three elements: a forked image called *siraha salawa*, a hook-shaped image called *sokhaekhae*, and a leafy plant called *sobulu* (Feldman 1985:72–75). The *siraha salawa* that was in front of one chief's house around 1900, seen in a photograph taken at that time by the Dutch administrator Schröder (fig. 4), had been replaced by two sticks and a sprouting coconut by 1974 (fig. 5). One stick is straight and supports a

Fig. 4. Exterior of the chief's house showing *be'elösöu* offering, Hilinawalö village, Mazingö district, South Nias, circa 1900. Schröder 1917, vol. 2: fig. 69.

clothesline; the second is hook shaped, and the coconut sports leaves. Images in human form have been eliminated, and the type of plant changed, but the essential elements are displayed in the correct position. If this interpretation is true, then the images are recognizable only by their context. A forked stick could not be used, as it would be instantly identified. Such disguised images would avoid criticism and the temptation to sell a sacred object.

Another disguise, the use of Western art styles for the indigenous religion has been examined by Father Hämmerle (1988). In 1984 Hämmerle discovered a carved board in the possession of the North Nias scholar Sökhi'aro Welther Mendröfa (ibid.: fig. 1). The sculpture was done by Mendröfa in 1974 as a copy, based upon a 1942 photograph of a much older object originating from a very old house in the North Nias village of Lölöwua. Hämmerle feels that because the house in question dates back to 1813, the original sculpture predates the arrival of Christianity (1988:193).[3] The style of the carving, showing two anatomically rendered nudes in relief seated in three-quarter view, is unquestionably Western and has no precedent in Nias tradition. Hämmerle admits that the figures resemble Adam and Eve and that he has never seen anything quite like this in traditional Nias (1988:

Fig. 5. Exterior of the chief's house, showing possible *be'elösöu* image, Hilinawalö village, Mazingö district, South Nias, 1974. Photo: Jerome Feldman.

193). It seems probable that the sculpture was carved some decades after the construction of the old house in which it was found.

Despite the rendering of the figures, and a very naturalistic bird at the top, the sculpture could only have been done by a person from Nias. The peculiar combination of elements such as detached arms and *lasara* or *naga* (snake) figures is unique to Nias. It is evident from the information Hämmerle collected, that what would appear to be Westernized Christian sculpture indeed has meanings and references that go deep into Nias tradition. Every element in this complex board has an indigenous explanation. No other object in the more indigenous arts of Nias so directly illustrates Nias traditions. (Hämmerle 1988:201).

Without Mendröfa's explanation, it is impossible to understand the actual meaning of the board, which would undoubtedly be interpreted as a rendering of Adam and Eve, with the sun rising above them and a dove ascending. It would appear the intent was to disguise the expression of Nias tradition by clothing it in Western (and Christian) style. Certainly the concepts underlying the sculpture could have been expressed using Nias artistic conventions. As with the contemporary stone, metaphor seems to play a secondary role, or even no role, in symbolism.

The conversion of the population to Christianity has in fact been a dialogue between the traditional and introduced religious systems. Many elements of the Christian service incorporate forms from the indigenous belief system (see Schmidt 1967), and some forms of indigenous systems of belief find expression in Western art styles.

Nias Art in the Commercial Context

Although sculpture in human form is disparaged and nearly extinct in the cultural context of Nias, it is the most desired form in the art market. The people of Nias have understood this fact almost since the period of earliest contact. Certainly after conversion to Christianity some people sold the ancient images that were not destroyed or given away. The oldest recorded collection comes from the British period of Nias. In 1821, Dr. William Jack and Mr. Prince wrote to Stamford Raffles that "wooden images are to be found in all their houses which are regarded as a kind of lares or protecting household gods, but no worship is addressed to them; they are rather considered as representatives or memorials of their ancestors for whom they have great reverence" (Raffles 1830:493). Only one documented image, now in the British Museum, survives from this time, although two others in the collection are probably from this period (see Fagg 1977: fig. 54).

A close examination of museum collections reveals a body of sculptures in a variety of styles. Some of these styles can be explained in terms of function, while other forms are better understood in a regional context. Generally, roughly carved figures are intended for protection either from disease or from the unfortunate consequences of one's actions, such as headhunting, warfare, or murder. Such images frequently have flat projections (*daha*) protruding from their heads. They can range from simple twigs to huge complicated figures intended to ameliorate the problems arising out of warfare (*adu hörö*).

Finer images, such as those in the Raffles collection, represent ancestors. Because of the care and detail in their execution it is possible to discriminate styles of three regions of Nias. The figures of North Nias tend to be cylindrical; they have peaked headgear; and each holds a cup with both hands (see the stone example from North Nias illustrated in the frontispiece to Barbier and Newton 1988, and there mislabeled "west central Nias"). Central Nias figures are blocky and geometric. They usually have three prongs protruding from the head, and the hands either hold two pegs above the knees or meet in front of the belly holding nothing. It is common only in this region to find figures with both female breasts and a penis. South Nias images tend toward naturalism and hold a cup in the right hand and a peg in the left.

Such figures frequently wear helmets and have three projections forming their crown (Feldman 1985:45–78).

Ancestor images are made of a type of wood called *ma'usö*, in which the dead are considered to reside (Schröder 1917: vol. 1, 452). *Ma'usö* ranges from light to dark brown and closely resembles the skin color of the Nias people themselves (Hoog 1959:1–89).

Art for the Discriminating Collector

In some of the oldest museum collections there is a type of image that does not fit comfortably into the three regional styles. The images are highly naturalistic: the face has cheekbones; eyes fit into sockets in the skull; the mouth is full and slightly smiling; toenails are carved; and the figure is naturalistically proportioned. Frequently the image wears a turban, something not found on other types (fig. 6). Interestingly, this is the only figure type that appears in both old collections[4] and in late twentieth-century Nias (Viaro 1984:143). One was also collected by the missionary Horst Krank in the 1970s.

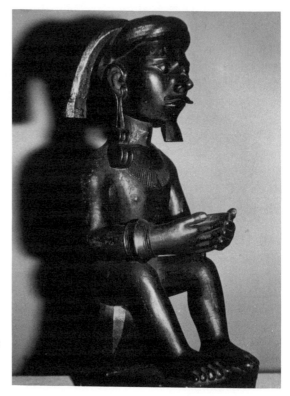

Fig. 6. Human figure of *kafini* wood created for the commercial market. Missionsausstellung Wuppertal. Photo: Jerome Feldman.

Why has this type of image survived virtually unchanged from the early twentieth century to 1990? The answer may lie in the fact that many of the examples appear to be made of a black wood, presumably the type called *kafini* in Nias. *Kafini* does not grow in Nias and must be imported from Pulau Pini in the Batu Islands, to the south of Nias. It is a beautiful and highly prestigious wood that is frequently used for planks in the finest chiefs' houses and for sword handles of weapons belonging to village rulers. It is not the appropriate wood for ancestor images. The extreme polish of the figures, their anatomical details, and the use of the turban all mark these images as atypical. Their survival into modern times indicates that, in contrast to ancestor images they do not have to be disguised, hidden, or destroyed, all of which demonstrates that these images were created to meet the prestigious requirements of the discriminating collector of Indonesian tribal art.

A 1987 Sotheby's catalogue demonstrates that Nias artist-entrepreneurs have an exacting knowledge of their market. New forms of sophisticated creations have entered the market and have fetched high estimated prices in the auction galleries. Not a single image in the catalogue is an authentic old piece (Sotheby's 1987:pls. 2, 96, 97, 100).

Art for the Tourist Market

While certain figures have been made for sale to the selective collector, other figures have been produced for the mass market. The figures are made of light-weight softwoods; details have been suppressed; and the images have a doll-like simplicity.

This change can be seen very early in South Nias. One of the oldest figures collected from the area is illustrated in figure 7. This may have been one of the two figures taken by the Dutch when they burned the royal palace in Orahili village in 1863 (Bossche 1864:259–260).[5] In true South Nias style, the figure is relatively naturalistic. The eyes are clearly shown and taper into lines along the temples, and the nose is pointed. The entire figure is clearly and boldly modeled, with distinct detailing on the headgear, earring, and necklaces. In its complete form, it would have held a shield in one hand and a sword or spear in the other. Such figures commemorate feasts for the smithing of gold ornaments and were hung along with female dancing figures in front of the trellis window at the front of royal houses.

By comparison, the image illustrated in figure 8 is quite simplified. Details are poorly carved, and it is made of lighter wood. While the artist recalled the image type correctly, the quality is unmistakably diminished. Collections of these images in South Nias made in 1931[6] (Bonnet 1931:378;

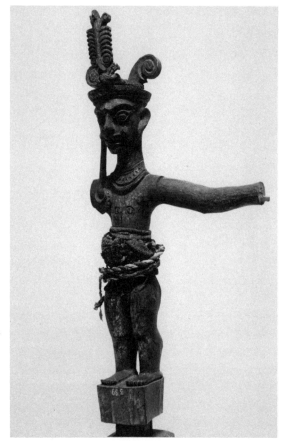

Fig. 7. Human figure, South
Nias, possibly acquired
1863. National Museum of
Indonesia, Jakarta, no. 68c.
Photo: Jerome Feldman.

Popescu 1977: figs. 1, 3, 4) give evidence that the quality of sculpture in
South Nias was in decline in the early 1930s. It is likely that most of the tra-
ditional sculpture in South Nias had vanished by 1920, as evidenced by
photographs of empty houses (Boer 1920, pls. 16–24).

Little if any memory of the subtleties of regional Nias styles survives in
modern examples. Figures are stiff; often the head is enormous; and, a sure
sign of acculturation, the figure is very often carved with clothing (Saleh
1980/1981: figs. 22, 55, 106–110, 121, 130–137). With the exception of jew-
elry, whatever clothing a traditional Nias figure wore was made of cloth.

It is primarily contact with Westerners that transformed the culture of
Nias. While the island spent centuries in deep isolation, it was never totally
out of contact with a wider world; change has always been a part of the cul-
ture. The people of Nias must define their own tradition in these times.
That there is still sculpture, that something of their own world view sur-
vives, is testimony to the strength of their heritage.

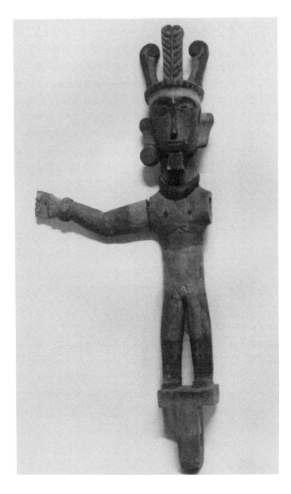

Fig. 8. Human figure,
South Nias, collected by
R. Bonnet in 1933.
National Museum of
Indonesia, Jakarta, no.
21415. Photo: Jerome
Feldman.

Notes and References

1. Out of respect for traditional people, I have always used the present tense in writing about Nias tradition. The use of the past tense implies that the tradition is dead. Here, however, there is a need to distinguish those objects and practices common to the past and those of the present. In doing so, I do not wish to imply the extinction of traditional Nias culture but merely acknowledge the prevalence of certain trends. Some of the traditional people who helped in this research are: Ama Bazanalui Fau, Ama Mendruatönöni Manau, the late Ina Sarifiti Nehe, and the late Ama Samögö Fau, all of Bawömataluo village.

2. The same use of traditional architecture as decoration for a modern building is common among the Toraja of Sulawesi.

3. Christian missionaries first arrived in 1831. Hämmerle omitted the American Congregationalist missionary Henry Lyman from his chronology of earliest mission-

aries (1988:193), although this does not alter his argument (see Thompson 1839; Lyman 1856). Lyman provided some of the earliest detailed descriptions of the culture of North Nias and the Batu Islands based upon his 1834 visit.

4. Examples of this type of image are in the following collections: Vereinigte Evangelische Missionsmuseum, Wuppertal, no. R7; Museum voor Volkenkunde, Rotterdam, no. 27160; National Museum of Indonesia, Jakarta, no. 25349; Dallas Museum of Fine Arts, no. 3250C; Dahlem Museum, Berlin; and a similar one in the Tropenmuseum, Amsterdam, no. 1588-2.

5. A change in the numbering system at the National Museum in Jakarta makes it impossible to tell for sure. In their 1922 catalogue all the oldest images received the number 68 (Schwartz 1922:7). Of the four South Nias images in this group, two of the finest are 68c and 68g. It is possible that these came from the palace at Orahili.

6. I wish to thank A. Bea Brommer at the Tropenmuseum, Amsterdam, for locating this source for me.

Barbier, Jean-Paul and Douglas Newton, eds.
1988 *Islands and Ancestors: Indigenous Styles of Southeast Asia.* New York: The Metropolitan Museum of Art.
Boer, D. W. N. de
1920 "Het Niassche huis." *Mededelingen van het Encyclopaedisch Bureau betreffende de Buitengewesten* (Batavia) 25.
Bonnet, R.
1931 "Stervende schoonheid." *Het Koloniaal Weekblad* 32:377–378.
Bossche, van den
1864 "Eene missive." *Notulen van het Bataviaasch Genootschap van Kunsten en Wetenschappen* 1:259–260.
Fagg, William
1977 *The Tribal Image, Wooden Figure Sculpture of the World.* London: British Museum.
Feldman, Jerome A.
1984 "Dutch Galleons and South Nias Palaces." *Res* 7/8:21–32.
1985 "Ancestral Manifestations in the Art of Nias Island." In *The Eloquent Dead: Ancestral Sculpture of Indonesia and Southeast Asia*, edited by Jerome Feldman, 45–78. Los Angeles: Museum of Cultural History, University of California.
H. S.
1902 "Missionsvandalismus auf Nias." *Globus* 82:179.
Hämmerle, P. Johannes M.
1988 "Sigaru Dora'a, Im Holz geschnitzte Lebensphilosophie auf Nias (Indonesiën)." *Anthropos* 83:193–202.
Hoog, J. de
1959 "Nieuwe methoden en inzichten ter bestudering van de funktionele betekenis der beelden in het Indonesisch-Melanesisch kultuurgebied." *Kultuurpatronen* 1:1–89.

Lyman, Henry
1856 *The Martyr of Sumatra: A Memoir of Henry Lyman.* New York: Robert Carter and Brothers.

Mundle
1902 "Nachricht." *Globus* 82:280.

Popescu, Traian
1977 "Colecţia "Leo Haas" plastica religioasa din insula Nias." *Studii şi comunicari de etnografie—Istorie* 2:483–491.

Raffles, Stamford H.
1830 *Memoir of the Life and Public Services of Sir Stamford Raffles, F.R.S. &c. Particularly in the Government of Java, 1811–1816, and of Bencoolen and Its Dependencies, 1817–1824; with Details of the Commerce and Resources of the Eastern Archipelago and Selections from His Correspondence.* London: John Murray.

Roth, R.
1985 "Objekt als Symbol: *Bulu Gana'a* eine Goldwaage aus Süd-Nias (Indonesien)." *Tribus* 34:121–144.

Saleh, M.
1980– *Seni Patung Batak dan Nias.* Jakarta: Departemen Pendidikan dan Kebuda-
1981 yaan.

Schmidt, W. R.
1967 *Das unbeendete Gespräch Südnias in der Begegnung mit dem Evangelium.* Wuppertal-Barmen: Verlag der Rheinischen Mission.

Schröder, Engelbertus Eliza Willem Gerards
1917 *Nias: Ethnographische, geographische en historische aanteekeningen en studiën,* 2 vols. Leiden: E. J. Brill.

Schwartz, H. J. E. F.
1922a *Gids voor den bezoeker van de ethnographische verzameling, Zaal A. Sumatra, Java.* Batavia: Bataviaasch Genootschap van Kunsten en Wetenschappen; Weltevreden: Evolutie.

Sotheby's
1987 *Tribal Art* (London), June 29–30, 1987.

Suzuki, Peter
1959 *The Religious System and Culture of Nias, Indonesia.* The Hague: Uitgeverij Excelsior.

Thompson, William, Rev.
1839 *Memoirs of the Rev. Samuel Munson and the Rev. Henry Lyman, Late Missionaries to the Indian Archipelago, with the Journal of their Exploring Tour.* New York: D. Appleton and Co.

Viaro, Alain M.
1984 "Nias: Habitat et mégalithisme." *Archipel* 27:109–148.

5 The Responsible and the Irresponsible: Observations on the Destruction and Preservation of Indonesian Art

JEAN-PAUL BARBIER

In 1864, the citizens of Bern, Switzerland, decided to destroy a wooden statue of Saint Christopher that had adorned their city for centuries. This act cannot be attributed to the Reformation, given that Bern was converted to Protestantism in the first half of the sixteenth century; since then, anti-Catholic feelings had certainly had time to be appeased. Rather, in the nineteenth century, the monument was considered to be "useless" and "cumbersome."

Without doubt, the pleasure of giving a new face to a village or the interior of a house has caused the disappearance of more evidence of the past than have revolutions or cannon fire. Most Western nations have only recently passed laws to protect outstanding sites and monuments, restraining by the same token the free circulation or exportation of works of art belonging to the national heritage. Yet countries as advanced as Switzerland in the fields of art history and the history of civilizations do not ban the sale of paintings by some of their most famous artists to foreign museums and collectors.

It is not surprising that Indonesia, which has been independent only since 1945 and since then has primarily been occupied with structuring itself economically and politically, has been unable to overcome obstacles to preservation. Enormous distances separate the country's many cultural centers, so that decrees from the capital take a long time to be enacted and longer still to be assimilated.

It is therefore futile to blame the inhabitants of the island of Nias or the Batak of North Sumatra for their failure to attend to the conservation of the impressive houses built according to traditions now vanished. Even the respect that commanded the preservation of an outstanding "seat of honor" in the middle of the village square of Hilisimaetano has not prevented the gradual damaging of the stone by children at play (fig. 1).

In what manner could this magnificent remnant of bygone days have been protected against irreparable damage? Should it have been left on the

60 JEAN-PAUL BARBIER

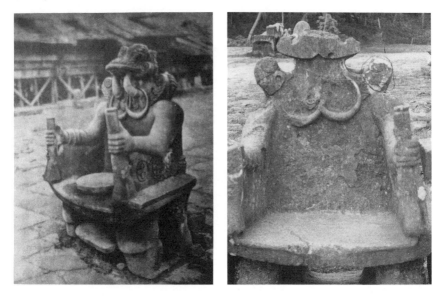

Fig. 1. The "seat of honor" in the center of the village of Hilisimaetano, Nias, as seen by Schröder in 1914 (left), and as photographed by Stéphane Barbier-Müller in 1976 (right).

spot and an appropriate shelter erected that would, however, have unfavorably altered the aspect of the entire village? Or should it have been transferred elsewhere in the village, or to the capital, Jakarta? Perhaps the family of the chief of Hilisimaetano should have been offered a replica, following the example of the Nigerian authorities' salvaging of the famous Tada bronze, which had been gradually disappearing under the effect of ritual scrapings.

In these cases, the intervention of a will external to the village and alien to the cultural context that gave birth to the work to be protected is questionable. Man has the right to die in peace once he has reached the end of his road in this world, and the same applies to civilizations, which are also mortal. The stone seat of Hilisimaetano had its day. At least there are photographs of it, more than is true of the Colossus of Rhodes or the many paintings of the celebrated Greek artists praised by Pliny.

Therefore the question is whether a government that has gained power over a hitherto autonomous society through the fortunes of international politics can claim to preserve that society's heritage against its will. Should it be decided in Ottawa to salvage a totem pole by removing it from its original site and entrusting it to the safekeeping of an institution? Should it be decided in Kinshasa to salvage the ancestor effigies of an ethnic group on the shore of Lake Tanganyika by removing them from the care of their legit-

imate guardians and placing them in a national museum, when that ethnic group has no sentiment of belonging to the nation of Zaire?

One seeks to distinguish between societies whose traditions are still alive and those to which a given monument has become meaningless, but is this reasonable? Is it safe to assume that a Macedonian community, previously Islamized but reconverted to Christianity after the fall of the Ottoman empire, derives no comfort from the Muslim stelae preserved in its cemeteries? By preserving the "seat of honor" on the same site for a century, the Protestant villagers of Hilisimaetano have established their indisputable will to claim a tradition that some observers consider to be irreparably damaged by the mutations and amputations it has undergone. But however subterranean the roots of this seemingly lost tradition, no one knows when or how it will sprout new shoots, or how high they will grow.

Does the domain of the responsible call for more elaborate comment? It is possible to expound a number of perfectly contradictory theories successfully, but in the end one is moved to ask whether in this domain the factor of chance is not the best judge. Owing to a stroke of luck, scholars rediscovered the chimera of Arezzo and the vase of Vix, to our bedazzlement. However, fate did not allow the conservation of all seven wonders of the world, thus sustaining our dreams, and it conjured away great civilizations, such as that of Tartessus, to the despair of the scholars. Yet beyond the legitimate desire to inventory the cultural heritage of humanity, beyond the concerns of science, is it not true that what is preserved after a disaster is all the more dear in light of great losses?

Turning to the domain of the irresponsible, a preliminary remark is necessary regarding the publicity over the pillaging of cultural property. This issue has not been stirred up entirely by the media, which have been accused of stimulating the antiquities markets by tempting traditional owners to sell their works of art. Owing to the humanistic curiosity characteristic of our era, which does not exclude any subject from investigation, numerous studies have been devoted to what formerly vanished noiselessly without a trace. But this same curiosity speeds up the destruction of the societies under study, for it is a short path from the libraries to the showrooms.

All this is a good illustration of the predicament experienced by those who frequent the showrooms: Knowing that clandestine excavations are carried out in Italy, should one refrain entirely from acquiring an Etruscan statuette for which there is no irrefutable pedigree? Or should one solely pursue one's mission and simply refrain from getting involved with dubious individuals? In other words, is it sufficient merely to avoid breaking the Ital-

ian law when buying a beautiful statuette in Florence, yet permissible to bid on an Etruscan bronze in an auction room in London, or New York?

Legislation has been adopted by certain countries (not including Indonesia) to ban practically all importations of artworks lacking a certificate from their country of origin or proof that they exited the country before prohibitions against the exportation of objects belonging to the national cultural heritage. This is the issue taken up by UNESCO, but without much success because of the implications of such encompassing restrictions. If one relates these attempts to stem the circulation of artworks to the issue of the protection of the Indonesian cultural heritage, one cannot fail to perceive that the identity of most of Indonesia's societies is threatened by contact with the modern industrial world, rather than by the sale of certain art objects to local merchants. Artworks depict these societies' social and religious traditions in visual form, such as sculpture, architectural designs reflecting a certain view of the cosmic order, textiles, or jewels and other insignia of rank and prestige. Yet the perennial transformation of customs, leading to the destruction or discarding of various sacred sculptures or objects, is not generally considered to be a noteworthy cause of this destruction. Who would deny that the greed of museums and private collectors does in some way minimize the destruction? But one is forced to admit at the same time that this greed contributes to accelerating such destruction. Here resides a terrible dilemma!

Does one wrong a people by imposing traditions that modify their social and religious structure? And even if one endeavors to protect them from all impure contact, would one not be converting them into living fossils, an act that would itself be an intolerable interference?

Consider the case of the Toba Batak group of Sumatra, most of whom converted to Christianity in the early twentieth century, while the Angkola Batak converted to Islam. Conversion has not prevented either group from preserving its own social structure and well-defined identity. Nor has it hindered those Batak with a strong personality from integrating themselves into the federalist state in which they play important intellectual roles. Would it have been possible to stem the flow of time just for the Batak and erect an invisible barrier around their mountains to force them to preserve the purity of their ancestral traditions and to maintain their beautiful carved houses, masks, and talismans? Is this not what some secretly wish? Progress, however, which implies change, relinquishment, and renunciation, is paid for dearly. Its price is precisely the giving up of the houses and masks. And for those who would object that these changes do not constitute "progress," is it permissible, on the other hand, to deny the Batak their right to swap their *ulos* shoulder cloths for a jacket? Is it possible to envisage,

say, the prohibition of human sacrifices but to go no further in the name of a moral doctrine that any modern state would wish to see applied? The introduction of a single foreign law into a given society is sufficient to cause social unbalance. The slightest change in the field of long-standing rules brings about a new way of experiencing the world, which ought to be faced with confidence.

Between 1974 and 1980, the small town of Parapat, North Sumatra, a mecca of tourism in the Lake Toba region, was literally cluttered with antiques stalls. Crammed on the sidewalk were pieces of superbly carved architecture, such as wooden *hombung* coffer beds or the *singa* figures that are placed symmetrically on Toba house facades (fig. 2). Anyone could buy these as souvenirs and have them mailed, without the feeling of committing a reprehensible act. Although no one at the time was really partial to these common and cumbersome objects, a market was eventually created because they had been discarded in bulk by the villagers.

One day I arrived in a village where I learned that the chief's *sopo* (rice granary) had just been sold for $500 to a Jakarta antiques dealer. I reimbursed the sum and told the chief that from now on the *sopo* was the property of the Indonesian government, to whom I would give the structure. I immediately got in touch with the assistant to Indonesia's vice-president, Adam Malik, who in turn informed the governor of North Sumatra. After having affixed a small plaque reading "Property of the Indonesian Government" on the salvaged *sopo*, I went home partly reassured (Barbier 1983: 196). In the following years, all was well, but in 1987, I discovered that the *sopo* had unfortunately been irreparably damaged and that the *singa* adorning the facade of the most beautiful house of a neighboring village had been

Fig. 2. Traditional chests, *hombung*, stacked in the street in front of an antiques stall in Parapat, North Sumatra. On the left is the first in a row of *singa* sculptures, 1980. Photo: Jean-Paul Barbier.

sawed off and sold (fig. 3). Batak art had been discovered by art lovers. I am convinced, however, that without these connoisseurs, all the buildings and furniture mentioned above would have been destroyed anyway. To maintain a traditional Batak house is a costly task; to build one is no longer possible. Traditional houses are frequently demolished to erect in their place small Malay-type houses, which are more convenient and also cheaper (fig. 4).

In 1987, I succeeded in discovering the whereabouts of a group of sculptures (fig. 5) identified by Schnitger (1943). To find them, I showed the Schnitger photograph to the inhabitants of all the neighboring villages, without much success, until the day a man admitted to me that these monuments had been the cause of a serious controversy involving about one hundred individuals belonging to the Pasaribu and Hutagalung clans. One of the sons of the person who had decided to sell the monuments explained to me that this affair had created enormous problems (persoalan), not because of the principle of selling the sculptures, but rather because of the way the proceeds of the sale had been divided. Not far away, however, about a dozen statues, including four equestrian figures, had been carefully preserved by the descendants of those who had them carved in their own image. Offerings continued to be made to these statues, and one of the owners had even aligned the effigies of his ancestors in front of his house, for fear that they might be stolen (fig. 6, see also Barbier and Newton 1988:61). I do not think that this man, whom I congratulated on the respect he was showing for the past grandeur of his lineage, would accept any offer for the sale of these monuments.

All this demonstrates that, except in cases of war, major disasters, or theft by unworthy citizens, a community would probably deprive itself only of that which is no longer considered indispensable or which can be replaced either by a new object of identical use or by a totally different object carrying an identical "value" (such as a motorcycle in lieu of an ancestral horseman figure). In one small Toba district near Sibolga, the community viewed its ancestral stone statues as remnants from bygone days and sold them, while the community nearby felt protected by monuments of the same kind and would not have parted with them for anything.

That the motorcycle does not possess the same value for Westerners is our problem. One might even express regrets that in Western countries, the possession of a motorcycle is no longer a sign of prestige, as was the case at the beginning of the century. It is perhaps the abundance of our riches that moves us to bemoan the effects of a symmetrical evolution, albeit of different result, in the societies of outer-island Indonesia. Can we be certain that the people of Nias, without their innumerable *adu* figures but wealthier in rupiahs, are not in a better position to find their way into the future?

Fig. 3. A *singa* sculpture (left) on a house facade in Lumban na Bolak, near Porsea, North Sumatra, 1980. A view of the same house (right) showing that the *singa* sculpture has disappeared and an electric meter is fixed to the decorated frieze, 1987. The villagers maintain that the people who installed the electric meters removed the *singa*. Photos: Jean-Paul Barbier.

Fig. 4. A traditional house (left), in reality a former rice granary transformed into a dwelling, in the small village of Pagar Batu near Lontung, Samosir Island, North Sumatra, February 1980. By November 1980 this dilapidated house was replaced by a small building (right), and the few carved elements that had survived were burnt. Photos: Jean-Paul Barbier.

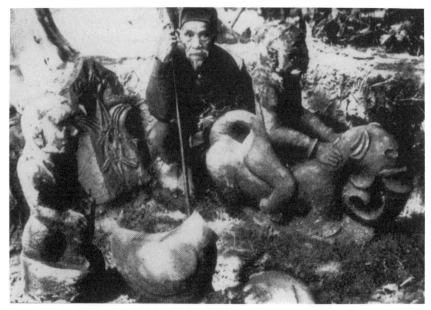

Fig. 5. Group of sculptures photographed by Schnitger (1943: pl. 83, fig. 7) near Sibolga. All these monuments were sold in 1985, causing conflict between two lineages of Toba Batak clans.

In Indonesia, that which bears testimony to the past becomes a mute witness from a bygone era as soon as it ceases to refer to a system of clear moral values. That the National Museum in Jakarta possesses a Batak stone rider, and that five or six other stone riders can be found in European and American museums, is probably satisfactory. It would be deplorable, however, if there were no such statue in Jakarta, and worse if there were none in Batakland. But unless an efficient system is created, this may well be the case soon.

Having ventured on such dangerous ground, and anticipating the criticism to which I expose myself, I shall not hesitate to mention a subject commonly avoided: the activities of the Indonesian antiques dealers, well known to anyone familiar with the archipelago. In Medan, in Jakarta, in Kuta (Bali), these individuals pull all the strings in the art market. Which honest soul has not felt a pang of anguish at the sight of incredible quantities of sculptures, such as drums (fig. 7) or funerary monuments, cluttered in a courtyard or by the roadside? It is impossible to believe that the sale of all this is voluntary everywhere; rather, thefts and the profanation of grave sites must certainly be involved. Yet I also remember the dilapidated houses, their carved planks discarded and neglected, and wooden monuments left to rot (figs. 8, 9) which could have been salvaged if a providential runner

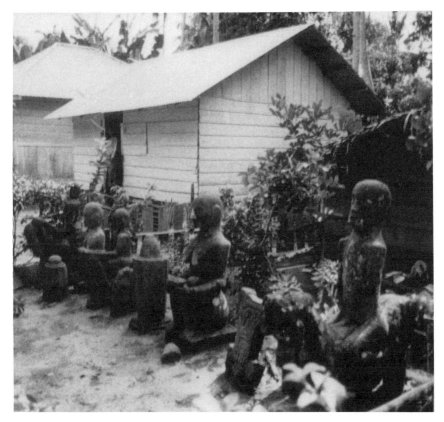

Fig. 6. Sculptures of poor workmanship dating from the nineteenth century that have been reassembled by their owner in front of his house in order to avoid theft or sale, 1987. Although there are still a number of stone monuments, there are no traditional houses in this inland region between Sibolga and Barus, which is inhabited by Toba who migrated there some centuries ago. Photo: Jean-Paul Barbier.

had discovered them in time. Sooner or later, the Indonesian government will be blamed for failing to prevent overt art trafficking and the destruction of entire villages from forced relocation caused by concessions for forest exploitation, as was the case in Kalimantan. It will take time for the many artworks handled by dealers in Paris, Brussels, and the United States since 1970 to reveal—to the public's amazement and the greater glory of the peoples thus pushed into the limelight—the richness and diversity of local and insular cultures hitherto known only to a handful of art lovers and scholars.

One day, strong museums will be established in Medan, Rantepao, and Jakarta. The Indonesian government will supplement the collections of these museums with pieces bought back from the West, following the example forcefully set by New Zealand and Nigeria. At the same time it is diffi-

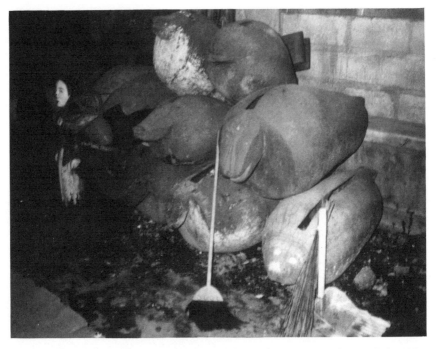

Fig. 7. Wooden drums from Eastern Java in front of an antiques shop in Bali, 1987. Photo: Jean-Paul Barbier.

cult to deny that the exhibitions devoted to "primitive" Indonesian sculpture in Belgium, France, and the United States have probably enriched visitors more than they have impoverished the people of Nias, Batakland, and Sumba. Now all art lovers, including private and public collectors in the West, face the responsibility of helping Indonesia and other countries in the same situation to enrich their collections with evidence of their prestigious past that they might lack. Rather than quarreling over respective responsibilities, such an initiative would constitute proof of constructive action going beyond criticism of villagers who are attracted by monetary gain, governments that face other problems, and all those who take advantage of the situation.

It is true, unfortunately, that bureaucrats all over the world are not always cooperative. On May 1, 1984, I wrote to the National Museum in Jakarta to offer about fifty sculptures of a type lacking in its collections. I added that a group of friends of Indonesia were willing to issue a catalogue published in English and Indonesian of the museum's entire collection of indigenous art. On May 23, 1984, I received a friendly letter from the director, who thanked me but declined the offer because of "overload of work and reorganization."

Fig. 8. Remnants of a sacred wooden horse and the pillars that supported the shelter under which the sculpture was located, in a village in the Nage region of Central Flores, 1983. Photo: Susan Rodgers, Barbier-Müller Archives, Geneva.

Fig. 9. Carved planks of an old house that had been devoted to an ancestor cult, rotting in the open next to a motorcycle (a modern symbol of prestige) in the Nage region of Central Flores, 1983. Photo: Susan Rodgers, Barbier-Müller Archives, Geneva.

Because objects refused by a museum risk being destroyed or damaged, museum directors are the guardians of a heritage that belongs not merely to the city or the country where their institution happens to be located. If museum directors themselves do not accept this responsibility, how can one require lineage chiefs or indigenous village elders to forgo improving their material conditions for the cause of preservation? The issue of responsibility does not apply to the fortunately rare cases of plain theft; but the problem of the preservation of Indonesian antiques is not restricted to the prevention of theft. Its solution lies in the hands of those who should unite in efforts to assemble worthy collections.

References

Barbier, Jean-Paul
1983　*Tobaland: The Shreds of Tradition*. Geneva: Barbier-Müller Museum.
Barbier, Jean-Paul, and Douglas Newton, eds.
1988　*Islands and Ancestors: Indigenous Styles of Southeast Asia*. New York: The Metropolitan Museum of Art.
Schnitger, F. M.
1943　"Megalithen von Batakland und Nias." *IPEK: Jahrbuch für Prähistorische und Ethnographische Kunst* 15–16: 220–252.

6 The *Nusantara* Concept of Culture: Local Traditions and National Identity as Expressed in Indonesia's Museums

PAUL MICHAEL TAYLOR

Several chapters in this volume examine changes to Indonesia's art forms, including destruction and loss due to the international primitive art market. Suppose we could prevent the local losses that occur as a result of the international exportation of collectible Indonesian art. What alternative is there to the decontextualization and loss that occur for this and many other local reasons? This essay attempts to consider the viability of Indonesia's fledgling but rapidly growing museum system as an alternative to such loss. A museum has many functions. In Indonesia as elsewhere these include preserving objects, but also publicly presenting them to tell a story. The 1980s and 1990s constitute a period of rapid growth in Indonesia's museum system, with centrally planned regional museums taking shape in every province. To watch this expansion of a centralized museum system throughout the archipelago, and reactions to it, is to watch Indonesia's center and periphery debate their public presentation of themselves.

The history of collecting and of museums is part of Euro-American cultural and intellectual history; several recent studies (e.g., Hinsley 1981; Stocking 1985; Clifford 1988; Price 1989; Karp and Lavine 1991; Karp et al. 1992; Shelton, in press) examine that history for the evidence it presents about changing Euro-American ideas about "exotic" peoples.

These issues are also beginning to be studied among the new museums of developing nations. Such studies begin by asking, for any culture and time: What is a museum understood to be? How are objects selected for inclusion? How are they presented and explained? We can ask these questions of Indonesian museums.

Indonesia's approximately one hundred forty museums are of four major administrative kinds: First, administered separately and in a class by itself, is the National Museum of Indonesia in Jakarta (fig. 1). Founded in 1778 as the Bataviaasch Genootschap van Kunsten en Wetenschappen (Batavia Society for the Arts and Sciences), it is the inheritor of magnificent Dutch colonial collections. The National Museum has one of the world's great, old collections of Indonesian ethnography, and its collection of oriental ceram-

Fig. 1. Courtyard of the National Museum of Indonesia, Jakarta, 1987. Photo: Paul Michael Taylor.

ics is also one of the world's best. Second, there are the provincial museums (one in each provincial capital; although only nineteen are built, the other eight exist on paper and in plans). Because many provincial museums also administer separate site museums (Le Mayeur Museum, administered by the Bali Museum at the former Balinese home of the Belgian painter Adrien Le Mayeur de Merpres; or the Batak chief's compound at Pematang Purba, administered by the North Sumatra Museum), the number of actual museums is much higher. Collectively they come under the administration of the Directorate of Museums. Third, there are the seven city museums of the city of Jakarta and the science museums, the former administered by the city of Jakarta and the latter by the Indonesian Institute of Sciences; both also have consultative relations with the Directorate of Museums. Finally there are a few, though often important and dynamic, private, or nongovernment, museums (see ASEAN COCI 1988; DPK 1989).

Still, our first question, What is a museum understood to be? is one that Indonesians seem to wonder about themselves, as indicated by the writings of Bambang Soemadio, former director of the Directorate of Museums (Soemadio 1985, 1987). He writes that when Indonesians think of another Western import, the "zoo," they have an image of what to expect if they were to go there. Not so with museums, which are very recent in most prov-

inces, and which generally have low visitation by Indonesian citizens compared to Euro-American attendance at Western museums.

The answer is certainly being formed in Jakarta. All provincial museums and other government museums fall within administrative guidelines of the Directorate. Such guidelines include programmatic statements about the function of museums as well as details such as design and cataloguing methods. Even private museums refer to these guidelines. But the generalizations we make about Indonesian museums might be restricted to the structure imposed by an elite in Java on the provinces. Yet each provincial museum staff selects those elements of the province's culture that are worthy of exhibition within the centrally planned guidelines that shape every government museum.

There are, however, at least some museums with a familiar shape and a clear public image: those that were not built as museums. The Sultan's Palace Museum of Ternate, for example (fig. 2), continued to be a functioning palace long after the Sultan's Palace Museum was founded there in 1916 (Wall 1924). Since 1976, the Sultan's Palace Museum has been integrated into the provincial system of the Directorate of Museums in conjunction with the extensive restorations of the late 1970s financed by the Indonesian government's Department of Education and Culture in consultation with the North Moluccan regional government (Alam 1985). As a museum it is not modern by most standards. In June 1988, I found that only one junior person staffed it; the current collection catalogue then consisted of a handwritten list of collection objects, interspersed with the list of office supplies

Fig. 2. The Sultan's Palace Museum (Museum Kedaton Kesultanan), Ternate, 1987. Photo: Paul Michael Taylor.

and furniture, in a thin, inexpensive, faux-marble notebook (compare the published catalogue in Wall 1922:138–153, and the much reduced catalogue published by MNSL 1982).

In July 1987, then-Director General of Culture Dr. Haryati Soebadio had complained to me about the many problems the directorate's staff had with this museum. She explained how soon after the government-sponsored renovation of the late 1970s was completed the descendants of the former sultan (the sultanate was officially abolished) began moving back in, regularly occupying the building as their home. The son of the last sultan, who then lived in Jakarta and held a position in Indonesia's parliament, is still treated by the Ternatese themselves as the sultan for purposes of carrying out some traditional ceremonies, and his large family is of course respected in Ternate. Although the sultan's palace is officially a museum, it remains one of the most powerful symbols of the sultan's power along with the regalia.

The foremost object of local veneration and preeminent example of regalia is the crown of the sultan of Ternate, the hair of which is ritually clipped back once a year, for it magically continues to grow. For a few years after the museum's renovation, the crown remained visible to the public. Now it is very difficult to gain access to see or photograph it. The museum-going public brings bottles of water each day to place at a prayer-rug altar set up outside the room containing the crown. There prayers are carried out three times daily, after which the museum-goers return to take the blessed water home to cure fevers and illnesses.

Visitation to the museum in this North Moluccan town is much higher than that of the larger, more modern museum in the provincial capital of Ambon. This is undoubtedly due to the fact that the Ternate museum continues the locally useful, highly symbolic functions of the sultan's palace. Traditional Ternatese rely on their sultan and his *sakti* (power) for such things as ritually appeasing the volcano that occasionally menaces the entire island.

On display in the museum are some signs of the recognition of the sultan's power, such as the staffs said to have been sent in tribute by the sultans of Mindanao, Sulu, and Sabah (fig. 3). Also displayed is at least half of the sultan's banner, showing the symbols of sun and moon, male and female. But the seal that symbolizes the sultanate is missing from the other side of the banner (fig. 4). Other objects are missing as well, including all thirteen seventeenth-century helmets of the sultan's private guard. Although he was aware of the documents that turned over the palace contents to the Ministry of Education and Culture, the museum's staff member—an employee of the ministry—emphatically denied they had been "stolen."

Fig. 3. Staffs of office in the collection of the Sultan's Palace Museum, Ternate, traditionally believed to have been sent as tribute to the sultan. Left to right: Mindanao, silver and base metal, 151.5 cm; Sulu, silver and base metal, 151 cm; Sabah, wood with mother-of-pearl inlay, 138 cm.; 1987. Photo: Paul Michael Taylor.

Speaking to me in Tobelo (the West Papuan language I studied, closely related to Ternatese), he said they had merely been taken by *ma dutu* ("the owner") and his family.

In museum work, unlike real fieldwork, one does not expect interruptions of the kind that I experienced on June 17, 1987, as I was studying Ternate's museum collections. A sudden bustle of comings and goings led me to discover that a prominent person in the sultanate had died that morning, and that the funeral would begin shortly. I soon discovered that, indeed, the *soa hukum* of Ternate, a member of the sultan's informal cabinet, was dead. In a house near the museum, people assembled for the ceremony, then some carried the body to the newly restored sultan's mosque—on the museum grounds—for prayers before burial.

Although the member of parliament, the last sultan's son, was unable to attend, some local teachers and civil servants suddenly donned traditional garb and took their honored places at each stage of the ceremonies (fig. 5). Gathered there, in short, was the cabinet of a shadow government that

Fig. 4. Flag of the sulta-
nate of Ternate with "sun
and moon" on reverse. Seal
of the sultanate on obverse
had been removed when
the flag was photographed
in June 1987. Photos:
Paul Michael Taylor.

Fig. 5. Traditional *(adat)* leaders of the sultanate of Ternate gathered together for the funeral of the *soa hukum* of the sultanate, Ternate, 1987. Photo: Paul Michael Taylor.

comes together only on such ceremonial occasions. In my opinion, that body administers the museum at least as much as does the Ministry of Education.

The sultan's palace converted to a subprovincial museum provides only a partial view of how a former sultanate's political and ideological identity is being negotiated with a central government in Jakarta. In some respects, Ternate is an anomaly—certainly its museum is—because the centrally developed, nationwide museum structures have only very imperfectly been imposed there. We can consider, by way of contrast, a museum that was built as a provincial museum, one that works well: the Museum Negeri Nusa Tenggara Barat (Western Lesser Sunda Islands Provincial museum), on Lombok Island (fig. 6) (see MNNTB 1986). The grounds around the museum contain examples of architecture from different parts of the province, such as a fine Lombok granary. (Provincial museums without this feature are urged to use scale models in a museum gallery.) The museum also maintains a series of performances on the museum grounds, such as the singing of Sasak epics by boys in traditional dress. The collections, the core of a museum, are well catalogued and well maintained (fig. 7) (MNNTB 1982). Museum-based, locally published research even extends to nonmaterial aspects of culture, such as local folklore traditions, whose preservation

Fig. 6. The Western Sunda Islands Provincial Museum (Museum Negeri Nusa Tenggara Barat), Mataram, Lombok, 1987. Photo: Paul Michael Taylor.

Fig. 7. A portion of the Sasak palm-leaf manuscript collections of the Western Sunda Islands Provincial Museum, well catalogued and well maintained. Photo: Paul Michael Taylor.

and "display" are considered integral to a museum's other public functions (MNNTB 1987).

The exhibits follow a standard format, found throughout Indonesia's provincial museums. Their core is a series of displays, many in glass cases, on local culture and history (crafts, customs, historical events and personages). At Lombok's museum, the aesthetic quality of the selections used for exhibits is quite high (fig. 8). To reach these exhibits, one invariably first passes through an area describing astronomy and physical geography of the earth, especially Indonesia, then the natural history of that particular province. Finally there is in each provincial museum an area set aside as the Ruang Nusantara—the *nusantara* (archipelago) room, or gallery—where visual comparisons are made between local artifacts and those from elsewhere in Indonesia. The *nusantara* room might contain, for example, swords or wedding costumes from each province in the archipelago.

Thus viewers are first placed in the physical universe, then in the context of local fauna and flora, then presented with the cultural artifacts and his-

Fig. 8. Lombok spinning wheel in exhibit on local textile weaving, Western Sunda Islands Provincial Museum, 1987. Photo: Paul Michael Taylor.

tory of their province. Finally, in the *nusantara* gallery these local traditions are compared to those elsewhere in Indonesia, with the implication that, for all its variations, Indonesia is one. This flow through exhibit areas is used throughout Indonesia in buildings built as museums, and modified for buildings that have been converted to museums. Its wide use is a triumph of centralized planning.

The old Fort La Galigo in Ujung Pandang (fig. 9), now converted to South Sulawesi's provincial museum, has a modified version of this layout (see MNLG 1981; MNLG 1986). Each provincial museum decides what aspect of local culture to display: La Galigo, for example, emphasizes South Sulawesi's maritime culture, drawing on the museum building's architecture and history as a coastal fort. This also has the effect of emphasizing the predominant local ethnic group, the traditionally maritime Bugis. (In fact, despite large-scale foreign tourism to the Toraja areas of the province, the Toraja are virtually unrepresented at La Galigo; see chap. 3, above.) The museum presents one of the most widely used kinds of *nusantara* gallery displays: sets of male and female dolls dressed in wedding garments of each province—a custom also seen in places like Jakarta's Taman Mini amusement park (Writer's Group 1978). (Although bride and bridegroom dolls are the most popular method of setting up *nusantara* sections of museums, any item can be chosen for comparison; weapons are displayed in the *nusantara*

Fig. 9. The South Sulawesi Provincial Museum (Museum Negeri La Galigo), set up in Fort La Galigo, Ujung Pandang, 1987. Photo: Paul Michael Taylor.

section of the Central Sulawesi Province museum in Palu.) At La Galigo, the wedding costumes of the Bugis are used to represent the entire province (PPPSS 1983). Again, the intended message to the people of each province is: "We are distinctive as a province, but we are one with the rest of the archipelago." In this country of over seventeen thousand islands, "archipelago" is an apt metaphor for "nation."

Since collections are small in many provincial museums, planning, along Directorate of Museums guidelines, can be more heavily emphasized. In fact, La Galigo's administration building is almost as large as its museum. From its offices come research reports based on fieldwork rather than museum collections. The studies focus on material culture and traditional technologies of the province, such as descriptive records of material culture in various districts (MNLG 1984, 1985a, 1987), or a descriptive study of the technology associated with one district's sago production (MNLG 1985b). Within that building, various subsection offices revolve around the museum's central office of administration. The most prominent chart in that central room shows lines of command and communication (fig. 10): the head of the museum reports to the director general of culture, but gets directives from the director of the Directorate of Museums, must consult with a number of other luminaries, and must coordinate with still more. The chart is helpful in positioning each employee within an ideal hierarchy,

Fig. 10. Chart in the central administration office of the South Sulawesi Provincial Museum showing "Employee Status Based on Personal Data," 1987. Photo: Paul Michael Taylor.

and the lines of communication connecting the boxes (or offices and their officeholders) reflect ideals of orderly communication and authority.

Another chart, shown looming above its proud compiler (fig. 11), lists each museum employee by rank from highest to lowest, showing his or her name, title, civil service grade, date appointed to that grade, salary, age, marital status, number of dependents, and other data. In the public parts of the museum, the province is publicly presented as having a rightful place in the larger scheme of the nation and the natural world. Behind the scenes, the status of each employee, as a person and as an officeholder, is similarly

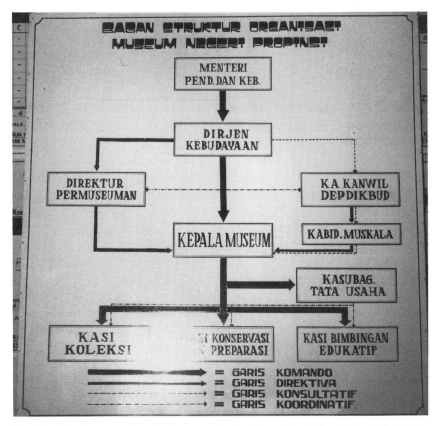

Fig. 11. Organization chart in the central administration office of the South Sulawesi Provincial Museum, 1987. Four kinds of lines connect offices: wide, solid lines of command; thin, solid "directive" lines indicating that guidelines are provided; dashed "consultative" lines prescribing consultation with offices outside the line of command, such as provincial government offices; and dash-and-dot lines designating "coordination." Photo: Paul Michael Taylor.

publicly presented as having a place in the social world of the civil servant and citizen. Indonesia's national motto here applies: Unity in diversity.

Such attempts to find unity in diversity are not new: every emerging nation must continue to try. In Indonesia, such attempts were at the core of the Dutch anthropologists' concept of Indonesia as a "Field of Ethnological Study" (Josselin de Jong, J. de [1935]; Josselin de Jong, P. de 1984). The notion of applying the archipelago concept (*wawasan nusantara*) to culture can perhaps be attributed to a metaphor introduced by a former foreign minister of Indonesia, Mochtar Kusumaatmaja. As an international lawyer, and Indonesia's representative to the United Nations' conferences on the law of the sea, Kusumaatmaja introduced the "archipelago concept" of naval law. He argued that a nation's boundaries at sea should not be measured only from each shoreline, but instead that archipelagic nations should be treated as one unit, including the waters within their self-proclaimed borders. The success of his archipelago concept, which was eventually ratified by the United Nations, may have induced him to apply the idea to Indonesia's culture, as a symbol of the unity of the diverse regions in Indonesia.

Let us turn now to the question of whether, and how, the rapidly growing museum system might be an alternative to the destruction and loss of Indonesia's material culture. Certainly, conserving and encouraging the continuation of local crafts are among a varying set of stated goals listed in the annual reports of most Indonesian museums, always including the goal of representing unity in diversity in the archipelago.

We can examine this question by considering the Museum Negeri Siwa Lima in Ambon, capital of the Moluccas (fig. 12). A dynamic, modern provincial museum that was built as a museum (MNSL 1977), it maintains a "hands-on" gallery where school groups can practice making sculptures or other crafts in imitation of those in the displays nearby. Like many provincial museums, it brings together in its design elements from various regions of the province, in an intentionally contrived and inauthentic way, as motifs painted around the building. This presentation of pan-Moluccan motifs outside, along with the *nusantara* room inside, says to the visitor: "The Moluccan province is one, within the Indonesian archipelago which is one. Though your ethnic group in Maluku is distinctive, it is one with the rest of Maluku; though Maluku is distinctive, it is one with the *nusantara*. Unity in diversity."

Yet even this dynamic museum has not yet fully assured the public that it is a safe repository to protect Moluccan artworks from destruction. For example, the labels on many of the museum's best sculptures, including some borrowed for exhibition in the United States (Taylor and Aragon

Fig. 12. Siwa Lima Provincial Museum (Museum Negeri Siwa Lima), Ambon, Moluccas, 1987. Photo: Paul Michael Taylor.

1991: figs. VIII.20, VIII.30, VIII.31), credit two donors. The catalogue cards, however, list all the sculptures as "confiscated" from the same two individuals, as the museum staff in 1987 insisted was the case. No documentation about the provenance of these important pieces was confiscated with them; those data were lost.

In 1988, I was able to locate one of the collectors, a European biologist living in California. He recounted that the pieces were not confiscated at all. He had collected ancestor figures from places such as Babar and Leti islands because local Protestant missionaries destroyed the pieces they found stored in caves to discourage ancestor worship. For years he had signed collecting agreements requiring that biological specimens be divided with local institutions. He therefore proposed a division of his sculpture collection with the Museum Negeri Siwa Lima, and his offer was accepted. He claims not only that he turned over the collection and its documentation, but also that the museum then traded the best pieces away to a local Catholic priest.

The loss of provenance data is tragic, but it happened in the 1970s, before today's staff was in place. Could such an oversight happen today? Charges of this sort are sufficiently frequent among dealers and collectors and so successfully used to justify the removal of artworks that a national effort is required to restore confidence.

These are exciting times for Indonesia's museums. The recent rapid growth of provincial museums indicates that a national effort of major proportions is already underway—as does the fact that a museum improvement and training program was an important part of the U.S.- and Indonesian-sponsored Festival of Indonesia in 1990–1991 and its associated exhibits. In the meantime, under present constraints, the physical demands of maintaining the collections already in existence overtax Indonesia's greatest museums and would make it difficult for them to invest in acquisitions. Certainly their present levels of funding make it impossible for them to approach the primitive art market.

The strength and scientific importance of Indonesia's National Museum lie in its old collections (see MNI 1980–1986). In storage areas underneath display cases, damage and loss due to overcrowding and neglect are frequent. The overwhelming majority of the ethnographic collection need major restoration; the records that could document the objects' provenance and context are in no better shape. Certainly there are exceptions, like the beautifully renovated and secure "Treasure Room" (DPK 1972), made possible by help from the government of Japan.

The purpose of these remarks is not to disparage a small, hardworking staff at one museum faced with vast tasks. It is, instead, to productively raise the level of concern about the ability of Indonesia's museums to accomplish a museum's most elementary function—at least in our Euro-American concept: to preserve objects for the future. This concern is already being addressed by Indonesians, and it needs full support.

One argument for keeping artifacts in museums near their place of origin, which is also an argument for provincial museums, is that they stimulate the local continuation of craft and art forms. Many provincial museums maintain encouraging programs in this regard, from craft classes for children to traditional house construction on museum grounds. Such programs also certainly stimulate the production of fakes, which raises the related question of whether the growth industry of faking could not become a safety valve, reducing pressure for the loss of indigenous Indonesian art. Perhaps activists who care about the loss of Indonesian art should reconsider their view of those who make and sell fakes. Would it not be easier for us to teach armies of local sculptors, weavers, and other artisans to produce better replicas than to beef up border security?

Replicas become fakes only when fraudulently presented as old to make them more acceptable to collectors. Another tactic for preserving art and artistic traditions is to try to influence the taste of collectors so that they accept replicas. The Ceramic Society of Indonesia has already pioneered

exhibitions of modern ceramics done in antique style (see, for example, Adhyatman 1983), with the intention of raising the acceptability of replicas for art collectors.

Yet the fact remains that Indonesians are beginning to fill their museums with collections, and will continue to do so as museums expand and as traditional methods of keeping such treasures change. The museums maintain material, such as the ancestor figures of the moluccas, for which traditional methods of care have been abandoned as the population has converted to Islam or Christianity. In other cases, like that of the manuscript history of the sultanate of Tidore (fig. 13), displayed near the *nusantara* room in the Tidore Sultanate Memorial Museum on Tidore Island (MMKT n.d.), the traditional institution that curated the objects (the sultan's palace) has itself become a museum. This manuscript is a sacred, meaningful heirloom, an icon for the Tidorese people. Yet it is obviously disintegrating on its silver tray in the palace museum. There are not yet paper conservators on Tidore, nor in any Indonesian museum. If we ask the questions, Would this manuscript be in better shape if it had been taken overseas fifty years ago, or ten, or one? the answer is emphatically yes. Yet the Tidorese would consider it sacrilege to sell it, and most outsiders would surely agree. The iconic value of the object to the Tidorese people outweighs concerns about the material

Fig. 13. Manuscript history of the sultanate of Tidore, Tidore Sultanate Memorial Museum (Museum Memorial Kesultanan Tidore), Tidore, 1987. Photo: Paul Michael Taylor.

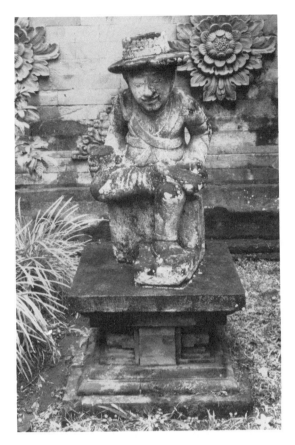

Fig. 14. Statue of a European, ca. 1920s, stone; on the grounds of the Bali Museum (Museum Bali; formerly Balisch Instituut) Denpasar; 1987. Photo: Paul Michael Taylor.

object alone. It remains with the regalia in the sultan's palace, which itself continues the liminal relation between the Tidorese community and the national museum system into which the palace has precariously been integrated.

A pensive statue on the grounds of the Bali Museum provides a metaphor for our conclusions (fig. 14). Many of Indonesia's great ethnographic and art collections exist in museums whose resources are inadequate to maintain them, let alone expand them. Yet we are now witnessing a major, very promising national effort to improve that nation's museum system and to expand it to every province. At the same time, Indonesians are creating new concepts of a museum's place in society, particularly as mediator between local traditions and national identity. In other words, in their approach to the museum, as in this statue, Indonesians have taken a European model and are starting to create something distinctively theirs.

References

Adhyatman, Sumarah
1983 *Keramik Mutakhir Bergaya Antik/Modern Ceramics in Antique Style*. Jakarta: Himpunan Keramik Indonesia.

Alam, Syamsir
1985 "Museum Kedaton Ternate." *Museografia* (Jakarta) 14(4):35–41.

ASEAN COCI (Association of South East Asian Nations, Committee on Culture and Information)
1988 *The Directory of the Museums of ASEAN*. Ed. National Museum of Singapore. n.p.: ASEAN COCI.

Clifford, James
1988 *The Predicament of Culture: Twentieth-Century Ethnography, Literature, and Art*. Cambridge: Harvard University Press.

DPK (Departemen Pendidikan dan Kebudayaan)
1972 *Katalogus Koleksi Etnografi dan Sejarah Lokal, Kamar Khazanah Museum Pusat*. Jakarta: Departemen Pendidikan dan Kebudayaan, Proyek Inventarisasi dan Dokumentasi Kebudayaan Nasional, Direktorat Jendral Kebudayaan.
1989 *Pembangunan Permuseuman di Indonesia Sampai Akhir Pelita IV*. Jakarta: Departemen Pendidikan dan Kebudayaan.

Hinsley, Curtis M.
1981 *Savages and Scientists: The Smithsonian Institution and the Development of American Anthropology 1846–1910*. Washington, D.C.: Smithsonian Institution.

Josselin de Jong, J. P. B. de
[1935] "The Malay Archipelago as a Field of Ethnological Study." In *Structural Anthropology in the Netherlands: A Reader*, 164–182, edited by P. E. de Josselin de Jong. The Hague: Nijhoff, 1977.

Josselin de Jong, P. E. de
1984 *Unity in Diversity: Indonesia as a Field of Anthropological Study*. Dordrecht: Foris.

Karp, Ivan, and Steven D. Lavine, eds.
1991 *Exhibiting Cultures: The Poetics and Politics of Museum Display*. Washington, D.C.: Smithsonian Institution Press.

Karp, Ivan, Christine Mullen Kreamer, and Steven D. Lavine, eds.
1992 *Museums and Communities: The Politics of Public Culture*. Washington, D.C.: Smithsonian Institution Press.

MMKT (Museum Memorial Kesultanan Tidore)
n.d. *Museum Memorial Kesultanan Tidore "Sonyine Malige."* N.p.: Museum Memorial Kesultanan Tidore.

MNI (Museum Nasional Indonesia)
1980– *Koleksi Pilihan Museum Nasional*. 3 vols.; vol. 1, 1980; vol. 2, 1984; vol. 3,
1986 1985/1986. Jakarta: Proyek Pengembangan Museum Nasional.

MNLG (Museum Negeri La Galigo)

1981 *Mengenal Museum Negeri La Galigo, Ujung Pandang, Sulawesi Selatan.* Ujung Pandang: Museum Negeri La Galigo.

1984 *Laporan Penelitian dan Pengadaan Koleksi di Kabupaten Selayar.* Ujung Pandang: Museum Negeri La Galigo.

1985a *Laporan Penelitian dan Pengadaan Koleksi di Kabupaten Luwu.* Ujung Pandang: Museum Negeri La Galigo.

1985b *Teknologi Pengolahan Sagu di Kabupaten Luwu.* Ujung Pandang: Museum Negeri La Galigo.

1986 *Petunjuk Museum Negeri La Galigo, Ujung Pandang.* N.p.: Proyek Pengembangan Permuseuman Sulawesi Selatan, 1985/1986.

1987 *Laporan Penelitian dan Pengadaan Koleksi di Kabupaten Mamuju.* Ujung Pandang: Museum Negeri La Galigo.

MNNTB (Museum Negeri Nusa Tenggara Barat)

1982 *Katalog koleksi Museum Negeri Nusa Tenggara Barat.* N.p.: Proyek Pengembangan Permuseuman Nusa Tenggara Barat.

1986 *Petunjuk Singkat Berkunjung ke Museum Negeri Nusa Tenggara Barat.* N.p.: Proyek Pengembangan Permuseuman Nusa Tenggara Barat, 1985/1986.

1987 *Cupak Gerantang.* N.p.: Proyek Pengembangan Permuseuman Nusa Tenggara Barat, 1986/1987.

MNSL (Museum Negeri Siwa Lima)

1977 *Guide Book, Museum Siwa Lima.* Ambon: Proyek Rehabilitasi dan Perluasan Museum Maluku.

1982 *Dari Foramadiahi ke Limau Jore-jore (Sejarah Singkat Kedaton Kesultanan Ternate).* Ambon: Museum Negeri Siwa Lima Ambon.

PPPSS (Proyek Pengembangan Permuseuman Sulawesi Selatan)

1983 *Pakaian Adat Bugis Makassar.* Ujung Pandang: Proyek Pengembangan Permuseuman Sulawesi Selatan. 1982/1983.

Price, Sally

1989 *Primitive Art in Civilized Places.* Chicago: University of Chicago Press.

Shelton, Anthony

in press *Museums and Changing Perspectives of Culture.* Special issue of *Cultural Dynamics* (Leiden).

Soemadio, Bambang

1985 "Strategi Dasar Kebijaksanaan Pengembangan Permuseuman di Indonesia." *Museografia* (Jakarta) 14(4):1–6.

1987 *Sejarah Direktorat Permuseuman.* Jakarta: Departemen Pendidikan dan Kebudayaan.

Stocking, George

1985 *Objects and Others: Essays on Museums and Material Culture.* Madison: University of Wisconsin Press.

Taylor, Paul Michael, and Lorraine V. Aragon

1991 *Beyond the Java Sea: Art of Indonesia's Outer Islands.* Washington, D.C.: National Museum of Natural History; New York: H. N. Abrams.

Wall, V. I. van de

1922 "Het Museum Kedaton van Ternate. Korte beschrijving met catalogus."
 Oudheidkundig Verslag (1922):138–153.

1924 "Het Museum Kedaton van Ternate." *Nederlandsch Indië Oud en Nieuw* 9(5):
 165–172.

Writer's Group

1978 *What and Who in Beautiful Indonesia.* Jakarta: Writer's Group. Originally
 published as *Apa dan Siapa Indonesia Indah* (Jakarta: Taman Mini Indonesia
 Indah, 1975).

7 International Art Collecting, Tourism, and a Tribal Region in Indonesia

LAURENCE A. G. MOSS

Collecting art is a significant and growing human vocation and avocation (Alsop 1982). An expanding part of this activity is interest in "tribal art."[1] In the seventeenth century the material culture of tribal peoples, along with curiosities of the natural world, were collected for wonderment and metonymic reference. Later, such objects were acquired as artifacts exemplifying systematic taxonomy. Collecting became the concern of scientific men, and the volume of objects collected grew seemingly exponentially. By the end of the nineteenth century evolutionism dominated the classification of artifacts, testifying to more primitive stages in the theory of human "development." In this lies the origin of the term still used by many today, "primitive art." Based in the relativist anthropology of the late nineteenth century, artifacts, arranged in either evolutionary series or synchronous ethnographic presents, became alleged objective witnesses to the multidimensional life of cultures, especially the cultures of non-Western people (Clifford 1988). In the twentieth century, along with continuing currency for the above paradigm, much of the material culture of tribal peoples has been transformed into art (Clifford 1988; Coe 1986; Cole 1985; Rubin 1984).

Considerable argument revolves around whether such objects were or are art for the people making them, or are art only for outside collectors, who imbue the objects with their own culture's aesthetic. Others maintain a universal aesthetic exists that transcends specific cultures. Regardless of the origin of the drive, there is an expanding international desire to collect tribal art.

This demand has directly impacted the Lesser Sunda Islands (or Nusa Tenggara) in eastern Indonesia. This island chain, stretching 1,500 kilometers from Bali toward Australia, was drawn into the international art market in the early 1970s. Change has been swift, so that by 1990 the islands were almost drained of their old treasures. Will the people of the Lesser Sundas lose, with their relics and heirlooms, cultural resources that are both a part of a way of life they value and an economic asset?

International Forces: The Tribal Art Market

The makers of the objects sought by tribal art collectors live in rural settlements, as do most of the people of the Lesser Sunda Islands. With sacred and mundane purpose the villagers embellish their lives with handcrafted objects, often of considerable beauty. Materials include wood, stone, horn, bone, ivory, plant and animal fibers, base and precious metals. They carve, weave, and paint animal, human, vegetable, and ethereal subjects, which frequently do not fall neatly into these categories. The whole object may be the focus of the image maker, such as a wooden statue of the ancestor (fig. 1) or a supernatural beast wrought in gold (fig. 2), or the imagery may be confined to the handle of a horn spoon (fig. 3), incisions on a bamboo container, or the fabric of a cotton sarong (fig. 4). These kinds of objects have been illustrated in this and other publications (especially Barbier 1984; Barbier and Newton 1988; Feldman 1985; Gittinger 1979; Greub 1988; Holmgren and Spertus 1989; Khan Majlis 1984; Langewis and Wagner 1964; Moss 1986; Rodgers 1985; Solyom and Solyom 1984; Taylor and Aragon 1991).

In the 1970s such objects were common in most hamlets of the Lesser Sunda Islands, but by 1990 the old objects had almost disappeared and little was being made in the old ways to replace them. In West Timor the incised bamboo lime containers were replaced by empty metal flashlights, and plastic bags were substituted for the carved ebony and sandalwood tobacco boxes of East Sumba. Ancestor figures generally have not been replaced. Hand-woven textiles, probably the most abundant and ubiquitous of the adorned objects, were still seen in daily use or on ceremonial occasions; however, far fewer exhibited the beautiful dyeing and weaving common in the 1970s. What has happened, and so quickly and universally, in these islands? Moreover, although there appear to be ample skill and knowledge remaining to make replacements, why is it rarely done?

Old things wear out, especially utilitarian ones used daily. Even allowing for natural disasters like flood and fire, heirlooms and similar valued objects are severely depleted throughout the islands. Most of these objects entered the international art market, as the material culture of North America, Africa, and Oceania did previously (Cole 1985).

The material culture of the Lesser Sundas was included among the artifacts and specimens taken back to Europe by colonial administrators, missionaries, men of science, and sailors, especially during the nineteenth and early twentieth centuries. Indonesian textiles in particular were evident in the trade and mission exhibitions held in European cities. Among them were textiles from the Lesser Sundas. From the 1920s, the large, bold, and

Fig. 1. Human figure (spinning wheel upright), West Sumba, wood, H. 58 cm. Laurence A. G. Moss collection, Santa Fe, New Mexico. Photo: Laurence Moss.

Fig. 2. Crocodile figure, East Sumba, gold, L. 9.5 cm. Lawrence A. G. Moss collection, Santa Fe, New Mexico. Photo: Reece Metcalf-Rehm.

Fig. 3. Spoon, West Timor, horn, L. 25 cm. Laurence A. G. Moss collection, Santa Fe, New Mexico. Photo: William McLennan.

colorful Sumba *hinggi*, male mantles (fig. 5), were in vogue, especially in the Netherlands, as exotic home decoration, typically as table coverings. Large collections of textiles accumulated in Dutch and German museums.

There is little research on the history of collecting tribal material culture as art (Clifford 1988), but a brief outline can be drawn. In the visual arts, the earliest commercial gallery and museum exhibitions of material culture

Fig. 4. Textile (sarong),
Belu area, Timor, cotton,
57 × 113 cm. Laurence
A. G. Moss collection,
Santa Fe, New Mexico.
Photo: Emmo Italiander.

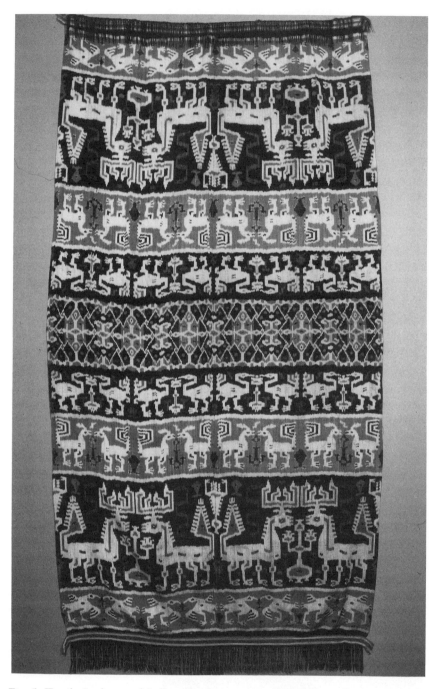

Fig. 5. Textile (male mantle), East Sumba, cotton, 132 × 267 cm. Laurence A. G. Moss collection, Santa Fe, New Mexico. Photo: Russ Clift.

as art occurred in Europe and North America about 1920. Avant-garde artists of continental Europe were interested in the artistic solutions of "Negro" and "Indian" artists. Paul Gauguin, Alberto Giacometti, Paul Klee, and Pablo Picasso number among the moderns who admired, collected, and were influenced strongly by this art and helped focus attention on it (Clifford 1988; Rubin 1984). Against the backdrop of a growing cognizance of tribal peoples, interest in collecting modern art expanded the ranks of tribal art collectors in the 1950s. Art dealers, aesthetically attracted to tribal sculpture and masks in particular, were quite important in establishing tribal art as a sector of the international art market. From the late 1960s until 1980 was a boom period in the United Kingdom, the center of sales at the time, with Americans as the principal clients (MacClancy 1988:166–167). The 1980s saw an expansion and popularization of interest in tribal art, which was no longer the domain of socioeconomic and artistic elites, a condition reflected in increasing information and access in the form of exhibitions and publications.

The large prestigious museums offered exhibitions such as *Te Maori*, which had its debut at the Metropolitan Museum of Art, New York, in 1984, and *Art of the Naga*, shown first in Geneva and then at the Los Angeles County Museum of Art in 1984. Many smaller museums and galleries became involved. For example, the San Francisco Craft and Folk Art Museum exhibited *Art of the Lesser Sunda Islands* (Moss 1986). The larger shows traveled to a number of sites, and well illustrated publications accompanied them.

Along with the growing interest in tribal art taken by art museums, museums of anthropology and natural history also appear to be exhibiting artifacts of tribal people as art. This results partially from a blurring of distinction and partially from a belief that such a portrayal is more popular. The museums have moved outside their walls, displaying their collections in airports and involving private corporations more in exhibitions. Business corporations themselves seem to be more interested in tribal art since the 1980s: in addition to sponsoring museum exhibitions, they purchase tribal art for their own collections and exhibitions. One of the largest such corporate sponsorships, entitled *Out of the Mists*, exhibited Northwest Coast art from the Museum of the American Indian, New York, at the IBM Center of Science and Art in New York in 1984. Indonesian tribal art is the subject of a similar exhibition assisted by the private sector; *Beyond the Java Sea: Art of Indonesia's Outer Islands*, organized by the National Museum of Natural History, Smithsonian Institution, showed some two hundred objects in three American cities in 1990–1991.

The increasing number of publications on tribal art is another indication

of growing interest, and possibly sales. "The market engenders a written history of primitive art that reflexively stimulates the market itself" (MacClancy 1988:172). The style of this publishing gives prestige and legitimacy, and perhaps investment value, to the collection of tribal art. Typically, the scholarly language and publishing format of Western art history are employed, lending the authority of that tradition. In addition, correctly or incorrectly, rubrics of Western aesthetics are used, enlisting established and valued evocations. Publications bridging the disciplines of anthropology and art history, although tentative, contribute to the weight of tribal art collecting. Many believe that objects worthy of study are worthy of collecting.

Most tribal art collectors have little interest in related scholarship, except as an adjunct (Cole 1985; MacClancy 1988). Many collectors and dealers believe their art can and should be appreciated with an intuitive aesthetic, timeless and of universal application. An example is a museum publication in which a French author pens poetic evocations inspired by spoons from various tribal traditions, including the Lesser Sundas (Butor 1986:37).

Exhibitions and publications (typically catalogues) on Indonesian tribal art have increased considerably between the mid-1970s and early 1980s. At first textiles formed the focus of the shows and publications, but from the early 1980s there was a broadening of subject matter, with objects of wood and precious metal coming to the fore. Exemplifying the lack of exhibitions on specific regions or cultures of tribal Indonesia, apparently only one treated the Lesser Sunda Islands alone (Moss 1986). The art of these islands, however, has played a significant role in general exhibitions of Indonesian art, especially of textiles. Although the Lesser Sundas have been a focus of much of the ethnographic research on Indonesia, little information has been generated on the role of art in the islands' communities, or the art per se.

Paralleling the increase in exhibitions and publications, commercial art galleries, especially in Australia, France, and the United States, began to give more attention to Indonesian tribal art in the 1980s. The activity of the prestigious art auction houses, such as Christie's and Sotheby's, reflected a similar trend.

Accompanying this growth in interest is a broadening of what is considered tribal art, blurring distinctions of artifact, fine art, decorative art, craft, and souvenir. Art collectors seek sculpture, masks, weapons, furniture, architectural components, jewelry, textiles, and an array of tools and household utensils such as baskets, bowls, spoons, and fishhooks. The distinction between tribal and Western art has become blurred as media from the Western art tradition, especially intaglio, are adopted in whole or in part, and

anonymous tribal art makers become individual artists. Museums, art galleries, and individual collectors are now consciously collecting both Western-influenced works and new replicas of traditional objects. This part of the market is important to the rejuvenation or continuity of tribal traditions, most notably those of the Canadian Northwest Coast and the American Southwest (Adair 1944; Ames 1981; Coe 1986; Cole 1985; Wade 1985).

Tribal art confronts collectors with more problems of authenticity, valuation, and taxonomy than do other art categories, and the inclusion of newly made objects is especially troublesome (MacClancy 1988). Objects made for the tourist, those made by other aboriginal or white artists, and works that may cross the undefined border into contemporary art have increased ambiguity. In turn, such ambiguity greatly increases the volatility of an already turbulent environment for the artist, collector, dealer, and museum curator. Changes in the tribal art market cause waves in a much larger pond. In part this speaks of a significant and welcome shift in taste to include all cultures through time: "In a process, 'justly celebrated as one of the most significant cultural achievements of our century,' the artifacts of all periods and all cultures came to be admired as art" (Cole 1985:281). In addition to enriching our aesthetic experience, this change may weaken the bigotry exemplified in the tenacious belief that present non-Western ethnic groups and races represent earlier stages of Western evolutionary progress through time. Some analyses, however, suggest the opposite—a continued exaggeration of the Other, with its racist and imperialist origins (Clifford 1988; Said 1978).

The shift from material culture to art and the expansion of admissible material have contributed to the demand for objects of the Lesser Sunda Islands since the early 1970s. The decrease in aesthetic old objects from established field sources is a key factor. Oceanic and North American objects (particularly Northwest Coast) were almost completely absorbed in the 1960s by collectors, especially museums. Since then, rarely do significant objects come from these sources, which are virtually depleted (Coe 1986; Cole 1985). Africa, although probably the most fertile source of tribal art in the past, is fast approaching, or is already in, a similar state. Therefore, from the early 1970s collectors were looking in earnest for untapped field sources, and Indonesia was one of the few remaining.

Another factor causing the greater demand for tribal art in the 1980s was the impact of a growing leisure class. More people, particularly in the wealthier nations, were able to participate in the collection of art. The distribution of discretionary resources reached well into what was referred to as the middle class, or more appropriately, the leisure class.

The cause of the focus on tribal art in the West is complex. The growing

demand for the different, more exotic Other has much to do with an increasing disenchantment with, and at times distrust of, the cultural by-products of our technologically driven societies. Urbanization, mass production, and the accompanying alienation from spiritual beliefs, community, and natural materials appear to be moving a significant number of people to seek from other cultures what they believe has disappeared in their own. They seek what is perceived to be less sophisticated and homogenized, more spontaneous, spiritual, and made-by-hand in the art of tribal peoples. Feelings of disenfranchisement and powerlessness motivate people to seek power as symbolized in other cultures (Donald Rundstrom, personal communication, 1989). And "the mystery that Westerners attribute to these [tribal art] objects is an ultimate explanation of their fascination" (Mac-Clancy 1988:168). Ownership of these exotic objects represents distance and time appropriated, the cultural Other tamed (Stewart 1984:146). We are appropriating from others through the very concept of culture (Clifford 1988).

Objects are tangible manifestations of the Other. Many who seek escape from the mundane, the expected, do so commonly in the perceived different. Leisure time and surplus cash are allowing greater numbers to travel, whether that travel be real or simulated. Just as simulation accounts in part for increased book and television consumption, it also probably accounts for much art purchasing, and, with the increasing demand for the unusual, for the purchasing of exotic tribal art. The Other's culture is experienced through its art, a process Aspelin (1977) refers to as "indirect tourism," which is available from art galleries, antique shops, auctions, and museums. Moreover, if an object has become rare, and therefore both difficult to find and expensive, it can be further simulated, thereby giving rise to a large trade in reproductions, both fake and acknowledged. Passing off reproductions as the original objects sought by collectors is a part of the tribal art market.

A societal condition related to the general increase in a "leisure class" (MacCannell 1976) is emerging as quite significant to the global dynamic of tribal-art-collecting—tourism. Between 1970 and 1990, global tourism grew by nearly 300 percent; it is expected to increase by half again before the year 2000. Tourism is estimated to already be the world's largest employer; 112 million people worldwide (Eber 1992). Art collectors are part of this mass global movement, and an increasing percentage of them travel to "exotic" places. Collectors often state that the search and discovery of the art object account for much of their pleasure. Travel to the source can heighten this emotion, especially with the additional prospect of a bargain.

The dynamics of tribal art, tourism, and cultural change constitute an

academic interest principally involving anthropologists (N. H. H. Graburn, Jules-Rosette, Kairs, Wade). There is considerable overlap between tribal and tourist art, and differentiation is problematic and consternating for those participating in the international art market. The exchange of money for object remains the real arbitrator, and typically, a considerable gap exists between the more highly valued tribal art and the ethnic tourist art object. Each is generally thought to be made for a different purpose: tribal art for indigenous use, tourist art for exchange with the outsider. However, the auction room proves the ambiguity of this and similar distinctions. In the eighteenth century, among the objects collected by Captain George Vancouver on the Northwest Coast of North America were canoe models, supposedly made expressly for exchange with white traders. They are among the earliest tribal art objects of continuing value. Argillite carvings from this locale, made for the same trade, have been collected since the late 1800s and are also an established category of tribal art. Similarly, Navajo silver and turquoise jewelry and rugs made for the tourists since the same period are collected as art. Contrary to common presumption, tribal art is not essentially noncommercial; rather, "the co-existence of spiritual, aesthetic and commercial forces is always visible" (Clifford 1988:250).

Age appears to be the single most significant attribute of authenticity for the market. Preferably, the object should have been made before or very early in the history of contact with Western societies, and therefore be considered pristine or purely tribal in concept, aesthetic, and construction. Few objects meet this criterion, but the older they are, the less contact or acculturation they have, the better. Of course, few tribal objects are easy to date, as they are characteristically without signature and written historical documentation. Documented collection history or datable, in situ photographs add authenticity and value to a piece; patina also assists. Objects with a recognizable style that was established in the market early, especially "good" classical pieces with a consensus on their aesthetic merit, command recognition and the seal of authenticity, and a high price. An object difficult to categorize is a high risk. In this market environment, the reputation of the dealer for honesty and an "eye" for "good" pieces are perhaps more important than in any other sector of the international art market.

The term "good" is commonly used by dealers, collectors, and some curators in describing a superior and authentic tribal art object. Charles F. Newcombe and Franz Boas, collectors of nineteenth-century Northwest Coast art, "used the word but without definition. Sometimes it seems to have meant old; certainly it meant genuine, probably it also contained a strong, if vague aesthetic sense" (Cole 1985:291).

In this arena of collecting, the "fake" is a constant threat, as the genuine

is difficult to ascertain and eludes clear definition. Since most tribal art is anonymous, the criteria mentioned above are crucial to market confidence. There are considered to be a large number of fakes in this market. Difficulty of detection is a key reason; another is the market's growth. "A market for good, genuine objects stimulates the traffic in fakes. As the number of good, genuine items decreases, the production of fakes rises in step with a rise in prices" (MacClancy 1988:171).

A closer look at the term "fake" is important for an understanding of the present and future market for Lesser Sunda art objects. Simply put, the term means "something made to deceive," but its usage by collectors, dealers, and museum curators is more ambiguous. The primary criterion of age is important in authenticating and appraising tribal art, but at the same time interest is expanding in fine-quality new objects. Some fear that if a new object is as attractive as an old one, the value of the old will be reduced. And because the tribal sector of the international art market does not have the means of distinguishing new from old that exist in other market sectors, such as Western painting, there is the fear of a new piece being presented as old.

A beautiful piece of Lesser Sunda gold jewelry, recently made either for use in the hamlet of its origin or to sell outside (a traditional practice), is considered a fake by one tribal art collector. The piece would be a fake even if it was crafted by a skilled master of the same tribal people who fifty years ago made a similar object in the collector's possession. An article on the faking of Indonesian tribal art (Vion 1987) shows photographs of a number of objects made to replicate older objects in foreign collections. The new pieces were copied from exhibition catalogues and are intended to be sold as old, authentic objects. The intent to deceive is apparent. But what about the large Flores Island carving illustrated in the article, made to replace one sold to an art dealer (fig. 6)? If in ten years the makers sell it, too, to an art dealer, is this replacement a fake?

It is common in the context of the African art market for statues and masks to be carved in the ritually correct fashion but sold before the associated ceremony is performed. At times both the carving and ceremony are commissioned by dealers. Are these objects fakes? Is this a long-term characteristic problem or only a temporary issue in the history of tribal, tourist, and folk art? The word fake should be avoided, except to denote an object clearly represented as something it is not, especially because it may disparage fine replicas and other contemporary art being sold as such, which are significant in the economies of tribal peoples. This is an important issue for the continuance of cultural resources in the Lesser Sunda Islands.

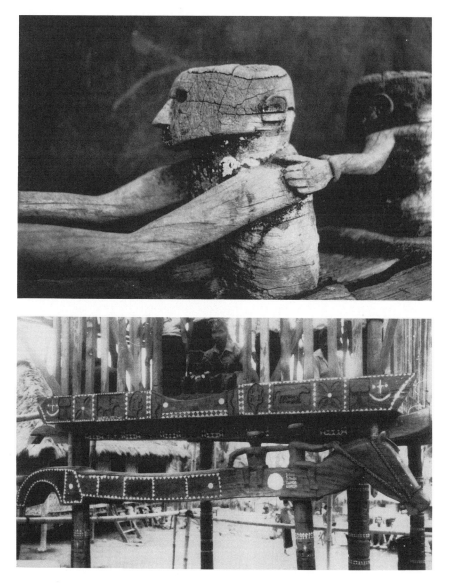

Fig. 6. Detail of an original Nage horse figure (top) from Central Flores, photographed in 1986 in an antiques shop in Bali. Horse figure erected in 1986 (bottom), made to replace the original figure, which was sold. Photos courtesy of Barbier-Müller Archives, Geneva.

International Forces: Societal Change

Major societal forces that do not originate in art collecting and tourism, but do significantly influence these activities, affect the marketing of tribal art of the Lesser Sunda Islands. Change in the spiritual beliefs of the people as outside organized religions make converts is one important force that works to reduce the making of art objects. Christianity and Islam are expanding in the islands, and while some accommodation is being made to the old beliefs, many are passing. In part this reduced strength of the ancestral ways is a result of a multiplicity of societal changes occurring simultaneously in the islands' hamlets, of which religious conversion is only one. The external demand for the old objects of spiritual meaning factors into the pressure for change from new religions; the two claims are mutually reinforcing. When the old object has gone (whether discarded after conversion or sold to dealers), its spiritual significance may not be transferred to a new object. An example of this phenomena takes place on the island of Sumba. "A *mamuli* (pendant) which commemorates a charismatic ancestor or is used in communications with the spirits is not replaceable in any sense. . . . The selling of these objects threatens the unity and meaning of a life based on exchanges between wife-givers and wife-takers, and between men and gods" (Hoskins 1988:137).

The force of "modernization" is also changing ways of life in the Lesser Sunda hamlets. The government of Indonesia, assisted by bilateral and multilateral international agencies such as the Canadian International Development Agency and the international Bank for Reconstruction and Development, acts to improve the economic and social welfare of Indonesians. In this process ways of life change, and with them material culture. These changes have been both welcomed and declined, less successfully, by the people of the Lesser Sundas. These islands entered center stage in the development plans of national and international authorities about the same time that the international tribal art market began to focus on Indonesia, in the mid-1970s. A regional development study and plan for the Lesser Sundas was undertaken between 1972 and 1977. Subsequent implementation of related projects established a cash economy in the islands, especially through changes in farming (notably cash crops for international markets), health and education, and transportation and communications systems. Although no sudden or mass alteration in the social and physical environment typically occurred, by the early 1980s cultural and geographical changes began to be manifest perhaps more widely and in less time than ever in these islands' past. The impact differs from island to island and within each island. On Sumba, "pressure to invest in education, cattle or

modern trucks has convinced many once wealthy families they should sell their gold heirlooms, and increasing rate of Christian conversion has modernized the ritual status of these objects" (Hoskins 1988:137).

Tourism appears to be an important component of planned development for the Lesser Sundas. Indonesia, with the assistance of the United Nations Development Program and the World Tourism Organization, has been implementing a plan to attract tourists to the region since the early 1980s (World Tourism Organization 1981). Crucial to the marketing of these islands are their cultural resources. The tourist is encouraged to view the exoticism of the people, and purchase their arts and artifacts, while enjoying the islands' balmy climate and scenery. Virtually no attention is given to planning and managing cultural resources, only to their increased use. The goal, to earn foreign currency from tourism, is shortsighted and destructive. Even in the context of this goal, without careful maintenance the life of the golden goose will certainly be shortened.

War has also been a societal force in the region. Regardless of the rationale, war has destroyed much of the cultural fabric of the people of Timor since the mid-1970s. Communities have been devastated by firepower and resettlement, and people have been stripped of their adorned objects, many of which appear for sale on Bali.

The Exchange

The collection of Lesser Sunda tribal art is an activity that has grown and matured from 1970 to 1990. The intensity and brevity of the collecting are primarily the results of the external forces described above, along with the efficiency of this contemporary hunting and gathering process. In addition, there has been comparatively little to collect, perhaps because the peoples of these islands may not have been as prolific as in other tribal areas of the world targeted earlier. Certainly their poverty in a rapidly engulfing cash economy is also an important factor; the three provinces making up the Lesser Sunda Islands are the poorest in Indonesia (measured in per capita income and caloric intake).

Reflecting on the history of collection on the Northwest Coast, Cole (1985:311) concluded that the process was basically an exchange, which had value, typically economic, for both the indigenous seller and the outside seeker. Although both parties benefited, the seller was disadvantaged by the international economic system, because he was buying from a cash surplus economy with scarce or irreplaceable items that were the products of a predominantly subsistence economy. This same situation prevails in the Lesser Sundas, where it is also a story of increasing demand for old objects (made

fifty or more years ago) and decreasing supply. However, beauty has been more important in the case of the Lesser Sundas, artifacts per se being of little interest.

Early in the 1970s, collectors of Lesser Sunda art focused on textiles and ancestral sculpture. But as virtually nothing was known about the material (except for Sumba's textiles, recognized in Europe since the last century), buying was rather indiscriminate. Paralleling the global condition, from the mid-1970s a wider variety of objects was sought as art, including beautiful utilitarian objects and jewelry. At the same time they were beginning to be more specifically identified and described. Textiles from Sumba remained the most known, sought after, and costly. Although prices had increased, a fine Sumba ikat *hinggi* made from homespun yarns and vegetable dyes could still be purchased in the regional art marketplace, Bali, for $75 to $300 (fig. 5). Fine textiles from the other islands were typically less expensive. The well known *selimut*, or male wrap, from the Lio area of Flores cost about $75, one from Savu, about $20 (fig. 7). This variation in price appeared to correspond with consensus in the foreign market on aesthetic value and availability. From the late 1970s the supply of the high-quality, or "good," old textiles began to decrease rapidly, while demand increased at a similar pace. Prices for the most sought after were doubling every six months or so.

At that time greater increases in price were reported for ancestral sculpture and heirloom jewelry. Compared to textiles, these objects were rarer, although demand for the sculpture seemed to increase the supply slightly in the early 1980s. For a brief period around 1980 the small island of Atauro, near Timor, was surprisingly fecund, the source of some twenty-five to thirty-five ancestral figures (fig. 8) (Moss 1986:12–13). As with textiles, Sumba appears to have been the richest among the Lesser Sunda Islands in most of the other kinds of objects sought by collectors.

Most of the few old objects left in the islands' hamlets in 1990 were known to seekers, who began playing the time-honored game of patient ingratiation. However, as demand and price increase, two other art-market tactics have come into play—imitation of old objects and theft. In the 1980s imitations were scarce and easily identified due to poor workmanship. But as Lesser Sunda ancestral sculpture, ceremonial house doors, and masks began to approach the prices obtained for similar Nias and Batak works, the most highly skilled carvers were recruited. Similarly, with gold and silver jewelry commanding high prices, smiths are making convincing replicas. Skillfully woven copies of heirloom textiles are also being sold as old. The theft of heirlooms and relics does not seem so pronounced as in the Toraja region of Sulawesi, but perhaps only because there has not been the same opportunity. There seems to be comparatively less to steal, and what exists

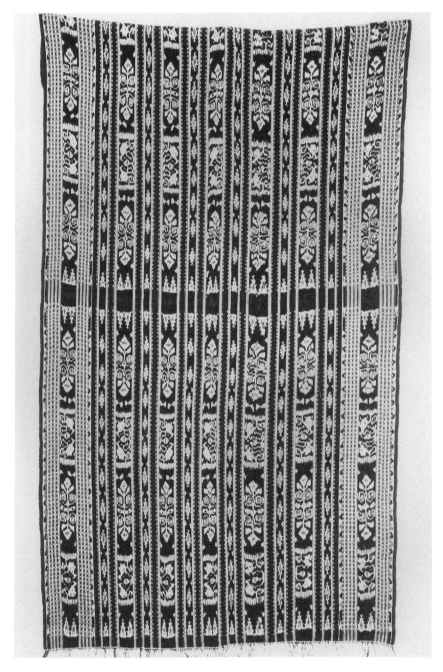

Fig. 7. Textile (male mantle), Savu, cotton, 38 × 78 cm. Laurence A. G. Moss collection, Santa Fe, New Mexico. Photo: Laurence Moss.

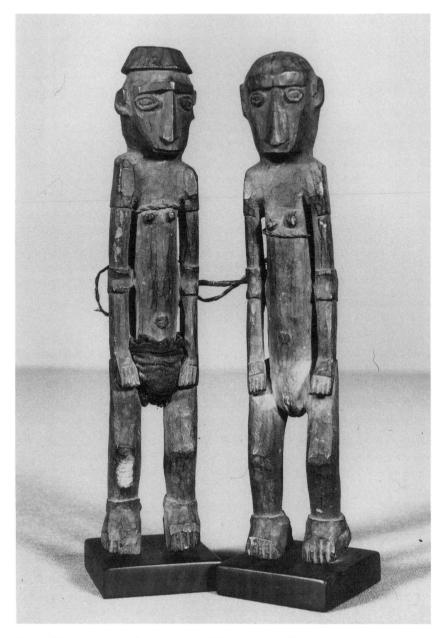

Fig. 8. Human figures, Atauro, wood, H. 22 cm (female), 23 cm (male). Laurence A. G. Moss collection, Santa Fe, New Mexico. Photo: Russ Clift.

tends to be carefully protected within private dwellings. West Flores, how-
ever, has suffered from the theft of its outdoor memorial works. Because the
bones of the dead are no longer a collection target, grave robbing has not
been a problem in these islands. But a few aesthetically appealing bronze
objects from the Lesser Sundas appeared for sale in the late 1980s, and
burial sites may become a new focus in supplying the growing international
art market.

Although since 1980 demand for new Lesser Sunda Island art has been
very limited, the strongest demand is for "functional traditional" textiles.
Such objects may show some modification due to external contact, but they
continue to function within the values and aesthetic system of the peoples
making them (Graburn 1984:396–399). In 1982 four types of Lesser Sunda
textiles sought by outsiders were studied (Moss 1986:24). There was consid-
erable demand for medium-quality, moderately priced textiles conforming
to the functional traditional description. These typically seemed to be less
than twenty years old and sold on Bali for $25 to $160 (figs. 7, 9). Few in
this category were wholly vegetable dyed, and they were usually made of
machine-spun cotton. But handwoven and conforming with old design tra-
ditions, they conveyed a strong sense of authenticity. Of higher quality and
price than this type of textile were the heirloom cloths (fig. 4) and their rep-
licas, the former usually fifty or more years old, the latter less than ten. Both
represented the best in aesthetics, weaving, dyeing, and materials. Al-
though the old textiles were in great demand, there was only a modest inter-
est in the new ones. The fourth type, low-quality weaving, cost little and
was often made expressly as inexpensive tourist souvenirs or piece goods for
the Bali garment industry. Demand for this fourth type had leveled off by
1982 (Moss 1986:29).

These four categories were still useful for analysis in 1988. By that time
the supply of all types was considerably less, and prices were much higher,
except for the finest-quality new replicas. In 1982 I interviewed twenty-five
Bali dealers who estimated that the demand during the following year for
moderately price functional traditional textiles would be 57,000 to 67,000
pieces (Moss 1986:24). In 1988 seven dealers stated that fewer collectors
were actively seeking these textiles because the supply had dramatically
decreased, some types having disappeared. In addition, the available textiles
of this type were newer than in 1982, seldom more than five years old. The
market for high-quality new pieces, sold as contemporary art, had increased
marginally. Most dealers agreed that they handled new textiles because the
old ones were unavailable, not because of actual demand.

In the tribal art market an inordinate number of dealers are also collec-
tors (MacClancy 1988), a condition that holds true for the Indonesian con-

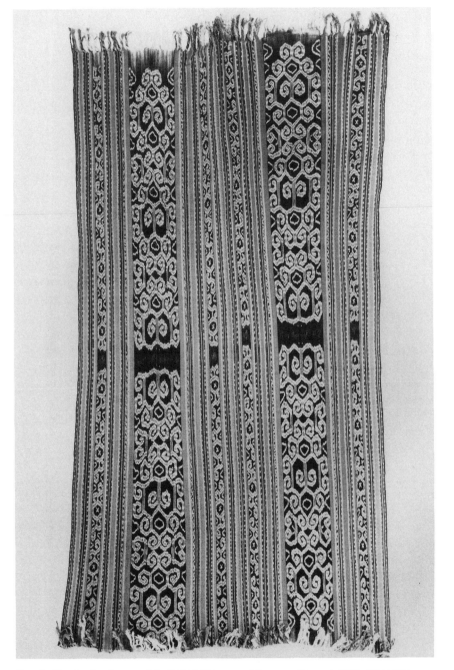

Fig. 9. Textile (male mantle), Niki Niki area, Timor, collected 1980, 95 × 196 cm. Laurence A. G. Moss collection, Santa Fe, New Mexico. Photo: Reece Metcalf-Rehm.

dition. Further obfuscating the exchange process is the rapid change in the roles of seekers of Lesser Sunda art during the last two decades.

In the early 1970s, in the context of an embryonic international market for Indonesian tribal art, the main facilitators of the Lesser Sunda market were the dozen or so young foreign dealers residing on Bali. At the time, most bought art on a part-time basis. They sought out beautiful objects on Bali, the Lesser Sundas, Sulawesi, Borneo, Sumatra, and in the Philippines. They also obtained them from runners, bringing material from other islands to Bali, and if the price was right, from the antique and art shops of Bali. These resident foreigners sometimes sold to the discriminating tourists or art collectors visiting Bali. Usually they took "collections" of art to the metropolitan centers of Australia, Europe, and North America to sell to other dealers, museums, and individual collectors.

In the mid-1970s Bali was becoming an important tourist destination and emerging as a principal marketplace for Indonesian tribal art. Jakarta excelled in Sumatran material; Bali specialized in Lesser Sundanese; and they shared the supply of art from elsewhere, notably Borneo and Sulawesi. By 1980 Bali had outpaced Jakarta. Bali's exotic culture and beautiful natural environment, excellent tourism infrastructure, the continuing supply of art and crafts of Bali and the eastern islands, and the resident foreign dealers constituted the ingredients for a global art market. By this time, while the number of resident foreign dealers had increased marginally, the earlier ones had become full-time dealers. They spent much less time seeking art in the islands and more time selling it in the metropolitan centers of the world. Competition had increased considerably. More art dealers from the world's centers made purchasing trips to Bali, buying from the resident foreign dealers but also directly from Indonesian sources. Tribal objects, especially textiles from the Lesser Sundas, crowded the Bali shops (Moss 1986:11). Although these shops tended to specialize in the lower end of the market, several shop owners competed with the resident foreign dealers. Additional competition came from island runners making direct contact with the metropolitan dealers. This usually occurred on Bali, but a few outside buyers went into the islands seeking the runners, and on rare occasion to the hamlet sources.

During the 1980s, as the supply of art rapidly decreased and prices increased, competition among the seekers become pronounced. Few serious foreign dealers continued to reside on Bali. The competition within Indonesia and from metropolitan dealers squeezed out most part-timers and amateurs, and the remaining resident foreign dealers grew to international status, characteristically dealing in more than Indonesian objects and living in more strategic locations, such as Los Angeles, Paris, or Bangkok. Many

Indonesian dealers have shifted to other merchandise, such as furniture and leisure garments, or into other businesses, such as the tourist industry (Suryanti 1988). Others are selling new art, either recognized as such or as old objects. With fewer art objects pursued by more money, the growing need for capital has played an important role. Speculative investors became involved in the tribal art market in Indonesia. Elsewhere much of the Lesser Sunda art obtained since 1970, especially the best, remained in the possession of dealer-collectors. Few of these old objects, and virtually none of the new, are in public collections. The holdings of the Barbier-Müller Museum, Geneva, are the notable exceptions.

The objects of the Lesser Sunda Islands that were treated as art had, and to a lesser extent still have, functional roles in the cultures of these islands. Many have a mundane use, such as vessels and clothing. All play important roles in people's relations with other people, with the dead and the supernatural, with animals, and with the natural environment. Although the objects' functions are understood, very little is known about related concepts of beauty (see Adams 1969, 1980; Barnes, chap. 2 above; Feldman 1985; Fox 1973, 1977, 1980; Maxwell 1981; Rodgers 1985). Since 1970 social and economic forces of change have generally weakened the traditional value of old objects to Indonesians, and their worth to the outsider has increased to the degree that cash value for the local owner exceeds the value traditionally associated with retaining possession.

The size of a *pusaka* (treasury of valued objects) has apparently been of primary importance to the number and price of objects flowing out of the islands. Elite families in particular had sizable *pusaka*. As prices increased, owners felt more incentive to sell.

Individuals and families also sold for reasons of perceived friendship and social obligation, typically at the request of the buyer. Such motivation can be coercive in nature, as when a member of a local elite, acting as a buyer's agent, uses his social position to pressure the owner to sell. Another kind of involuntary sale I have witnessed takes the form of entrapment. Store-bought goods, including alcohol, are sold on credit, in excess of what is known to be an individual's or household's ability to pay. Subsequently the provider, typically a local merchant, demands and obtains repayment in valuable art objects. Cole (1985) reports that the same gambits were used in the nineteenth century on the west coast of Canada. Natural disaster is also a cause. Hard times visited on a household or hamlet by drought or flood have frequently forced the sale of precious objects in the Lesser Sundas (Moss 1986:13–14).

In general the draining of the region's precious objects started in those places with easiest access to Bali and with the most attractive art. Lombok,

East Sumba, and the Lio area of Flores were the principal sources initially. Although the art of East Timor was of comparatively less value in the 1970s, and the location was remote, pieces began arriving in Bali in 1975 as a result of armed conflict on the island. Later, West Timor, West Sumba, Savu, Roti, Lembata, and other parts of Flores moved onto center stage.

Many hamlets of the Lesser Sundas have a tradition of selling their textiles that predates the 1970s. In some hamlets women have traditionally woven textiles exclusively for their household's needs, in others surpluses were produced for sale. Part of this exchange activity may be better characterized as gift giving (Adams 1969; Rodgers 1985). However, for at least several hundred years some peoples of the Lesser Sundas wove and traded textiles on a more commercial basis. This seems particularly true of East Flores and West Timor.

Hamlets continue to sell textiles for commercial gain. In 1982 a study of communities selling textiles revealed that three seemed to rely primarily on weaving for their income. Pero, West Sumba, produced an unusually large number, 8,000 annually, or about 100 to 120 per household. Nggela, in the Lio region of Central Flores, wove 1,200 textiles per year, or 6 per household, of which two-thirds were sold in neighboring settlements. Moliru, East Sumba, made 600 textiles annually, 4 per household, selling one-half to three-quarters into the Bali market (Moss 1986:30–31). (See figures 10 and 11.)

Aesthetically, only Moliru's textiles would be desirable to the international art market, and in the moderate-quality, moderately priced class. Although the dyes were a mixture of vegetable and commercial, the yarns machine spun, and the old motifs frequently simplified, the work was undertaken with care and skill, resulting in a fine representation of the weaving tradition. But as these cloths were not conscious copies of old ones and were also used by the households that wove them, they should not be considered "replicas" or commercial art. "The local people start to make an exact replica just for sale, adhering to main traditional forms and designs which satisfy their own aesthetic traditions and guarantee some form of 'authenticity' to the buyers" (Graburn 1984:399).

Textiles historically appear to have been the most favored aesthetic medium of the tribal peoples of Indonesia, including the inhabitants of the Lesser Sundas (fig. 12). There is evidence that many continue to weave in this island region, and much that is woven is aesthetically attractive to outsiders. But despite increasing demand, weaving is decreasing. Some hamlets have stopped weaving altogether, even though skills remain and the people state they would like to continue to weave. Although some argue that the only market is for old textiles, research indicates that the demand for some

Fig. 10. Weavers selling textiles, Pero, West Sumba, 1982. Photo: Laurence Moss.

Fig. 11. West Sumban pur-
chasing East Sumban *hinggi*
at airport, Wangipy, East
Sumba, 1982. Photo:
Laurence Moss.

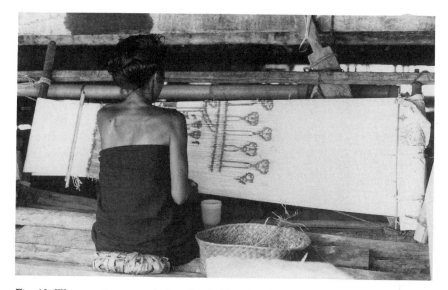

Fig. 12. Weaver tying warp design, Rindi, East Sumba, 1978. Photo: Laurence Moss.

new types, while comparatively less, is still strong, especially for functional traditional textiles (Moss 1986). The linkage between market and maker turned against both and proceeded to strangle the weaving of textiles. How did this occur?

A significant factor is that the weavers have very poor knowledge about their contemporary market. They do not know the demand and prices in the market center, principally Bali. The behavior of middlemen appears to be a principal reason for the decline in the weaving of higher-quality textiles. Most are merchants in a long tradition of exchanging goods along profitable chains of middlemen from regional capital to the hinterland and the reverse. When external demand developed for textiles, as with any other commodity, merchants gathered them locally and moved them up the chain, constituted typically of extended family relations. At each link usually over 100 percent profit was made. The merchants had no particular interest in the textiles and little or no understanding of the intrinsic aesthetic or cultural value of the objects for either the makers or foreign collectors. They entered the market when there was a comparative abundance of older textiles in many of the hamlets, and were able to draw on this storehouse. The cost of the textiles was low, not even covering replacement, as the merchants were later to learn. Those in the chain in or close to Bali also increased their profits considerably by withholding desired textiles from the market, doubling or tripling their gain.

Later, in the early 1980s, when the market heated up, this system proved

too slow, causing some merchants, usually the sons, to short-circuit the hierarchical chain by taking the textiles directly from the sources to Bali. As the surplus of old textiles was sold, the merchants went to the weavers for replacements. However, since they have been unwilling to pay enough to support the weaving of comparable textiles, the weavers respond to this squeeze by reducing their cost (in material, energy, time) per unit. This typically results in inferior textiles with simplified patterns, weak, machine-made yarns, nonfast commercial dyes, and poorly executed weaving. In turn, the market rejects the product, or will pay an insufficient amount for the middlemen to continue trading and the weavers to continue weaving. More critical than the other forces that come into play, this linkage between the source and market center has resulted in less weaving throughout the Lesser Sundas, and in some communities, none. Not only have the indigenous people lost most of their beautiful old objects but the exchange is crippling their ability to maintain a remaining significant cultural resource, their textile tradition.

Sustaining Cultural Resources

It is unlikely that much can be done to stop the outflow of the remaining old art of the Lesser Sundas, unless demand were to markedly decrease. Therefore, to sustain the region's cultural resources, the people of these islands must continue to make the material manifestations of their cultures for as long as they choose. Core responsibility for the planning and management of cultural resources must rest with the particular communities involved, assisted by outside facilitators. There is, however, no guarantee that aesthetic products will result from such maintenance, especially from the point of view of the interested outsiders, be they art collectors, tourists, government planners, or anthropologists.

There appears to be strong sentiment in the communities to maintain their textile traditions in particular. For example, despite the decline in weaving activity, many women wear their traditional costume on a daily basis, and both men and women wear or otherwise use their textiles on ceremonial occasions. Most weavers interviewed said they would welcome the opportunity to make fine textiles for others, provided they receive fair compensation.

Some externally assisted textile projects have already been undertaken in the Lesser Sundas. However, the results have been unimpressive the few times that the Indonesian government and bilateral aid agencies (usually motivated by potential sales to tourists) involved themselves in the making or marketing of textiles. Neither the weavers nor the buyers appear satis-

fied. The foreign buyer in particular typically wants an "authentic" weaving, from which the product of such sponsored projects has usually deviated considerably.

The Indonesian government and bilateral and multilateral international development organizations rank aid to this and other cultural resources quite low. With the exception of UNESCO, these institutions do not have a cultural resources perspective (Moss 1986). Similarly, central government officials responsible for national and regional development, although now emphasizing tourism, do not seem to realize the importance of sustaining cultural resources that attract tourists. Planning and managing the use of these resources is not yet being undertaken by the government and is facilitated by only a few small foreign-assistance bodies. In addition, representatives of the Indonesian government typically feel no cultural affinity with this tribal art. They either do not perceive it as art or consider it to be of little cultural significance.

Until 1990 only two private business concerns have involved themselves in sustaining and marketing the textiles of these islands. Neither was successful. On the other hand, small nonprofit, nongovernmental organizations (NGOs) are demonstrating success in textile projects in eastern Indonesia. Typically, they put in the extended time necessary, bring appropriate knowledge, have understanding of and sensitivity to local culture, and emphasize local decision making. Such projects are few and their impact is quite small, primarily due to very limited resources and a focus on production rather than marketing. The Social Research and Development Institute, Maumere, Flores, supplies materials on credit to weavers in several hamlets, whose finished textiles, if high quality, are purchased and resold with assistance from the German embassy in Jakarta. A similar project, focusing on four West Timor hamlets, was begun in the mid-1980s by the Australian embassy. The Australian National Gallery supports the project by selling the textiles in its shop; profits are returned to the weavers. The gallery has also purchased new textiles for its own collection (Maxwell 1987:8).

Improvements over past assistance attempts would be long term, more informed and sympathetic involvement and a greater emphasis on marketing. Such outside help should also have as primary objectives local control and self-help, as much and as soon as possible. It seems unlikely that the government of Indonesia or international governmental and quasigovernmental organizations have the appropriate orientation and skills to be directly involved. When local communities need such external assistance, it should be channeled through nonprofit NGOs that have experience with cultural resource projects and, preferably, with the Lesser Sundas.

Most weavers need assistance in developing an accurate and timely understanding of the market—where, when, and how much of what. They also need a sympathetic marketing network, which probably means eliminating most middlemen between them and, initially, Bali and Jakarta. This in turn suggests management aid, delivered through marketing cooperatives based on local cultural models of reciprocity. Credit assistance, possibly via credit unions, which are experiencing success in a number of the islands' communities, could provide seed capital for up-front costs, such as weaving materials. Marketing and production need to be structurally linked, perhaps through a textile marketing center located on Bali. It could be started and initially staffed by professionals who would train local people to undertake the marketing analysis and promotion needed by the weavers. Direct links to foreign markets should be a later concern, as these initial local and regional activities will be difficult enough.

Programs should focus first on the demand for functional traditional textiles, both moderate-quality, moderate-priced cloths and fine-quality, high-priced cloths. More promotional work will probably be necessary for the latter, which still has a very small market. Moderate quality does not suggest compromise on weaving and dyeing skills, but rather the use of machine-made yarns and either a mixture of commercial and vegetable dyes or better commercial dyes than are used now. Experimentation will be necessary.

Although external funding for textiles as a sustainable resource will probably remain quite limited, some money should immediately be allocated for purchasing old art in the islands. These objects should go into study collections located as close as possible to the originating communities. Greater and more innovative attention ought to be given to subnational museums or cultural centers (see Taylor, chap. 6 above). An attempt should also be made to keep *pusaka* collections intact, perhaps with a long-term purchase agreement for local study collections in the event owners decide to sell. The collection of old textiles must be undertaken on an emergency basis, to intercede before the region is drained by external demand.

Paralleling the actions outlined above, a national sustainable cultural resources policy must be established, especially for tribal cultures. The policy should be implemented as part of Indonesia's regional development plans, programs, and projects. Also, in areas where tourism development is not part of regional planning, the opportunities for and threats to a people's cultural resources should be assessed and the use of their resources carefully planned. However, an environment sympathetic to the maintenance of cultural resources will probably exist only after national schools teach that sustainability is both just and economically sound. Policies and maintenance programs will probably not have substantial impact until the peoples of

these islands come to feel that their ways and heritage are respected, not threatened, by the wider world.

Notes and References

1. Following Clifford (1988) and Rubin (1984), the term "tribal" is here preferred to "primitive" in reference to the arts of more or less noncentralized societies with simple technologies. While both words are inadequate and fraught with issues, "primitive" is rejected due to its negative evolutionary connotations.

Adair, John
1944 *The Navajo and Pueblo Silversmiths.* Norman: University of Oklahoma Press.
Adams, Marie Jeanne
1969 *System and Meaning in East Sumba Textile Design: A Study in Traditional Indonesian Art.* Southeast Asian Studies. Cultural Report Series 16. New Haven, Conn.: Yale University.
1980 Structural Aspects of East Sumba Art. In *The Flow of Life: Essays on Indonesia,* edited by James Fox, 208–220. Cambridge: Harvard University Press.
Alsop, Joseph
1982 *The Rare Art Traditions: The History of Art Collecting and Its Linked Phenomena Wherever These Have Appeared.* New York: Harper and Row.
Ames, Michael
1981 "Museum Anthropologists and the Arts of Acculturation on the Northwest Coast." *B.C. Studies* 49 (Spring): 3–14
Aspelin, P.
1977 "The Anthropological Analysis of Tourism: Indirect Tourism and Political Economy in the Case of the Mamainde of Mato Grosso, Brazil." *Annals of Tourism Research* 4(3): 135–160.
Barbier, Jean-Paul
1984 *Indonesian Primitive Art: Indonesia, Malaysia, the Philippines, from the Collection of the Barbier-Müller Museum, Geneva.* Dallas: Dallas Museum of Fine Arts.
Barbier, Jean-Paul, and Douglas Newton, eds.
1988 *Islands and Ancestors, Indigenous Styles of Southeast Asia.* Munich: Prestel-Verlag.
Butor, Michael
1986 *Le Congrès des cuillers,* Geneva: Musée Barbier-Müller.
Clifford, James
1988 *The Predicament of Culture, Twentieth-Century Ethnography, Literature, and Art.* Cambridge: Harvard University Press.
Coe, Ralph T.
1986 *Lost and Found Traditions, Native American Art 1965–1985.* New York: The American Federation of Art.

Cole, Douglas
1985 *Captured Heritage: The Scramble for Northwest Coast Artifacts.* Vancouver, B.C.: Douglas and McIntyre.
Eber, Shirley, ed.
1992 *Beyond the Green Horizon: Principles for Sustainable Tourism.* Godalming, U.K.: World Wide Fund for Nature.
Feldman, Jerome, ed.
1985 *The Eloquent Dead, Ancestral Sculpture of Indonesia and Southeast Asia.* Los Angeles: Museum of Cultural History, University of California.
Fox, James J.
1973 *On Bad Death and the Left Hand: A Study of Rotinese Symbolic Inversions, Right and Left.* In *Essays on Dual Symbolic Classification,* edited by Rodney Needham, 342–368. Chicago: University of Chicago Press.
1977 "Roti, Ndao, and Savu." In *Textile Traditions of Indonesia,* edited by Mary Hunt Kahlenberg, 97–104. Los Angeles: Los Angeles County Museum of Art.
1980 "Figure Shark and Pattern Crocodile: The Foundations of the Textile Traditions of Roti and Ndao." In *Indonesian Textiles: Irene Emery Roundtable on Museum Textiles, 1979 Proceedings,* 39–55. Washington, D.C.: Textile Museum.
Gittinger, Mattiebelle
1979 *Splendid Symbols, Textiles and Tradition in Indonesia.* Washington, D.C.: Textile Museum.
Graburn, Nelson H. H.
1984 "The Evolution of Tourist Arts." *Annals of Tourism Research* 11(3): 393–419.
Greub, S., ed.
1988 *Expressions of Belief: Masterpieces of African, Oceanic, and Indonesian Art from the Museum voor Volkenkunde, Rotterdam.* New York: Rizzoli.
Holmgren, Robert T., and Anita F. Spertus
1989 *Early Indonesian Textiles from Three Island Cultures: Sumba, Toraja, Lampung.* New York: The Metropolitan Museum of Art.
Hoskins, Janet
1988 "Arts and Culture of Sumba." In *Islands and Ancestors, Indigenous Styles of Southeast Asia,* 120–137. Munich: Prestel-Verlag.
Khan Majlis, Brigitte
1984 *Indonesische Textilien, Wege zu Göttern und Ahnen.* Cologne: Rautenstrauch-Joest-Museum für Völkerkunde.
Langewis, Laurens, and Frits A. Wagner
1964 *Decorative Art in Indonesian Textiles.* Amsterdam: C. P. J. van der Peet.
MacCannell, Dean
1976 *The Tourist: A New Theory of the Leisure Class.* New York: Schocken.
MacClancy, Jeremy
1988 "A Natural Curiosity, the British Market for Primitive Art, Anthropology and Aesthetics." *Res* 15:163–176.

Maxwell, Robyn J.
1981 "Textiles and Tusks: Some Observations on the Social Dimensions of Weaving in East Flores." In *Five Essays on the Indonesian Arts*, edited by Margaret J. Kartomi, 43–62. [Melbourne]: Monash University.
1987 "Southeast Asian Textiles: The State of the Art." Working Paper 42, Center of Southeast Asian Studies. Melbourne: Monash University.

Moss, Laurence A. G.
1986 *Art of the Lesser Sunda Islands: A Cultural Resource at Risk.* San Francisco: San Francisco Craft and Folk Art Museum.

Rodgers, Susan
1985 *Power and Gold, Jewelry from Indonesia, Malaysia, and the Philippines.* Geneva: Musée Barbier-Müller.

Rubin, William, ed.
1984 *"Primitivism" in 20th Century Art.* 2 vols. New York: Museum of Modern Art.

Said, Edward
1978 *Orientalism.* New York: Pantheon Books.

Solyom, Bronwen, and Garrett Solyom
1984 *Fabric Traditions of Indonesia.* Pullman: Washington State University Press.

Stewart, S.
1984 *On Longing: Narratives of the Miniature, the Gigantic, the Souvenir, the Collection.* Baltimore: Johns Hopkins University Press.

Suryanti, Nora
1988 "From Antiques to a New Type of Tourists." *Indonesian Observer* 13 (November): 7.

Taylor, Paul Michael, and Lorraine V. Aragon
1991 *Beyond the Java Sea: Art of Indonesia's Outer Islands.* Washington, D.C.: National Museum of Natural History; New York: H. N. Abrams.

Vion, Anne-Marie
1987 "Indonesian Fakes." *Art Tribal* 11:16–19.

Wade, Edwin
1985 "The Ethnic Art Market in the Southwest, 1880–1980." In *Objects and Others: Essays on Museums and Material Culture*, edited by George Stocking, 176–191. Madison: University of Wisconsin Press.

World Tourism Organization
1981 *Tourism Development Plan, Nusa Tenggara, Indonesia.* Madrid: World Tourism Organization, Series no. ins/80/104.

8 Whither Dayak Art?
MICHAEL HEPPELL

Dayak art is in the final stages of a slow, terminal illness. It will pass away having contributed many beautiful objects to museums, objects that are likely to remain curiosities because of the dearth of reliable information about them. In libraries one searches long and hard for books on Dayak art, for few exist.

That the Dayak peoples throughout Borneo have produced major works of art is amply demonstrated by the prices that pieces can obtain in the major art auctions of the world. Exhibitions devoted to Dayak art, such as the 1991 exhibition at the Museum of Mankind in London, draw the world's attention to this art and generate interest in it. For those stimulated to acquire examples of Dayak art, the interest is short-lived because the supply is now virtually exhausted, and good modern examples are extremely rare.

Although one of the numerous Dayak art forms is monumental or civic art, a tourist wandering around the many towns of Sarawak, Malaysia, will not glimpse Dayak monuments commissioned by a civic or state authority. Over the border in Kalimantan, Indonesia, however, many examples of Dayak sculptures are on public display. In Samarinda, both the governor's residence and the governor's office have ceremonial poles (*beliring*, after the poles the Kenyah people erected after a head had been taken) on their grounds. Dayak monuments are placed in front of the government offices and civic buildings as well. Roofs of buildings display the two-dimensional Dayak designs that traditionally would have graced a Kayan, Kenyah, or Kajang *salong* (grave house). For a time such recognition gave many communities pride in their art and a desire to continue to design, carve, and paint. Many have built traditional houses (*balai desa*) or meeting houses (*rumah adat*), which are resplendent with local designs.

Despite these hopeful signs, there are contrary ones. Javanese design and craftsmanship appear to be in the ascendant in Kalimantan. A Javanese sculptor was commissioned to produce a sculpture of dolphins for the approach to a new bridge across the Mahakam River. In a recent reconstruction of a famous Benuaq longhouse near Tanjong Isui, the Dayak figures placed in front of the entrances to the longhouse were carved not by Dayak but by imported Javanese and Buginese craftsmen.

In 1990 Kalimantan, the able Dayak artists and carvers were all middle-aged or older. The young take no interest in artistic endeavors. They see the art of their mothers and fathers as a token of their former primitivism rather than as objects of undeniable beauty or an expression of a unique way of perceiving and representing aspects of their world.

Among the Dayak, in one generation traditional art has moved from the esteemed to the embarrassing. In the past, the artist was highly valued. Among the Iban, for example, skill at carving was a token of refinement and added greatly to a person's eligibility for marriage. A future carver would serve his apprenticeship by decorating bamboo cylinders with foliate scrolls and giving them to young women he was wooing. Such cylinders were tokens of love affairs and would be used by the young woman to store small pieces of weaving equipment like bodkins. Women were more likely to be attracted to a man with artistic skills than one without, because the tokens of an affair were highly desirable. In turn, the young woman would reciprocate by weaving something such as a tobacco pouch for her beloved. Weaving, too, was a highly respected skill among the Iban, and accomplished weavers were very desirable partners. Consequently, artistic skills and accomplishment gave both sexes the pick of the available mates.

For Dayak art to survive and flourish in a modern idiom, imaginative government programs will need to reinstill in the various groups living in Borneo the high value they once placed in their art. As governments have concentrated on economic development, encouragement of art forms has tended to be neglected while scarce resources are channeled into economic programs. With the acquisition of reasonable levels of wealth comes the time when funds can be diverted to the development of traditional art. If spent wisely, funds dedicated to art will show a good economic return, though one that is much more difficult to quantify than, for example, an investment in an oil palm project. As leisure becomes a major industry, art can become a powerful lure to attract leisure spending.

As used here, the expression "Dayak art" includes products of all the inland peoples of Borneo. A general description of the various art forms practiced in Borneo is most easily approached by focusing on one group that has developed a particular form to a greater level of sophistication than any other group, and then by examining the work of other groups. Thus the great painters, beadworkers, and mask makers are the Apo Kayan groups originating in the upper reaches of the Kayan River in East Kalimantan. The great weavers are the Iban people of Sarawak. For sheer range and diversity, the great carvers of figures are the Luangan, Ngaju, and Ma'anyan groups living in Central and East Kalimantan. The great monumental carvers are the Kajang, whose massive *keliring* (burial poles) are powerful pieces

of great artistic merit. The silver workers are the Maloh from the upper Kapuas in West Kalimantan, who used to travel around Borneo producing silver ornaments for other Dayak groups, especially the Iban.

Nor is Dayak art confined to the aspects briefly described here. Many skills, like potting and iron forging, are lost and never likely to be revivified. Other skills, like etching and dyeing bamboo, are almost extinct.

Human Sculptures

Dayak figurative carving is inextricably linked to Dayak religious beliefs. Traditionally the Dayak were animists; as such they believed there was a mortal dimension to life that comprised the everyday waking experience of human beings, and also an extramortal dimension that operated on a supernatural plane. The latter plane bustled with spirits of tangible objects and of intangible phenomena like sickness, and with other spirits, both benevolent and malevolent, that were believed to come into contact with humans from time to time, to their benefit or discomfort. Dayak carvers produced physical figures, or images, that were made to operate in the metaphysical world of spirits and demons.

In order for a figure to operate at the supernatural level, it has to experience a radical transformation from a carved piece of wood to an animated form of great power. The change is effected by a ceremony that summons an appropriate spirit to take up residence in the wooden form, after which the figure is able to fulfill the function for which it is designed.

In terms of function, figures can be divided into several types: those that bring supportive but aggressive spirits to protect or do something beneficial for an individual, household, or community; those that notify the spirit of a recently departed person that a surrogate body has been provided for the departed soul to lodge in when it returns to its former abode; those that exorcise malevolent spirits from a patient, forcing them to move to a figure carved as a vehicle to rid the sick person and the community of those spirits; and those that enable a figure to project something unpleasant on someone. A fifth kind of figure is simply decorative, carved to grace some object, such as the figural bamboo stoppers the Kayan carved and the figures Iban carved on their spinning wheels.

Figures may be carved for specific purposes. Most commonly they act as guardians of people or property, encourage fertility, guard rice plants (*padi*, the most important crop of the Dayak and the centerpiece of most Dayak religious activity), provide a physical form to which a sickness infecting a human being can be transferred, and supply a physical form for a dead soul to rest in on its infrequent journeys back to the land of the living. In all but

the last of these guises, a figure does not represent anything. It is neither more nor less than a figure.

The two most frequent kinds of figures are the aggressive, protective guardians, such as those used by the Kayan and Kenyah, and the ones providing a physical form to which a sickness is transferred, a type of figure which the Melanau of northern Borneo have developed to a high degree of sophistication.

In the past, when Kayan and Kenyah heard of sickness upriver, one of the preventive measures they took was the carving of huge *hudog* figures. These figures, often of warriors brandishing sword and shield, were placed in front of and behind a longhouse to attack the spirits of sickness before they were able to enter. Crocodile figures were also carved and placed beside all ladders leading into the house from paths to the river. Such figures were designed to terrify, in the belief that if they could frighten human beings, then they would frighten the spirits of sickness.

When the bases of the figures were sunk into the ground, a ceremony was held. A pig and a chicken were sacrificed and their blood drained into an upturned gong. Invocations were made calling on the gods to assist the spirit of the *hudog* to do its important work. The figures and each member of the house were then sprinkled with the sacrificial blood to purify them. This ceremony animated the figures so that they were able to perform their functions with all the aggressiveness expected of them.

Of all Dayak groups, the Melanau and the Benuaq have probably the largest pantheons of figures carved to serve as vehicles to remove sickness from a patient. The account of Melanau figures that follows is derived from several descriptions (Morris 1953; Gill 1968; Chong 1987; Stephen Morris and Tuton Kaboy, personal communications).

The Melanau have a category of spirit called *tou*, which are either creations of an almighty or reincarnated humans. A person becomes sick when a malignant *tou* enters his body and drives out his soul. Melanau treatment of sickness involves determining the identity of the spirit infecting a person, making a figure, called a *bilum*, out of sago pith in that spirit's image, and then having a curer project his soul into the patient's body and drive the spirit out, forcing it to take refuge in the *bilum*. The carved piece of sago pith remains "raw" until the curer spits betel juice on it and incites the malevolent spirit to take up residence there. At this point, the figure is transformed, and anyone who knocks it over or interferes with it in any way would be fined for a serious infraction. After the ceremony, the *bilum* is cast away into a nearby river or in the jungle, depending on the origin of the *tou* whose image it replicates.

The most important curing ceremony requires up to twelve *bilum* to be

carved and placed in a model boat, located outside the patient's house. A second set of *bilum* is placed in a model house, located within the patient's house. The *bilum* in the boat are made to receive malign *tou*, those in the house, benign ones. The model house and boat are joined by a path of woven fronds. A swing is also constructed on which the patient is rocked for up to five nights, during which time the curer works to expel the spirits infecting him. The malign spirits flee from the patient along the pathway of the palm frond to find solace in their own images resting in the model boat. The boat is then cast off into the water to take the evil spirits and the sickness they bring far from the village.

For the Melanau, it is critical that a *bilum* be carved in the exact image of the malign *tou*. Only then will the spirit recognize its image and go there after it has been cast out of the patient. Aesthetics in this case are not a consideration. The efficaciousness of the *bilum* is entirely dependent on the correctness of the form, the balance of the finished object, and its likeness to conventional representations of the particular spirit believed to be infecting the patient.

There are over one hundred named *bilum*. Carvers, therefore, require an encyclopedic knowledge to represent them all accurately. Despite the number of *bilum*, their individual characteristics are well known, though they differ from one Melanau region to another. Characteristic forms include heads without bodies, signifying a spirit that causes headaches; long, loose hair, signifying widowhood; protruding tongues, signifying a ghost; and wings, signifying a spirit living in the heavens. *Bilum* are also depicted holding their victims. Most have common attributes like crowns, horns, or turbans.

Both the *hudog* and *bilum* traditions produced distinctive styles and sculptures. Who, then, is making such figures today? The answer is no one in the case of the Kayan and the Kenyah, and a few older men in the case of the Melanau. Instead, carvers churn out miniature figures and other curious objects of little artistic merit for the tourist market. Prices received are poor; the artists themselves remain poor. Not surprisingly, the occupation is regarded by the young as possessing little worth and providing less regard.

And yet, one must ask, are there not opportunities to encourage sculptors and their art? The woods are still available in abundance. The requisite tools, if not possessed, can readily be acquired. Among the Melanau, the skills are current. Among the Kayan and Kenyah, there are still plenty of skilled carvers who are largely prevented from carving by the demands of Christianity. All that is probably required to free them from the proscriptions of religion is for benefactors to be found to commission pieces.

One does not have to travel far to see the possibilities. In Bali, for exam-

ple, woodcarvers flourish, and the best now live in substantial houses, usually with a factory attached. The purist might decry a lowering of standards as output becomes more important than quality. Nevertheless, the skills have been maintained and they are now employed to supply the tourist market. Before this market burgeoned, carvers were always in demand to produce the sculptures required to decorate the many Hindu temples that abound in Bali.

In Sarawak, Chinese temples frequently have large guardian figures at their entrances. Buildings guarded by Kayan, Bidayuh, Melanau, or Iban figures simply do not exist. Not even the longhouses frequently visited by tourists have any carving either in front or inside. Figure carving is simply not appreciated and has drifted into desuetude.

When considering a future for sculptures different from the hackneyed figures that are made for sale to tourists, one might turn to an interesting development in East Kalimantan. There, a Kayan by the name of Uvong Asan, concerned that traditional Kayan beliefs had been cast aside as a necessary condition of becoming Christian, carved a number of figures in an attempt to remind his children and grandchildren of the old traditions. Not being literate, he had no other means of expressing himself for posterity. The distinctly Kayan carvings he has done give an idea of the traditions or legends the carvings represent, showing how the past might be a source of inspiration for traditional sculptures. Subjects of his carvings include a widow wearing plain barkcloth headgear as a sign of mourning, holding a leaf package of rice to signify that life must go on; a man carrying two poles used to measure the length of a shadow to determine when rice sowing should begin; two figures depicting the myth of Anye Wang (a part-canine, part-human predator who preyed on Kayan in a mythological past); and a particular water spirit helping an invalid to recover during a curing ceremony. Such works indicate a direction Dayak carving might profitably take after the present predilection with bric-a-brac and artificially aged copies for the fake market passes.

Textiles

The great textile makers of Borneo are the Iban, but many other Dayak groups also used simple back-strap looms. Most, like the Kayan and Kenyah, wove simple patterns mixing undyed threads with brown-dyed threads. The Benuaq of the middle Mahakam used the resist tie-dye method of weaving called ikat but traditionally only wove five patterns. The Tebidah and possibly the Ot Danum of the upper Kapuas in West Kalimantan practiced a technique known as *pilih*, in which colored supplementary weft

threads are used to introduce patterns. The few examples of their work that survive suggest that the range of patterns was not great.

The Iban practice four techniques on their back-strap looms: ikat; *pilih*; *sungkit*, in which supplementary weft threads are knotted around the warp before being locked into place by the weft; and *songket*, a technique similar to *pilih* that uses silver or gold threads for the supplementary weft. The *songket* technique, which Malays use on their treadle looms, was adapted by the Sarebas and Krian Iban to their back-strap looms. The technique died out but then reemerged in the Batang Ai region, where an Iban woman who had learned the technique in Brunei demonstrated it to interested women.

For the traditional Iban, textiles are imbued with ideas of war and agriculture. Woven products were regarded as central to success in the two former principal ventures of the Iban: taking heads in war as they expanded through the island of Borneo, and cultivating rice to sustain them wherever they settled. For the Iban, heads represent fertility and rice represents the source of all life.

Like sculptures, textiles operate in a spiritual world, capturing and harnessing the power of the spirits depicted. Not all designs are equally powerful. They range from those on women's skirts that are of little potency because they are worn by women, to *rang jugah*, the very breath of a trophy head, which in the Balleh and Batang Ai regions is regarded as the most powerful pattern of all. The more powerful the design, the closer it brings an Iban to the spirit world—and the greater the danger there is for the weaver as she seeks to capture the essence of the spirit and render it in cloth. However, once completed, a more powerful design affords greater protection to the user. In the presence of a spirit, it provides a potent barrier between a mortal and the potentially destructive powers of the spirit.

Textiles have many uses for the Iban. The most important is to provide a vehicle by which an Iban is able to communicate with his tutelary spirits and the gods. The central Iban textile is the *pua'*, often referred to as a blanket but more appropriately simply called a cloth. An Iban at night will retire swathed in a *pua'*, which should be decorated with designs sufficiently powerful to bring beneficial dreams. Dreams are believed to be the means by which the gods communicate to their earthly cousins. Appropriate dreams are necessary before any important or dangerous venture, providing insight as to the most auspicious time to start and whether the omens bode well.

Many of the most potent *pua'* designs depict spirits from Panggau, in Iban mythology, a place just below the doors to the heavens. The principal characters in Panggau resemble the archetypal Iban: bold, handsome, and courageous, a person who always wins in love and war.

In the hierarchical Iban society, Iban cloths are believed to have many of the characteristics of men of high status. Iban society has always been described as egalitarian, in the sense that there are no social impediments to an Iban achieving high status through his or her own endeavors. Yet the Iban are very status conscious. All Iban families are quite aware of their position and guard it jealously. Genealogies, kept by high-ranking families, trace ancestries through notable leaders back to a mythical past. Marriages are very carefully arranged to ensure that one's children do not marry a member of a lower-status family, especially one that is descended from slaves. Members of lower-status families are often referred to with scorn; they have little influence in longhouse affairs, are the butts of many jests, and often become the scapegoats for mishaps.

In Iban society, men have greater status than women, signified by the way women and inexperienced men are confined to the peripheries of a circle discussing anything of importance. A woman's voice is certainly heard, but it is the arguments of men that critically influence a decision. Within the fraternity of men, status can be achieved in many ways and in diverse fields. It was gained principally through feats of arms, the acquisition of wealth from travels, and leadership in war, and in major migrations in search of fortune into areas hitherto unoccupied by the Iban. An Iban who has never traveled is regarded as lacking experience and resourcefulness, and therefore unlikely to be able to give mature advice about important matters.

Successful war leaders and warriors received praise names to mark their deeds. Likewise, great *pua'* are given praise names. An original design is regarded as "male." Copies are always referred to as "female" (Freeman and Freeman 1950). Praise names given to patterns are legion. Two examples illustrate the metaphors used in textile design work:

Bong midang dudi di lantar, dulu genu genu
Bong penyau dudi ditebang, dulu beduru.
Boat for a voyage rumbling down to be launched
The keel once a trunk creaking before it was felled.

Kandong Ngibong berayah takang isang besembah
Jinga jinga dudok pelasar tikai pandan.
Kandong Ngibong soaring and swooping with palm frond in worship
Sitting bolt upright on a platform covered by a *pandan* mat.

The first corresponds to a design of a war canoe setting off on a quest for heads; the second shows the spirit of lightning winging its way up into the heavens.

Any design given a praise name is a powerful one. Consequently only

experienced weavers are spiritually equipped to weave such a design. Those of little potency are called simply *buah* X (where X is the name of the pattern).

Both the design and praise name of a cloth are revealed to the weaver in a dream from Kumang, a deity who taught the Iban how to weave and dye. The praise name is announced when the *pua'* is formally introduced into a longhouse at a festival commemorating the occasion. The new *pua'* is wrapped in a simple cloth. If the design is an innovative one, a man of distinction will always reveal the cloth. Offerings and invocations are made and a cockerel is slaughtered. The *pua'* is then carefully unwrapped and unfurled by the man, and the praise name announced. Traditionally, the ideal time for this was immediately after a man had returned with a head, which had been received in the new *pua'*. Later, at a ceremony, both man and *pua'* received their praise names together.

A praise name redounds to the credit of the weaver, who becomes known by the names of the great *pua'* she has woven. Like a successful warrior, the woman is referred to by these praise names on formal occasions. A noted weaver, Enyan of the ulu Delok, for example, described receiving a praise name as making her feel the very epitome of Kumang.

Pua' also gain status by traveling. They do this by being given to a man of renown, preferably one living in a distant longhouse. Men of renown are said to "obtain red-dyed *pua'* " and "successfully plunder an enemy's country" *(boleh pua' kumbu, boleh ngerumpak ngagai menoa munsoh)*. The gift is handed over after a formal ceremony that includes invocations and offerings to the gods. The ceremony varies in size depending on the potency of the design of the *pua'*. The higher the status of the man receiving the gift and the more distant he lives from the house of the weaver, the greater the status conferred on the *pua'* and the weaver, whose name and skills travel with the *pua'*. The gift is usually received as a parent would welcome a son returning from his travels, with the words: *"Udah datai, dek, belelang!"* (Ah, so you have arrived from your wanderings!). The reference is not to the cloth, which, by some stretch of the imagination had travelled through time or space, but to the fact that great *pua* are conceived in Panggau and therefore start their life alongside Kumang and the other deities there. Only on the design's being revealed to the woman and then set out on a loom do the *pua'* start their journey to the land of mortals.

What has happened to Iban textile design in the past century? Significant changes have occurred, especially since World War II. At the end of the nineteenth century, with the pacification of most Iban areas and the arrival of traders on a regular basis, prespun threads began to appear for sale in Iban areas. For the Iban, these threads had two great advantages. They

overcame the need to embark on the lengthy process of preparing spun threads from raw cotton. Furthermore, some of the yarns were especially fine (one called *benang gaja* was particularly desired), enabling weavers to produce more refined designs; they could crowd detail on detail without losing any of the essential fluidity of the design. The level of detail achieved with these yarns simply could not be reproduced using the coarser, home-grown cottons.

By 1949, what some would call degenerative changes were just beginning to occur. Where cash crops, Christianity, and the lure of European living standards triumphed, weaving simply died out. In those areas that remained deaf to the pleas of missionaries, the Iban were beginning to find the requirements of what they regarded as good ikat design quite onerous. Although coils in ikat works were extremely attractive, they were crowded together and therefore difficult to tie and retie (Freeman and Freeman 1950). Consequently, a number of changes to textile designs began to appear: although coils did not completely disappear, in many designs they were replaced by other elements. Grosser, bulkier, and more brutish designs maintained traditional elements but enlarged them and placed them in a static format. Predyed threads began to appear in up-country bazaars in the late nineteenth century and were initially used for the borders of *pua'*. As a result, brightly colored borders appeared, in marked contrast to the muted, natural colors predominating in the body of the piece. Predyed yarns also came to be preferred in *sungkit* work, initially because their fineness allowed a much tighter knot and, to a discerning Iban eye, a far more pleasing product.

New colors became popular in *sungkit* work prior to World War II, possibly because they were the only threads available. Since the 1940s, *sungkit* work using natural dyes has virtually disappeared. In its place are cloths with crimson backgrounds and designs generally picked out in yellow and greens rather than in blues, blacks, and the natural color of cotton yarn. Designs generally have become static and cumbersome despite the fact that the materials lend themselves to the fluid patterns of the past. These developments represent a substantial change in the aesthetics of the Iban that has not appealed to the art connoisseurs of the West.

The adoption of aniline dyes was a change much longer in coming because of the resistance of older women. Skill at dyeing, or at least the preparation of the mordant, was what set one woman apart from other women, and all women apart from men. As women's work of the highest ritual order, dyeing was recognized as of the greatest importance in the designation of the consummate master weaver as a woman *tau tar, tau ngakar* (who can dye and prepare the mordant).

Dyes are crucial in this process. However well the yarns are tied, if the dyes fail, the cloth also fails. But problems can arise with fickle natural dyes. Sometimes a fabulous effect is obtained; another year the same procedure may produce quite different results. Consequently, it is believed that divine intercession is essential to exercise absolute command over the parts of the process that are beyond human control. The mordant application, which is critical to achieving a constant red on the yarn, was raised to a ritualized task of the highest order for Iban women.

Because of the central importance of dyeing in an Iban woman's value system, the perpetuation of traditional methods was utterly dependent on the endurance of that value system. With headhunting outlawed, education being deemed more important than the traditional skills, which were becoming less and less relevant, Christianity supplanting traditional beliefs, and a consumer society beckoning, the Iban value system changed quickly and fundamentally. Cash became important for buying the consumer goods that bore witness to a household's success and status. With the advent of outboard motors, chain saws, and fluorescent lights, weaving moved from its central position in Iban life to a peripheral one. Income was generally obtained from cash crops, such as rubber and pepper, whose cultivation required women to work longer hours. With less free time, those women still producing textiles found that aniline dyes presented one more labor-saving device. Occasionally an ambitious woman experimented with a different balance of colors, or a green background, or an airplane pattern in the colors of the Malaysian airlines system. Most simply copied traditional designs and tried to match the traditional dyes as closely as possible using aniline ones.

Gone, then, are the fluid, subtle designs that are so onerous to tie and dye, yet so pleasing to the eye. Gone, too, is the desire of men to wrap themselves in powerful *pua'* in which to sleep and dream, or to have beautiful *pua'* woven to reflect the skills of their household. As a result, contemporary designs are made with purchased, predyed thread.

Educational attainment has become a better indicator of a young woman's marriage prospects than an ability to weave. No longer do young girls sit with their mothers and learn the rudimentary skills. Indeed, a woman exhausted from her travails in the *sawah* or rubber garden is far more likely to turn on the television than to pull out her loom. Weaving has become a quaint oddity, serving in the Balleh region as a means to earn a few dollars on the tourist market for a child's education, or in Sarawak's Second Division as a last handhold on a glorious past.

Can a future be secured for Iban weaving? Certainly the Iban are in a happier situation than the Benuaq of East Kalimantan. Benuaq weaving

virtually died out in the 1960s. Fortunately, in the early 1980s there were still enough Benuaq women who remembered how to weave to resurrect the art form. A concerned government took a number of women to Java, where they spent a week honing their weaving and dyeing skills. They returned and started to provide traditional dresses and jackets for Benuaq dancers, who are often shown on television performing traditional dances. The cloths have been selling in tourist shops and have been the subject of fashion interest—one well-known Jakarta designer created a range of clothes using Benuaq ikat cloths.

It is unlikely that Iban traditions, strong though they are, will be sufficient to ensure the future of weaving unless the activity can present economic opportunities to weavers. The future thus depends on the marketability of the cloths produced. If cloths can command realistic prices, then gifted weavers will produce textiles for the market, and, through their success, encourage younger women to improve their weaving skills.

Traditional Iban cloths can sell for thousands of dollars, but modern ones rarely bring a few hundred dollars. The difference between the old and the new is not one of degradation of skill; there are undoubtedly a number of women who still possess the skills in abundance. The difference in value lies in the aesthetics of the completed cloth. The market sets a premium on the soft, restrained colors of natural dyes. The modern Iban weaver, however, buys brightly colored threads for her *sungkit* work and uses aniline dyes for ikat work, neither of which produces the desirable deep reds and indigos of traditional cloth.

For the Iban, the reds were traditionally the most important colors, and substantial rituals were associated with applying red dyes. Reds were obtained from four sources: *engkudu* root (*Morinda citrifolia*), *beting* (unidentified), *engkerebai* (*Stylocoryne* spp.), or *engkala* leaves (*Litsea garciae*). *Engkudu*, the most popular source of red, was once planted in the vicinity of a longhouse, but it is becoming scarce. Dyeing with *beting* has almost ceased in Sarawak, although Balay Iban in and around Simanggang, in the Second Division, still use it. Weavers themselves only rarely cultivate the plants from which the dyes are extracted. Instead, they buy their natural dyes in powder form from specialist shops. Given the increasing demand for naturally dyed textiles in the West, it would not be difficult to process the indigos, reds, and other colors into powders in Sarawak and provide them to Iban weavers. Predyed threads using natural dyes could also be produced centrally and distributed locally to compete with the bright commercial threads available. It would then be necessary to encourage the Iban to use only these dyes in cloths they produce for the market. Their own aesthetic

predilections could be followed in weaving and dyeing cloths for their own use.

Masks

Masks are no longer made for any functional purpose in Sarawak, as they still are across the border in East Kalimantan. The Balau and Kayan of the upper Mahakam annually perform their *hudog* dancing after the rice has been planted. The Modang, farther downriver, perform their own masked *hudog* dancing just prior to the new farming season. Far to the west, the Kendayaan of West Kalimantan still use fantastic hand-held masks in harvest rituals. All these groups also put on special shows for tourists, and some compete. For example, many Dayak groups meet at an annual festival in Tenggarong, East Kalimantan, where *hudog* dancing is an event, and communities compete as they did in the past.

In Sarawak, the Melanau, the Iban, and the Kenyah and Kayan all traditionally made masks. The Melanau used them in much the same way as the Kayan. At an annual ceremony, held to initiate the fishing season or to assure the fertility of fruit gardens, dancing men and women put on masks to drive away evil spirits. The Melanau masks represent *tou* spirits (Gill 1968), which have the power to frighten off other evil spirits that might attack crops or the fish on which coastal Melanau communities depend for sustenance.

The Iban carved masks for three purposes. They were placed on scarecrows to frighten off birds intent on consuming rice. Masks were also worn during the period of *bebuti* in major festivals, when a kind of carnival atmosphere prevails and each sex dons the other sex's clothes. Men donned masks and set out to terrify the assemblage, especially unmarried girls. Others were used to frighten recalcitrant or mischievous young children.

This third type represents an evil female house spirit who lives in the loft and gobbles up children. The masks are usually worn by older women whose immediate families have no children, so that young children never happen upon a bodiless mask. They vary from painted cross sections of gourds to intricately carved and painted wooden masks. Most have wide staring eyes and an open mouth with teeth bared and lips everted; great prominence is usually given to the teeth. The hair of the mask wearer is covered by a cloth. The mask wearer peers from around a door or through an opening into the loft and moans at the child. Most children are transfixed with fear at seeing the apparition before running for protection to a parent or caretaker.

Kenyah and Kayan masks (called *hudog*, as are the figures placed outside longhouses to prevent the entry of sickness) operated in the spiritual world. Once the weeding was finished and the rice had begun to mature, all that could be done to assist the growing rice was to guard the fields from attack by pests. The Kenyah and Kayan protected the crop with a ceremony called *adat lemimpa*. On the second day of a three-day festival, wooden bull-roarers were made. A boat that had been used the previous day in a cleansing ritual was taken to the fields and filled with water. At each rice farm, the water was sprinkled over the field so that the rice spirits would drink and prosper. During this ritual, many men wore masks representing the rice spirits. They would proceed to the margins of the fields, calling to all the evil spirits to come and eat. Thereupon they would leave food for the spirits. Having given the spirits time to eat, the leaders would tell them to go away and not destroy the fields so that the people could prosper. According to Kenyah/ Kayan belief, once someone eats food offered by another, he will be super- naturally accursed if he later attacks the person who offered the food; spirits are believed to suffer similarly.

Once the ceremonies in the fields were finished and the participants had returned to the longhouse, they would put on highly decorated *hudog* masks. Unlike those representing the rice spirits, these masks were meant to frighten. They generally were painted in an aggressive style, with staring eyes, hyper- trophied ears, and open mouths, with the lines accentuated by pointillist dots. The *hudog* masks were the Kenyah's means of frightening away evil spir- its likely to attack the growing rice. The spectators not wearing the masks, by analogy, represented these spirits, and the mask wearers would try to terrify the spectators into taking flight. The mask wearers usually also carried staffs, with which they struck anyone bold enough not to flee.

The final act in this festival secures the fertility of the growing rice. Once the dance ground is deserted, the masked dancers repair to the river and collect containers of water. Still masked, they proceed from apartment to apartment, sprinkling the inhabitants with fertilizing and cleansing water. The gods are invoked to grant abundance and prosperity, and the mood of the house gathers in confidence.

After this ceremony was over, a huge *hudog* in the form of a dragon or crocodile made its entrance, representing future prosperity. The body con- sisted of up to forty people. It entered each house (Kenyah villages tradition- ally consisted of contiguous longhouses) and made its way to the headman's apartment, where it performed a dance. The headman then presented the figure with a plate of food and invited it to eat, while at the same time invoking the gods to ensure a bountiful supply of rice and game. The head- man then asked the *hudog*, had it ensured that all the community's needs

would be met? Yes, said the *hudog*. Had it ensured that the community would live in prosperity? Yes, replied the *hudog*. The interrogation over, the *hudog* retired, and the festival closed.

Among the Bahau, Kayan, and Modang of the Mahakam, masks and dancing are closely related, as they are on Java and Bali. The Kenyah/ Kayan masks described above and the Iban masks used during *bebuti* are for entertainment. However, a whole repertoire of masked dances was once performed by the Kayan and Kenyah (Revel-Macdonald 1978). In one, the wearer imitated the actions of whatever animal or spirit the mask represented. A gifted actor demonstrated his detailed knowledge of the behavior of the animal or spirit he was imitating.

Such performances undoubtedly appeal more widely than to a local group residing in a longhouse, and there are undoubtedly many men and women who can still use masks in mime and dance to put on entertaining performances. Today, however, such performances hardly ever occur, and the tradition is virtually dead. The Kayan, Kenyah, and Iban masks made today are sold in tourist shops.

Beyond their ritual uses, the power of the masks to divert and to entertain cannot be underestimated. The performances occur in a carnival-like atmosphere during periods of uncertainty in the rice cycle. These are times when people need reassurance. If the weather has been inclement or the rice has been attacked by pests or disease, any diversion to take a household's mind off the possibility of a crop failure is welcome.

The overriding impression of anyone seeing the masks in action is the enormous fun that people get out of them. Working in the upper reaches of the Mahakam, I had to promise my crew that we would be back at their houses so that they could dance as *hudog*. And yet when I suggested that we go elsewhere to watch other *hudog* in action, there was not the same enthusiasm. Like all good actors, the dancers certainly achieve some sort of power over their audience. This is particularly obvious on those occasions when masks are put on to terrify. But there is something else. Sweating profusely under their suffocatingly hot costumes, the *hudog* dancers transcend the physical discomforts and experience something in a different realm. Such experiences appear to be incompatible with modern beliefs and monotheistic religion.

Notes and References

Editor's note: This chapter is revised and adapted by the volume editor and the author from Heppell's article "Whither Dayak Art?" (*Sarawak Museum Journal* vol. 40, no. 4, part 1 [Dec. 1989]: 75–91 and Plates IV–XII).

Chong, Chin Seng
1987 *Traditional Melanau Woodcarving (Bilum) in Dalat, Sarawak*. Kuala Lumpur: Persatuan Kesusasteraan Sarawak.
Freeman, Derek, and Monica Freeman
1950 "Ethnographic Notes on Iban Weaving." Manuscript in author's possession.
Gill, Sarah
1968 "A Survey of Sarawak Art." Ph.D. diss., Cornell University, Ithaca, N.Y.
Masing, J.
1980 "The Coming of the Gods." Ph.D. diss., Australian National University, Canberra.
Morris, S.
1953 *Report on the Melanau Sago Producing Community in Sarawak*. Great Britain Colonial Office. Colonial Research Studies 9. London.
Revel-Macdonald, Nicole
1978 "La danse des 'hudoq' (Kalimantan Timur)." *Objets et mondes* 18 (1–2): 31–44.

9 Unraveling Narratives

SHELLY ERRINGTON

On the Indonesian island of Sulawesi there lies a mysterious mountain plateau, Torajaland. Isolated from the outside world, the customs and rituals of the Torajan people have changed little for hundreds of years. According to legend, the first Torajans descended from heaven, on a great ladder which reached down to earth. So now, when someone passes on, their relatives help them make it back to heaven again. After an elaborate funeral ceremony, they climb swaying bamboo ladders, and place the coffins in caves, high up on the limestone cliff faces. Halfway to heaven. Then a carved wooden effigy (or *tau tau*) of the deceased is placed in a balcony, so the spirit can forever watch over the village. Today, it is possible to visit the lost world of the Toraja. A journey through time itself.

This text accompanies a 1990 Garuda Indonesia airlines advertisement (fig. 1), promising a glimpse of exotica for potential American tourists to Torajaland, Indonesia: a "mysterious" plateau, evoking Shangri-la; people "isolated from the outside world"; unchanging customs hundreds of years old; strange and pristine beliefs involving legends, ancestors, and ancient rituals still practiced; and, finally, the possibility of visiting this "lost world," which promises to be a "journey through time itself."

Buying "authentic" and "traditional," and preferably beautiful, rare, and sacred objects is one of the pleasures of tourism. Another Garuda airlines advertisement (fig. 2) reads "The best souvenirs of Indonesia have had previous owners." Many of the items it depicts as potential souvenirs are objects used in rituals.

At first glance, these advertisements provide us with nothing more than yet another text for the study of the Euro-American desire to be in contact with untouched peoples who live in a mystical, enchanted world in a time prior to money, pollution, and all the evils that beset us—prior to modernity, in sum, and therefore prior to "time." (That's why the visit is a [backwards] "journey through time itself.") "Cultural tourism," travel to observe a different people's way of life (thereby to experience it vicariously, but without the work, poverty, or uncertainty of real life), promises to put the tourist in touch with these supposedly idyllic and harmonious societies presumed to be so unlike our own.

Yet the story that knowledgeable readers can glimpse in the Toraja advertisement is far more complex than that, for the *tau tau*, the effigies staring

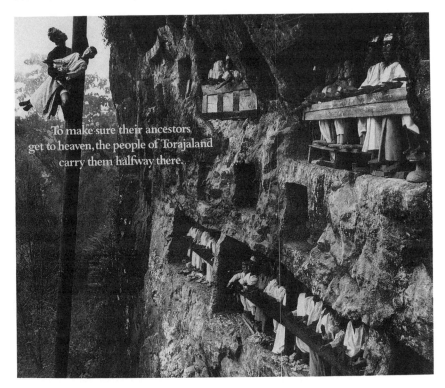

Fig. 1. Advertisement for Garuda Indonesia airlines. Reproduced by permission of Garuda Indonesia.

out from the cliff face in the glossy picture, are recently and poorly carved, of the wrong kind of wood, and they have never been part of an elaborate funeral.

The replacements, or fake *tau tau*, were installed because the older "real" *tau tau* had been stolen, leaving gaping holes. These vacancies had disturbed tourists, making them feel cheated. Prompted by the minister of tourism of the central government, local Toraja officials had the new carvings made and installed.[1] These newly installed, fake *tau tau* satisfy the requirements of full-color advertisements and, presumably, satisfy tourists, who know no better. Eric Crystal's essay in this volume tells us about the events leading up to the installation of the fake *tau tau*, chronicling the rapid depletion of real *tau tau* in the cliffs in a period of about fifteen years. Besides on the Toraja cliffs real *tau tau* can now be found hidden in well-disguised caves by Toraja people who fear their theft and in museums and primitive art galleries in Los Angeles and other Western cities.

Advertisements like these, which seem a simple case of an advertising

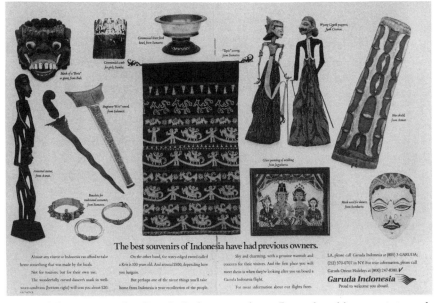

Fig. 2. Advertisement for Garuda Indonesia airlines. Reproduced by permission of Garuda Indonesia.

agency's effort to sell cultural tourism by tapping into Western desires to romanticize "simpler" peoples, actually require a complex social and historical reading of the Toraja people's current circumstances. To "read" these ads fully we need some knowledge of Indonesia, its government's policies toward the great diversity of peoples that compose the nation, its place in the global economy, and its efforts to preserve its material heritage in a new state-sponsored museum system; and, not least, we require some understanding of the international art market.

The essays collected in this volume provide some of the background that is needed to unpack the meanings of advertisements like these. Each tells part of a story: the effects of the international art market on particular cultures' ceremonial lives; the market's differential effects in selecting some objects as "art" while leaving others, and in encouraging some craft skills and not others; the policies of the Indonesian government in promoting "development," tourism, and a museum system; the efforts of well-meaning and knowledgeable collectors in helping to preserve objects. They are all informative, and some are illuminating. My contribution here is to provide a larger context for these essays, a context consisting of some of the ways that art, "primitive art," and national heritage have been talked about.

Many of the accounts and representations that circulate about non-Western arts that touch on the fates of "traditional" objects from the non-West-

ern world—whether the accounts be histories, case studies, policy statements, advertisements, or guidebooks—are embedded in the encompassing meta-narratives invented in Europe in the nineteenth century about progress. The point of the story of progress in the nineteenth century was to cast European civilization and technology as the peak of the unfolding of time and history. The twentieth-century avatar of these progressivist tales is the modernization narrative, whose theme is that time and history, like a bus, are going somewhere, and everyone has to get on the bus or be left behind. (See Clifford 1987 for a succinct statement on this point.) Some representations show a certain nostalgia for the "primitive," like the advertisement I began with; some are regretful or outraged; others remain cheerful, suggesting that change is inevitable and the best should be made of it; others are calls to action. Most of these stances are represented in varying degrees in this volume. Virtually all assume that "modernization" is inevitable.

After first sketching the major themes and some variations on the idea of progress, I will consider some other ways of accounting for the fates of traditional Indonesian objects in the late twentieth century. One of the larger points I want to make is that the universality of the idea of "Art" becomes a self-fulfilling prophecy, which sometimes works to the detriment of the peoples whose objects are avidly collected and honored as "art" objects. Another point that I trust will emerge is that the modernization narrative is not just an account of how things really are but is, rather, a tool or instrument that makes things become the way they are asserted to be. "Primitive" peoples and their arts and handicrafts do not "disappear" because of "progress"; rather, they are *made to* disappear as a result, sometimes unintended, of government policies. This fact is well understood and pointed out in several of the essays collected here.

Before and After Stories

One of the simplest ways to tell a single story about Indonesian art is as a before-and-after unidirectional tale (actually a fuller version of the advertisement I began with): *before,* the people of Indonesia (or wherever) lived a life in harmony with nature, making beautiful and sacred objects, which they used in their rites and ceremonies; *after,* Western civilization intruded, spoiling their natural idyll by introducing change (therefore, time) and money. The special twist of the tourist version is that you can visit these places before they are completely "spoiled" if you hurry.

Many Marxist accounts follow a similar script: *Before,* precapitalist economic formations were idylls of community and reciprocity; *after,* the cor-

rupting West, with its global markets and filthy lucre, bought up the communities' sacred objects and converted them into mere commodities. Thus Marxists classically viewed precapitalist formations with some ambivalence: things must get worse for these people before they can get better, for their idyll must be smashed so that they can pass through the stage of capitalism and thence make the revolution against it.

Some versions of this Marxist narrative parallel and grow from the same soil as the story of social evolution. It originated in nineteenth-century Europe. In the first half of the century, the idea of historical time as a continuous and progressive unfolding of long duration was being invented; this emerging notion of time is evident in Hegel's theory of history and in then-new hypotheses explaining the meaning of geological strata. By the second half of the century, the notion of gradual, continuous, unidirectional, and progressive temporal unfolding was applied to virtually all fields of knowledge; they became the accepted, mainstream, scientific way to account for differences among observed entities (e.g., species, races, civilizations). Thus nineteenth-century social theories tended to cast time, like an Aristotelian drama, as having a beginning, middle, and apex-end, and produced numerous theories of social development as three progressive phases: feudalism, capitalism, communism; magic, religion, science; early, middle, late; primitive, archaic, modern. These progressivist stories cast Europe as the peak of civilization. The European past and non-European societies, for their part, constituted in these narratives lower and earlier forms of life, destined to disappear, whose teleological meaning of existence was to be the precursor of the peak. The irony was that this social theory was, in fact, becoming true, because Europe's peasants, representatives of the feudal and agrarian past, were rapidly disappearing by being transformed into the urban proletariate. At the same time, exemplars of non-European social orders, in the form of Africans, Asians, Americans, and Pacific Islanders, were rapidly becoming colonized subjects. And so life confirmed meta-narrative then as now, by being forced willy-nilly to conform to that narrative, whether it (the proletarianized folk, the colonized Africans) wished to or not.

The modernization story is the same story, recycled for the twentieth century, as social evolutionism and progressivist liberalism. The idea is that low-technology, nonliterate (called "preliterate," as though they were destined to become literate), small-scale societies are doomed, for History is moving in a single direction, toward "modernity," which consists of high-capital investment enterprises, a monetized economy, political organization in the form of the nation-state, a secular, rational approach to life, and so forth. Backwards, primitive peoples live in the Stone Age and must develop, else they will be left behind, the story goes.

Where does the "primitive" fit in these meta-narratives? Not just Marxists but it seems the whole of Western civilization views the "primitive" with ambivalence. The notion of the untouched, harmonious idyll is an old topos in Western thought: the Romans had Virgil's Arcadia; the Middle Ages had the earthly paradise; the eighteenth century had the pastoral. For that matter, Club Med advertises itself as "the antidote to civilization." Yet the nineteenth-century story of progress and its twentieth-century avatar, the notion of modernization, put this idyll firmly at the bottom of the evolutionary ladder. During much of the nineteenth century and well into the twentieth, these "primitives" were regarded as savage, brutal, and heathen, and their imminent disappearance was generally thought to be a good thing. In the late twentieth century, by contrast, their existence is regarded with romantic nostalgia (as in the airlines ad). If they have not quite disappeared, their demise, due to the forces of modernization, tends to be regarded as inevitable.

Stories like these depend upon the notion of the "primitive," because the universal line of time needs a starting point from which to measure change and progress. If the "primitive" did not exist, it would have to be invented.

In recent years, the notion of the "primitive" has been widely discussed and deconstructed (see Torgovnick 1990), and the associations brought to mind by the term "primitive art" have been similarly attacked (see Price 1989). James Clifford (1988) has undermined the essentialist notion of Primitive Art by discussing the taxonomic shift that occurred at the turn of the twentieth century, which allowed the reclassification of "material culture" as "primitive art." Here I do not want to dwell on deconstructing the idea of the "primitive," which has (in some circles) been thoroughly accomplished, but to turn my attention to the idea of "art," particularly to the idea that art is universal and therefore can be found in distant times and climes, like the mountains of Sulawesi or the forests of Borneo.

Walter Benjamin's Story of Art

Toraja *tau tau*, African masks, New Ireland Malanggans, Aztec gold—how can all these things be classified as one thing, as types of "art"? Collectors, dealers, and art historians often answer that what makes an object art, and what distinguishes art from mere craft or artifact, is that "art" has a "transcendent" quality. Those enthusiasts of Primitive Art who talk about the "transcendent" qualities of art are usually more influenced by Hegel than by Marx, but a convenient starting place for the points I want to make is the insightful and influential account of the origins and development of art by the Marxist critic Walter Benjamin. Benjamin writes not of "transcen-

dence" but of "cult objects" that have "auras." These notions are close enough for my purposes. In "The Work of Art in the Age of Mechanical Reproduction" (1969 [c. 1955]), Benjamin's story goes something like this:

Originally, "the earliest art works originated in the service of a ritual— first the magical, then the religious kind." As an example, Benjamin mentions an ancient statue of Venus, made an object of veneration by the Greeks. He calls such works of art "cult objects." Cult objects had an "aura," which Benjamin defines as "a unique phenomenon of distance, however close it may be," and goes on to point out that "distance is the opposite of closeness. The essentially distant object is the unapproachable one. Unapproachability is indeed a major quality of the cult image" (243 n. 5).

The cult value originates in the work of art's sacred status for its community of worshipers; the piece may be beautiful, but it need not be, and it need not be often seen: "What mattered was their existence, not their being on view." He goes on: "The elk portrayed by the man of the Stone Age on the walls of his cave was an instrument of magic. He did expose it to his fellow men, but in the main it was meant for the spirits." Similarly, albeit historically later, "Madonnas remained covered nearly all year round; certain sculptures on medieval cathedrals are invisible to the spectator on ground level" (224–225).

Benjamin very usefully distinguishes between the cult value and the exhibition value of a work of art, which are sometimes in conflict. Gradually, his story goes, works of art were liberated from ritual practices; nonetheless, many were fixed in place or restricted in use, this fixity helping to preserve their auras. Eventually, works of art became more mobile, and that seems to have tipped the scale toward works of art being valued primarily or largely because of their exhibition value: "It is easier to exhibit a portrait bust that can be sent here and there than to exhibit the statue of a divinity that has its fixed place in the interior of a temple. The same thing holds for the painting as against the mosaic or fresco that preceded it" (225). Although works of art always retain some "aura," secular pieces are made to be viewed, and have been designed and worked to be aesthetically pleasing. Their exhibition value rather than their cult value is primary.

In short, Benjamin postulates a panhistorical category, "works of art," with two poles of value, the cult value and the exhibition value. Aura diminishes continuously and unidirectionally from the aura-saturated cult item. It never fully disappears in works of art, according to Benjamin, but their aura has declined in the modern age, particularly with the advent of mechanical replication through photography and films.

A contemporary reader of this essay is struck by the complete absence of

a mention of commodification, which in years of late loomed much larger than production in the analysis of objects, images, and images-as-objects, a study that Benjamin's essay helped to inspire. But the useful distinction for the moment is Benjamin's comparison of the cult value and exhibition value of a work of art.

The story Benjamin tells depends on the use of the panhistorical category works of art. Without it, he could not tell a unidirectional story about the change in status of works of art, from cult object to secular work of art, with aura as well as exhibition value, and finally to multiple copies depleted of aura and uniqueness.

Rather than imagine, as Benjamin does, the panhistorical category with two poles, let us envisage two classes of objects, the cult object and the work of art. If we view our topic not as one phenomenon but as two socially constructed and separate categories of classification, the story we tell about them will necessarily be different. It will not be a continuous narrative about changes in value, but a disrupted one of categories that impinge on and intersect each other.

The issue is how some cult objects but not others became and become absorbed into the category "art." This telling requires identifying each of those categories as social and historical practices, and it requires an account of the power of the market and the force of cultural categorization.

What Are Cult Objects?

What we can conveniently call "cult objects" in Indonesia can be identified in two ways. First, they are, as Benjamin puts it, unapproachable, distant even when near, and they should be treated with respect. In Indonesia, such objects are often believed to be inhabited by spirits, and offerings may be made to them regularly. They include gold family heirlooms and jewelry, believed to be inhabited by spirits or saturated with the soul of the ancestor; wooden effigies of the dead, placed after an elaborate ceremony on high cliffs; carefully worked textiles, used only for marriage exchange; or puppet figures, used in performances directed to a spirit audience, but around which humans are allowed to gather as well; and temples into which the spirits descend and which they inhabit on ritual occasions.

Second, either they are located in a fixed place from which they are almost never moved (in a family's ancestral house, in the temple, or high in the cliffs), or they circulate rarely, only on ceremonial occasions, and the objects for which they can be exchanged are limited in type. Typically, they had no price in money, and they were either unexchangeable or exchangeable only for very restricted types of other ritual objects considered their peers.

An example of the first are the *tau tau*. After being placed in the Toraja cliffs, they are left many years to deteriorate. They may be removed in order to be refurbished and put back, but that process constitutes a ritual cleansing, not a displacement. Their destiny, as it were, is to stay still forever, and not to be exchanged for anything.

An example of the second are the textiles used in marriage ceremonies in the Lamaholot region of the Lesser Sunda Islands. Certain of their threads are not cut, a process that must normally be done before a cloth can be worn. These uncut threads both prevent the marriage cloths' being worn and are a sign of their distance from everyday uses. Their sole purpose, for which they are crucial, is to be exchanged on the occasion of marriage ("Without cloth we cannot marry!"); but they are exchanged for only one other sort of item: elephant tusks.

Cult objects in Indonesia are often intricately worked and attractive, a sign of their value to the people who made them. Yet they need not be beautiful. Consider, for instance, the royal regalia possessed by the rulers and courts of the historical Indic states of the area, such as Bali, Java, and the Bugis-Makassar areas of South Sulawesi. The regalia consisted of a collection of objects said to have descended from the Upper World with the founders of the first dynasties of each realm, and added to by subsequent rulers. This collection of objects might include not only ancestral gold jewelry and betel boxes but also ancient torn silk flags, skulls or teeth, porcelain from China (sometimes in disrepair), and other generally motley, to Western eyes, items. Yet these were the sacred regalia of the realm on which prosperity and peace were thought to depend. All were cult objects, but only a few were made of costly materials and only a few would strike either Westerners or the people of these realms as beautiful.[2]

Sacred objects such as regalia, ancestor effigies, temples, and ceremonial cloth may indeed be made of precious materials, and carefully and intricately worked. Yet these objects were not made primarily for their "exhibition value" or for aesthetic contemplation. Their point was to exist.

With little emphasis on exhibition or exchange, there was little concern to preserve sacred objects in a "beautiful" pristine state. Consequently they could be allowed to deteriorate. And they could be replaced, because more could be carved or woven.

These things were and to some degree still are cult objects. Art objects are something else.

What Is Art?

If "cult objects," loosely defined, can be recognized in many different societies because they are treated as having special powers and because they

participate in highly restricted circuits of exchange or none at all, how can we recognize an "art object"?

Art objects have exhibition value, as Benjamin points out, and that value is based largely on their being beautiful, an idea that itself ought to be explored. But the term "exhibition value" tells only part of the story. I would suggest that "art" is a historical category, not a Platonic one valid for all times and climes, and that it emerged gradually in the West over a period of several centuries.

The Greeks invented art if we think of art as a mimetic representation or copy of something in the world. Romans refined the notion and practice of art; they were great collectors (and incidentally looters and forgers) of art objects, and without collecting, art as the social phenomenon we know would not exist.

The Renaissance refined the concept and practice of art in several ways. One was by inventing the modern frame, which does two things. It encloses and therefore isolates the art object from its surroundings ("the world"), thereby promoting the object's movability. And it reveals the fact that the work of art is not made for a single fixed place, such as a temple or cathedral, but can be hung on any wall, and in any place. An object that can be moved around is more easily commodified than something whose place is fixed. Art as we know it is a commodity, very much exchangeable for something else, usually money. Another Renaissance contribution to the developing idea of art was the invention of the individual artistic genius.

What we define as art emerged full-blown in the eighteenth century, when three important events occurred. First, a distinction was made between art and craft. Anything of utility became craft, a lower form of artifact. Second, Kant theorized art to be useless beautiful objects suitable for individual contemplation. And third, the auction houses of Sotheby's and Christie's were founded. These institutions' activities both facilitated the identification of art as useless, commodifiable objects and helped constitute it as such.

European history from the nineteenth century to the present played out and further developed these notions and practices. The most important events were the linearization of the story of art and the entrance of more and more objects into the category.

The linearization of the history of art should be seen, of course, within the general linearization and historicization of the past and of the natural world, perfected in the nineteenth century—from the invention of archaeology and geological time in the first half of the century, to Hegel's and then Marx's progressivist stories of the past, to Darwin and social Darwinists' tales of evolution from simple to complex. In that century, too, art history took form as a linear narrative.[3]

The second event, especially significant for any accounts we might wish to give of Indonesian "art" within European markets, is that more and more objects have entered the category "art." This story is told briefly but lucidly by Joseph Alsop in *The Rare Art Traditions: The History of Art Collecting and Its Linked Phenomena Wherever These Have Appeared* (1982). Alsop points out that the Renaissance developed a canon combining realism and beauty, which was enforced by taste and the market until the nineteenth century. Since then, what counts as art has been expanded and changed in three revolutions in "ways of seeing."[4] Each "revolution in seeing," the first of which he dates from the early nineteenth century, undermined and finally destroyed the Renaissance canon, and has consequently brought different (and usually more) sorts of objects into the category "art." Alsop's commentary on "primitive art" is especially vivid and succinct:

> With the former canon abandoned, in fact, all art gradually became equal—although some people's art has never ceased to be more equal than other people's. Group by group, culture after culture, the products of all the known non-Western cultures, whether surviving above ground or wrenched from the shelter of the silent earth, were scrutinized anew with altered eyes. Grimy archeological finds and obscure ethnographical specimens, curios from family whatnots, souvenirs of life on far frontiers, and loot from half-forgotten military expeditions to the remoter corners of the globe—all these came to be seen as works of art deserving the grave, minute attention of art historians, the angry rivalry of art collectors, and the more polite but no less cutthroat pursuit of museum curators. In the upshot, the descendant of the obscurest British officer who brought back bronzes from the sack of Benin in 1897 became a luckier man by far than the inheritor of the Greco-Roman marbles eagerly, expensively collected by one of the greatest Whig grandees of eighteenth-century England. And as these words are written, New York's Metropolitan Museum is building a whole wing to be devoted to "primitive art." (Alsop 1982:13–14)

In sum, the story of the notion and practice of art has a number of parts, which merged over centuries in the West: the ideas that art objects are different from the world, that they are useless, that they are commodities. Some commentators, in an effort to argue that the notion of art is universal, have located a definition in one or two concepts and practices, such as mystical power or the ability of all humans to make aesthetically pleasing patterns. I would argue, by contrast, that art cannot be located in any one or two of its concepts and practices but only in the aggregate. Although these pieces of the story can be disaggregated analytically and historically, they together constitute art as we know it.

Some items that find their way into museums and the art market may conform to most or many of these notions and practices but not all of them. As a result, although the center of "art" has never been in doubt (it remains

Renaissance paintings), there may be debate at the borders, when objects conform to some but not all of art's constituent components.

Consequently, I do not view art as a universally valid category, discoverable anywhere and any time retrospectively, but as a culturally and historically specific phenomenon. One of the curious things about art, however, as a cultural category and practice, is that it tends to absorb objects selectively into itself, thus becoming a self-fulfilling prophecy and making itself appear universal.

Art as a Self-Fulfilling Prophecy

I have argued that cult objects and art objects should be regarded as different things, because the concepts and practices that constitute each are quite different. Benjamin regards them as one entity with two poles—cult value and exhibition value—that are very different, even contradictory: the cult object need not be beautiful, whereas secular art objects are preferably both beautiful and well preserved. Benjamin implies that the conflict is even more extreme: being on view may help turn cult objects into secular objects —after all, allowing them to be "up close" instead of "distant" lessens their "aura."

Even though countless works in Western museums are former cult objects, such as religious paraphernalia looted from cathedrals, we do not usually notice the contradiction between their cult and exhibition value, because "this polarity," Benjamin writes, "cannot come into its own in the aesthetics of Idealism. Its idea of beauty comprises these polar opposites without differentiating between them and consequently excludes their polarity" (1969: 244 n. 8). This statement strikes me as a brilliant insight: When contemplating what we call works of art, we usually do not notice the contradiction between these two poles, or, as I would put it, these two categories, because they are reconciled in Hegelian idealist aesthetics. In this aesthetic theory, what is beautiful should be charged with meaning, an expression of Absolute Spirit, and what is charged with meaning should be beautiful.

This idea about art becomes a self-fulfilling prophecy when collectors and dealers select some but not all of the world's myriad objects to become "art." The market selects not only those that are ritually significant, but those that are beautiful; not only those that are beautiful, but those that are ritually significant.

Because "primitive art" is the last large subgroup of objects to penetrate the permeable borders of the category of art after the collapse of the Renaissance canon, we can see the process of art as a self-fulfilling prophecy quite

clearly by observing which cult objects from outside the West can become art and which ones meet resistance or are left behind. Elsewhere I have argued (Errington, 1994) that an implicit hierarchy exists that selects from the world of objects things to become "art" on the market and for museums. Art is preferably portable (paintings preferred to megaliths), durable (bronze preferred to basketry), useless for practical purposes in the secular West (ancestral effigies and Byzantine icons preferred to hoes and grain grinders), representational or at least iconic (human and animal figures preferred to, say, heavily decorated ritual bowls). Objects from Europe's past as well as "traditional" objects from places outside the European tradition can be included.

The question we can ask, then, is What happens when cult objects, unapproachable and sacred, sometimes ugly, often deteriorating, fixed spatially or movable only in very restricted circuits of exchangeability, meet the category of Western art? The brief answer is that objects that conform to many of the ideas and practices that constitute art will be selected for the art market; others become curiosities and antiquities in the international object market (which is larger than the art market); and still others will be left behind in the village, perhaps continuing as cult objects, perhaps becoming trash.

In Nusa Tenggara Timor for instance, as Ruth Barnes explains in her essay, both textiles and elephant tusks were cult objects, exchangeable for each other in marriage ceremonies; but only textiles became art objects for the art market. (For one thing, whereas textile museums do exist in Euro-America, elephant tusk museums do not; nor do we have museums of "objects once upon a time exchanged for textiles in various cultures.") The tusks may become curiosities or antiquities but probably not art. Stories of artifacts becoming art objects are told by several essays in this volume. In Torajaland and Nias (see Eric Crystal and Jerome Feldman, respectively), ancestral figures become art-market objects more often than do nonrepresentational objects from those places. Textiles, although having their devotees, are less obviously art objects than these ancestral effigies are, partly because they are not as durable and partly because of their association with the practical and decorative (craft as opposed to art, after the eighteenth century separation); yet beautiful textiles of ritual value enter the art market, whereas elephant tusks, their counterparts in indigenous exchange, may be left behind. Among the Iban, as Michael Heppell notes, beautiful old natural-dye weavings have become collector's items in the art market, whereas other crafts, unassimilated or unassimilatable as "art," such as Iban potting, iron forging, and etching and dyeing bamboo, have "died out."

Death, Authenticity, and Value

One possibility: People who once produced cult objects but who convert to Christianity or Islam thenceforth have no use for these things. Those who produced the cult objects die, and no one else learns the craft skills; hence the skills "die out." Another possibility: The ritual still flourishes, but the local society's participation in a money economy makes the people newly aware of the cost of labor, and they find it convenient to make cult objects for their own ritual uses more quickly than they made the old ones. The new cult objects, although "authentic" in the sense of being real ritual objects, are not so fine or beautiful as the older ones. On the art market, they are designated "of inferior quality." Yet another possibility: People retain some of the craft skills they used to produce cult objects, but they start using them to produce objects for the outside market (tourist art, souvenirs). And yet another: The cult objects are stolen and cannot be replaced.

The upshot of any of these paths to modernity is that intricately worked cult objects are no longer being produced, or are produced in very small quantities compared to the demands of the international object market. That lack of supply, coupled with a huge demand, deeply affects their price. Objects no longer being made are much higher in value than things that are. Alsop has put it very succinctly:

> On the most superficial level, it is a truism of the art market that the works of a dead but still-admired master are more valued than the works of a master still alive and currently productive. Death limits the supply; the law of supply and demand begins to operate; and so $2,000,000 comes to be paid for a Jackson Pollock, significantly described as one of the last of Pollock's major works to be available, In the same fashion, collectors', museums', and the market's interest in American Indian artifacts has been growing rapidly for a good many decades. Yet it seems most unlikely that this would be the case if the West were still dotted with trading posts where an illegal bottle of rotgut could still be exchanged for admirable examples of quill work and beadwork, featherwork, blankets, pottery, woodcarvings, and the like. While that was the situation, no one was interested in Indian artifacts except for a tiny number of ethnologically minded persons. (Alsop 1982:22)

This story is the reverse of the one about killing the goose that laid the golden egg. In art, the egg does not turn into gold until the goose dies.

Moribund "Arts" as a Self-Fulfilling Prophecy

To say crafts have "died out" makes it seem that social change toward "modernity" (such as a society's adoption of a cash economy or a world reli-

gion, or its participation in the nation-state and, indirectly, in the global economic system) is a natural process, analogous to biological processes of birth, growth, and death. The implicit notion behind metaphors like this is that world history is going somewhere—toward "modernity"—and that cultures and societies that do not step onto the road leading toward modernity will be "left behind" and disappear.

To imagine that the cultures and ways of life of marginal or impotent peoples who now find themselves within nation-states (rather to their surprise and often dismay) "disappear with the coming of modernity" is rather like saying that tropical rain forests also disappear, as though *Imperata* grass invaded and replaced dripping wet, densely growing flora of its own accord as part of a natural and inevitable process beyond the reach of human agency. Saying that rain forests disappear with the advent of modernity obscures the fact that they are cut down by lumber companies in collusion with the government of the nation-state in question, or that extensive fires occur because of clear-cutting.

Holding the belief that the culture is "dead", or that crafts die out as a natural process, has certain obvious psychological benefits for dealers, collectors, thieves, and governments, enabling them to ignore the fact that the looting of the cult objects may in fact hasten the culture's "demise," and, even if it does not, may simply be theft. Understandably, many dealers and collectors, who may well never have been to the societies that are the sources of the objects they deal in, tend to think that these societies are defunct. Toby Volkman mentions being in an art gallery in New York that exhibited a *tau tau*, labeled "Toraja: Figure." Having done anthropological field work in Torajaland, Volkman knew that all *tau tau* on the market have been stolen and spirited out of the area, for *tau tau* are not "art" and were not made for exchange; she also knows the pain these thefts cause the living Toraja. When she "asked the gallery owner about the provenance and meaning of [this sculpture], he assured [her]: 'The culture isn't really living anymore' " (Volkman 1990:99).

The gallery owner's ingenuousness seems to me related to the way the meta-narrative of modernity constructs "the primitive" as "the past." Just as in nineteenth-century evolutionist visions of the progress of human history, even "living" peoples and cultures are considered "archaic," a kind of pristine primitive in touch with the earliest "stages" of "Man"-kind's evolution as a whole—think of the many descriptions of non-Western peoples as Stone Age people entering the twentieth century and the like. "Stone Age" people may still be living, but they are "caught" in a previous era of time. Thus living peoples are classified as already "past," ready to disappear at any moment and charted for death. Nothing can be done in the way of artificial respiration, and hastening their demise can be no great crime.

Holding such beliefs has obvious psychological and policy benefits for governments, particularly if the government is controlled by individuals in an ethnic group or religion different from the ones whose crafts or ways of life are "dying out." Such a belief on the part of policy makers disguises to them as well as to foreign governments, foundations, and agencies the fact that these societies and their crafts and cult objects are *made* to "die out" as a result or side effect of government policies rather than as a "natural" process.

Laurence Moss implies this same analogy in his essay when he compares the cultural riches of Indonesia to a natural resource, and likens the government's policy of encouraging tourism, without controls, management, or plans for replenishment or preservation, to unplanned exploitation. It is sadly evident in many parts of Indonesia.

Michael Heppell speaks to this issue here as well, noting that a Javanese sculptor, not an Iban, was commissioned to make a sculpture of dolphins on a new bridge, and even the Dayak figures at the entrances of a famous longhouse were carved by Javanese and Buginese imported for the purpose. Thus, although the skills and tools still exist, Iban carvers do not have the opportunity or market to exercise their craft. Certainly this skill will "die out," but it can hardly be called a natural consequence of the march toward modernity. Policies could be instituted that would encourage these carvers and their crafts.

By the same token, Javanese dancers from major urban and cultural centers learn the dances of peoples of the "outer islands" (that is, not Java) and perform them on foreign tours and in the capital, absorbing them into their own repertoire as a "style." People of the "outer islands," although glad to see themselves represented on the national and international arts scene, tend to feel that something has been stolen from them. Local dances, even as "skills" and "styles," never mind as sacred events, will surely "die out" when the arena for performing them diminishes to nothing.

I call this general process "cultural strip mining," in which the shortest possible view is taken of "culture" as an economic resource, and policies are instituted for short-term profit that virtually guarantee the destruction of what is there at the present.

The strange irony, however, is that like the idea of art itself, "modernity" is a self-fulfilling prophecy. In the path of this ideology, ways of life do not "disappear" but are made to disappear, and it generally happens without much protest, because "You can't stop progress."

Preserving the Exhibition Value of a Work of Art

The small number of "authentic" "traditional" "sacred" objects, compared to the apparently unlimited demands of the international object market,

deeply affects their price, as mentioned. The discrepancy between supply and demand, as well as the identification of objects with the peoples who made them, who have now become, like it or not, component "ethnic groups" within nation-states, also deeply affects the objects' valuation: they become part of a people's or a country's "heritage," which is beyond price. These processes and ideas have the cumulative result of setting in motion tremendous efforts to preserve these "beautiful" "old" "traditional" objects.⁵ The impulse comes largely, though not exclusively, from private collectors and museum curators, and their views are often very simple: that preserving the past (in the form of old objects) is a good in itself.

Unlike many collectors of non-Western "arts" who buy only from dealers in Europe and America, Jean-Paul Barbier is interested in the cultures that produce the "art" and the governments whose policies regulate its traffic. The views he expresses in this volume concerning moral questions raised by the idea of preservation are concomitantly more complex.

Barbier's general story is a version of the modernization meta-narrative. He believes that local peoples convert to new religions and old cultures die out as a natural process: "Man has the right to die in peace once he has reached the end of his road in this world, and the same applies to civilizations, which are also mortal." Moreover, Europeans, like people of the third world, ruthlessly destroy their own heritage, presumably for the sake of "modernity": "Giving a new face to a village or the interior of a house has caused the disappearance of more evidence of the past than have revolutions or cannon fire." Barbier thus appears to believe that modernity is both a process built into the structure of history (civilizations die out as a natural process) and is also a humanly constructed narrative to which human agents cheerfully acquiesce by destroying the old for the sake of appearing new. He favors the preservation of old objects and believes that collectors, both private and public, ought to help Indonesia and other such countries "enrich their collections with evidence of their prestigious past that they might lack."

Barbier's overarching story, then, is one rendition of the modernization narrative: history is progressing toward a future in which certain kinds of cultures will die out, leaving behind a heritage of objects that should be preserved as tokens of the past. Both collectors and governments have a responsibility to collect and preserve these tokens for future generations, but the objects will almost inevitably be preserved in public museums or private collections because they are devalued, stolen, or neglected in the cultures that produced them (until, possibly, a future time, when these people will be glad that someone preserved their heritage).

The complexity of Barbier's views lies in his awareness of the intrusive-

ness of state power and the moral ambiguities for foreign collectors, who may intervene in altering a "natural" process. He asks:

> Should it be decided in Ottawa to salvage a totem pole by removing it from its original site and entrusting it to the safekeeping of an institution? Should it be decided in Kinshasa to salvage the ancestor effigies of an ethnic group on the shore of Lake Tanganyika by removing them from the care of their legitimate guardians and placing them in a national museum, when that ethnic group has no sentiment of belonging to the nation of Zaire?

Barbier goes on to tell of more complexities and his own experiences in Indonesia, which he found rather discouraging—particularly the National Museum's rejection of a generous offer on the part of a group of European collectors to help catalogue and preserve objects they considered part of Indonesia's heritage. To my mind, this incident points both to the present government's fixation on capital-intensive "development" and relative neglect of many other aspects of life, and to the genuine lack of governmental policies concerning the country's material "heritage" if the objects in question have not been slated for inclusion within the new provincial museum system.

The Narrative of Nationhood

"Traditional" objects form part of the nation's "heritage" from the past ("evidence of their prestigious past," in Barbier's phrase); hence nations ought to preserve the "traditional" and "folk"objects produced by the people who lie within its borders. Or so many people believe. Yet what does the preservation of the past have to do with nationalism? Why ought a nation-state to concern itself with objects from the ancien régime it may have displaced, or with the craft objects produced by people it is rapidly turning into urban proletarians? What interest do nation-states have in such objects, and what kinds of stories do they tell about them?

As a type of polity, nation-states constitute a recent invention in the history of the world.[6] They emerged in Europe from the collapse of old regimes, some of which collapsed gradually, others suddenly. The French Revolution provides a convenient marker to date the beginning of the era of nation-states; in the nineteenth century this new form of statehood consolidated and developed its characteristic forms and ideologies.

Two things (for our purposes here) about nation-states differed from the polities that preceded them. First, if the first task of a polity is to legitimize its own existence, nation-states were in a more difficult position than empires and kingships. The governments of these new polities could not sit-

uate themselves in the same myths of divinity that church and king had claimed, yet they needed to insist that they, and the territories and people they governed, were not a merely arbitrary collection. They had to assert that they rested on something as deep as God. Second, unlike kingdoms, which have "subjects," nation-states have "citizens" who form a "public." The public must be or become convinced of the legitimacy of the nation-state.

European nation-states justified themselves in the nineteenth century and the first half of the twentieth with tales made from two distinctive elements. The first of these is the notion of the "nation," which, for nineteenth-century Europe, meant, roughly, a people with a common language and, as the century went on, one "race" or "blood" and one cultural "heritage." (The idea that the "nation" should coincide with the "state" was fraught with difficulty—think of the Austro-Hungarian empire—but it could at least be utilized in some countries.) The second was the idea of time, of historical emergence as a continuous and progressive unfolding of events. The version of the past promoted by European nation-states of that era was, naturally enough, progressivist, telling of their own emergence from nation—a unitary people—to state.

The great era of nation-state formation in Asia and Africa, by contrast, was mid-twentieth century, when Europe's former colonies threw off the powers that had ruled them. The forms and problems of these newer nation-states are in some ways similar to those of nineteenth-century Europe. Like European ones, these twentieth-century nation-states formed themselves as political entities in opposition to the polities of the immediate past (usually colonial powers); the newer ones, too, have a citizenry who form a public. The very centralization of state power and the established ideology of nation-statehood (for example, equality for all citizens) require a type of legitimation for both found unnecessary by the ancien régime, in this case the old colonial power. And so, like the emerging European nation-states of the nineteenth century, newer nation-states of Southeast Asia must reinterpret past events and recontextualize objects from the past in order to make them speak to national culture and history.

The fiction, or "alibi" (Roland Barthes' term), used by nineteenth-century European powers to legitimize themselves was the idea of the "nation," the idea of one people, and it was cast as a story unfolding in time because that way of organizing the past conceptually was becoming pervasive at the time. But having the nation coincide with the state is not an option for many of the newer nation-states, simply because many of them are composed of diverse nations (whatever the term might mean: communities of language speakers, peoples with distinct customs and beliefs, people with a

shared "heritage"). Further, the boundaries of most of these newer nation-states coincide rather closely with the boundaries of the colonial possessions they once were.

Indonesia exemplifies both these points well. It contains an estimated three hundred distinct languages. Its peoples live in a wide variety of eco-niches, and range from those who hunt and gather in the mountains, to the wet-rice growing denizens of former Indic states whose economic surpluses were large and whose manners are hyperrefined, to international business people who live in urban centers of commerce and government like Bandung and Jakarta. As a territory, it coincides almost perfectly with the territory formerly under Dutch rule.

How to create a national story from those elements? Of course, the story of the glorious revolution is relatively easy to narrate: common oppression by a colonial power and a common effort to throw it off can suffice as the material from which to construct a story spanning from the coming of the colonial power until the revolution that liberates the oppressed and brings the nation-state of Indonesia into being. But after the revolution, the question for the nation-state of Indonesia is how to construct publicly a notion that "Indonesia" is not just an arbitrary collection of distinct "ethnic" groups thrown together once, during the revolution, against a common colonial power. As Clifford Geertz put it, writing around two decades after the Republic of Indonesia was established:

> The very success of the independence movements in rousing the enthusiasm of the masses and directing it against foreign domination tended to obscure the frailty and narrowness of the cultural foundations upon which those movements rested, because it led to the notion that anticolonialism and collective redefinition are the same thing. But for all the intimacy (and complexity) of their interconnections, they are not. Most Tamils, Karens, Brahmins, Malays, Sikhs, Ibos, Muslims, Chinese, Nilotes, Bengalis, or Ashantis found it a good deal easier to grasp the idea that they were not Englishmen than that they were Indians, Burmese, Malayans, Ghanaians, Pakistanis, Nigerians, or Sudanese. (Geertz 1973:239)

The problem has not gone away since Geertz's observations; if anything, the increasingly effective efforts of the nation-states to bring formerly isolated "ethnic groups" into contact with the government by means of state-sponsored educational, economic, and other policies have exacerbated dissent. At the same time, new technologies of communication and new organizations within the state apparatus have made the process a somewhat different one from what existed in newer nation-states during the 1950s and 1960s.

It seems to me that in Indonesia, two devices for promoting an encompassing state story are becoming prominent. One is the promotion, through textbooks and rewritings of local history (see, for example, Hoskins 1987), of the idea that "Indonesia" consists of a single people who have been in coherent communication from time long past, and they have been unified and in communication due to Javanese overlordship. A story circulates there that the peoples of "Indonesia" were once united under the overlordship of Majapahit, the fourteenth-century Javanese kingdom. This story implies that Indonesia is not merely and exclusively a product of Dutch activity. The story's second function, which will not escape those familiar with the country, is to justify implicitly the great predominance and overlordship of Javanese, who form something like 60 percent of the country's population and dominate numerically, culturally, and materially the government, army, business, and arts. In my experience, this story is believed mainly by officials connected with the government and by ordinary Javanese; people of the "outer islands" tend to be skeptical.

The second device by which a national story is being created in Indonesia is through the display of objects in public institutions. It will be obvious that objects from the "past," whether from ancient kingdoms or from hill tribes, present something of a challenge to the nation-state, which must recontextualize them and make them mean something that they did not when they were created and used. It is no accident that both the state fine art museum and the world's fair were invented in nineteenth-century Europe; they were created to provide sites where the nation-state's citizens could see the identity and achievements of the state made tangible through objects arranged so as to tell stories of progress and glory. When emerging nation-states of nineteenth-century Europe reinterpreted the objects of their royal pasts or their folk pasts in such a way as to result in themselves, a mania for monuments and museums celebrating the Nation ensued.[7] By the same token, it is no accident that currently the newer nation-states of Africa and Asia are founding, expanding, or promoting museum systems, which focus on "traditional" objects of "national" pride.

Indonesia's first museum was founded by the Dutch in 1778, and it still exists as the country's National Museum. In the late 1970s, however, a provincial museum system was instituted by the Suharto government, with twenty-seven provincial museums planned (some have been built). Paul Michael Taylor describes the system and several provincial and subprovincial museums in his essay. Taylor's view is that national unity is being asserted in museum displays with what he calls the "nusantara concept," the idea that every "ethnic group" is equivalent to every other one. Taylor's view of the nusantara concept as an official assertion of unity within Indone-

sia strikes me as quite persuasive. After all, the problem of a nation-state is not so much to historicize the past by creating a temporal linear narrative, although that is one possibility; rather it is to absorb the past and the present in order to create an account that results in itself as a nonarbitrary unit of people and territories, with the current regime as the legitimate power.

Taylor's discussion opens many more questions. He points out that local uses for regional museums may be quite different from what the central government intended or envisioned. In Ternate, for instance, the subprovincial museum is a converted royal palace, which stores paraphernalia for ceremonies (such as weddings and funerals) of the old regime. He sees the users of these objects, the old nobility of this former kingdom, as a shadow government of the area. Those observations confirm my experience in South Sulawesi, where the museum of the old kingdom of Bone has a similar function, and where offerings are made daily to the spirits of the old regalia, which lie protected and elevated in a back room. At the same time, the increasingly vehement modernist Islamic movements of Indonesia often object mightily to such "syncretism." People often dare not make their offerings openly to spirits residing in old objects for fear of derision or reprisals. One of the problems for the government of Indonesia, whether Sukarno's formerly or Suharto's currently, is to balance the claims of the Muslims with those of other groups. Thus, there is reason to believe that the current government's promotion of local cultures through the museum system has deeper political purposes.[8] In any case, museums in Indonesia, especially the subprovincial and private ones, are being used for a variety of purposes, and are sites that can be usefully studied to understand some of the contending forces in a country with interests in defining the meanings of "traditional" objects.

New Stories for Old Objects

The great unidirectional meta-narratives that used to organize much of knowledge and most historical accounts (such as the idea of progress, from social Darwinism to modernization theory, or the Marxian view that everything is inexorably becoming a commodity), those universal, abstract narratives that once served to make sense of myriad events, continue to be possessed and promoted by powers that can enforce them at the level of the state. Yet they no longer strike many people as true.

That is partly because the late twentieth-century world in which we live is a place and era of contested meanings, in which societies and cultures that were historically distinct cross paths and become enmeshed in markets, in tastes, and in exercises of power they were not invented for. Different com-

munities have different constructions of both objects and stories as well as the place of the objects in the stories. What strikes us now is less the stable meanings of objects, fixed by their place within an overarching universal mega-story, but rather their semiotic value for different communities of users and meaning-attributors. Objects whose meanings once seemed stable now are revealed as historically constructed.[9]

The view I have taken here is that objects are in fact meaningless, neutral, and mute. Their meanings are attributed, not intrinsic. Attributed meanings are socially constructed. Nonetheless, as a general rule, humans seem to have an urge to see the value and meaning of objects as intrinsic to them; they resist the notion that they are socially, historically, and economically constructed. That statement is as true of the most isolated mountain-dwelling tribesperson from the upstream regions of Southeast Asia traveling downstream to find potent amulets as it is of the most sophisticated New York philosopher writing on which intrinsic qualities of objects make them definitely, objectively, and panculturally "art."

Increasingly, however, the lives of people and things are intersecting in ways that were inconceivable a few decades ago. The Southeast Asian hill dweller may regretfully sell his potent amulet to an Indonesian merchant who makes the rounds of backwater "traditional places." The amulet may find its way to the antique shops and boutiques on Sanur Beach or Kuta Beach in Bali, and from there be bought by a European dealer, and eventually end up on the New York philosopher's coffee table. There it will be much admired as an example of the artistry and transcendent qualities of primitive art . . . which is, regrettably, disappearing with the advent of modernity, although beautiful examples of it may still be bought by cognoscenti willing to pay.

Objects are enmeshed in ideas and practices that constitute their meanings and place, and they are positioned within narratives that account for what they are. Different narratives are backed by different interests, and have different chances of succeeding and becoming "true." The meanings that "succeed," we realize, are those backed by powers that can enforce them.

What can be done or should be done to prevent the wholesale (no pun intended) looting, destruction, neglect, and deterioration of "traditional" objects from Indonesia? There are no easy answers, as essays in this volume make clear. Moreover, the problem is larger than the fates of the objects themselves: at issue is not simply the preservation of beautiful objects or the saving of a nation's heritage, but the treatment of cultural and linguistic "minorities" within the nation-state. This "treatment" involves more than the treatment of the objects they produce and produced; it means their live-

lihood and chance to participate in national life and the economy in a way that does not ultimately relegate them to careers as *becak* (pedicab) drivers on the fringes of urban areas. It does also include, however, their symbolic representation within the nation-state's cultural life, its self-representation in internal sites like the Beautiful Indonesia in Miniature Park outside Jakarta and its representation to other countries such as the recent Festival of Indonesia in the United States (1990–91).

In these notes, I have traced a few of the meta-narratives and cultural and economic practices that have resulted in the various fates that Indonesian "traditional" objects have met in the late twentieth century. If there is a moral, it is that the stories told, the accounts given, to explain these events can be forces in themselves, not just tales told about "natural" historical processes. Ideas, backed by powerful economic and political interests, create effects. If both Indonesian minorities and the objects they produced and continue to produce are to have other fates in the next century, it will be necessary to tell other, quite different stories about them.

Notes and References

This paper was written while I was a Fellow (1989–1990) at the Center for Advanced Study in the Behavioral Sciences at Stanford, California. Grateful acknowledgment is made to the center and to the support provided during the year by National Science Foundation Grant number BNS87-00864. Many thanks, too, to the Asian Cultural Council of New York for their generous grant enabling me to do research in Indonesia during the summer of 1989 on the fates of Indonesian "traditional" objects, especially in museums. And thanks to Kathleen Much, house editor at the Center for Advanced Study, for comments.

1. See Volkman 1990 for a more complete account and interpretation of this event.

2. Donald Brown (1971) nicely describes the differing interest among indigenous nobles and Westerners with respect to cult objects and beautiful or monetarily valuable objects by contrasting two accounts of the coronation of the sultan of Brunei (which is on the north coast of Borneo) in 1918; one is by a Western observer, the other by a Brunei noble of the court. The European describes the gold objects and pays scant attention to seating arrangements or ceremony; the Brunei noble describes the placement of objects and people (placement indicated rank), describing at length the ancient and venerable objects, not necessarily made of precious metals.

3. Phillip Fisher (1975) has argued that the invention of public museums, especially state-run fine arts museums, enabled and promoted the linearization of stories about art, and were consequently basic to the development of the discipline of art history (see also Bazin 1979).

4. He borrows the phrase from Gertrude Stein, who remarked that "People do not change from generation to generation. . . . Nothing changes from generation to generation except the things seen and the things seen make that generation, that is to say nothing changes in people from one generation to another except the way of seeing" (quoted in Alsop 1982:4).

5. These efforts include conversion of cult objects into commodity objects with exhibition value (i.e., art, available through the market), the neglect of cult objects that remain in situ (whether because these cult objects are usually allowed to deteriorate as a matter of course, or because the local people have converted to a new religion that neglects the old cult objects), and the disappearance of craft skills that allow the production of new cult objects or commodity objects made for the market of similar design to old objects.

6. See Peter Burke's *Popular Culture in Early Modern Europe* (1978) and Benedict Anderson's *Imagined Communities* (1993) for background on the invention of national folk and the invention of the nation state, respectively.

7. As the demands of the initial phase of industrial capitalism and the organization of the nation-state required people to become "citizens" and as, in the course of that century, nation-states increasingly removed the burden and profits of trade with colonies from the private trading companies' shoulders onto their own, museums and other public exhibition spaces (most obviously world's fairs) became explicitly didactic and explicitly linked to nation-state ideology and self-promotion. On monuments, see Horne (1984); on the links between the state and the fine arts museum, especially Napoleon and the Louvre, see Bazin (1979).

8. See Benedict Anderson's "The State and Minorities in Indonesia" (1987).

9. Probably no contemporary writer has had more impact in promoting this view than James Clifford, through his fine collection of essays, *The Predicament of Culture: Twentieth-Century Ethnography, Literature, and Art* (1988).

Alsop, Joseph
1982 *The Rare Art Traditions: The History of Art Collecting and Its Linked Phenomena Wherever These Have Appeared*. Bollingen Series 25. Princeton: Princeton University Press; New York: Harper and Row.
Anderson, Benedict
1993 *Imagined Communities*. 2d edition. New York: Verso.
1987 "The State and Minorities in Indonesia." In *Southeast Asian Tribal Groups and Ethnic Minorities*, pp. 73–81. Cultural Survival Report no. 22.
Bazin, Germain
1979 *The Museum Age*, translated by Jane van Nuis Cahill. 1st American edition. New York: Universe Books.
Benjamin, Walter
1969, "The Work of Art in the Age of Mechanical Reproduction." In *Illuminations*,
c. 1955 translated by Harry Zohn. Edited and with an introduction by Hannah Arendt, pp. 217–251. New York: Schocken Books.

Brown, D. E.
1971 "The Coronation of Sultan Muhammad Jamalul Alam, 1918." *The Brunei Museum Journal* 2 (3):74–80.
Burke, Peter
1978 *Popular Culture in Early Modern Europe.* New York: Harper Torchbooks, Harper and Row.
Clifford, James
1987 "Of Other Peoples: Beyond the 'Salvage Paradigm'." In *Discussions in Contemporary Culture Number One*, edited by Hal Foster, pp. 121–30. Seattle: Bay Press.
1988 *The Predicament of Culture: Twentieth-Century Ethnography, Literature, and Art.* Cambridge: Harvard University Press.
Errington, Shelly
1994 "What Became Primitive Art?" *Cultural Anthropology* 9 (2):201–226.
Fisher, Phillip
1975 "The Future's Past." *New Literary History* 6 (3):587–606.
Geertz, Clifford
1973 "After the Revolution: The Fate of Nationalism in the New States." In *The Interpretation of Cultures*, pp. 234–254. New York: Basic Books. (Originally published 1971.)
Gellner, Ernest
1983 *Nations and Nationalism.* Oxford: Basil Blackwell.
Horne, Donald
1984 *The Great Museum: The Re-Presentation of History.* London: The Works; Leichhardt (N.S.W.): Pluto Press Australia Limited.
Hoskins, Janet
1987 "The Headhunter as Hero: Local Traditions and Their Reinterpretation in National History." *American Ethnologist* 14 (4):605–622.
Price, Sally
1989 *Primitive Art in Civilized Places.* Chicago: University of Chicago Press.
Torgovnick, Marianna
1990 *Gone Primitive: Savage Intellects, Modern Lives.* Chicago: University of Chicago Press.
Volkman, Toby Alice
1990 "Visions and Revisions: Toraja Culture and the Tourist Gaze." *American Ethnologist* 16(1):91–110.

Contributors

JEAN-PAUL BARBIER
Barbier-Müller Museum, Geneva

RUTH BARNES
Ashmolean Museum, Oxford University, Oxford

ERIC CRYSTAL
University of California, Berkeley

SHELLY ERRINGTON
University of California, Santa Cruz

JEROME FELDMAN
Hawaii Pacific University, Kaneohe

MICHAEL HEPPELL
Hawthorne, Victoria, Australia

SUWATI KARTIWA
National Museum of Indonesia, Jakarta

LAURENCE A. G. MOSS
Asian Institute of Technology, Bangkok

PAUL MICHAEL TAYLOR
Asian Cultural History Program,
Smithsonian Institution, Washington, D.C.

Index

Adair, John, 99, 119
Adams, Marie Jeanne, 23, 24, 26, 112, 113, 119
Adhyatman, Sumarah, 86, 88
Adonara, 14
adu (Nias figures), viii, 43
aesthetics
 Indonesian vs. European, vii, 12, 98
 See also art, Indonesian, traditional
 beliefs about
Alam, Syamsir, 73, 88
Alsop, Joseph, 91, 119, 149, 152, 163 n 4, 163
aluk to dolo (Toraja ancestral religion), 30, 32, 40
Ambon, 83–84
Ames, Michael, 99, 119
amulet bundles *(ragö)*, Nias 44
Anderson, Benedict, 163 n 8, 164
antiques dealers. *See* art, dealers
Aragon, Lorraine V., 10, 89, 92, 121
architecture
 Batak, 63–65
 Dayak, 123
 Flores, 69
 Nias, 44–45
Arndt, Paul, 17, 26
art
 African, Meso-American, Indonesian
 compared, 2, 97, 143–144
 collectors and collecting institutions,
 1–2, 43–44, 91
 within Indonesia, 71–90
 their role in saving traditions, 9,
 59–72
 dealers, 7, 21, 33–40, 66–67, 105–116,
 160–162
 definitions and typologies of, 2–7, 98–99,
 141–162
 faking, 85–86, 100, 101–103, 139–140

Indonesian
 adjustments to market demand,
 9–11, 43–44, 47–54, 92–119
 definition/boundaries of, 5
 disguise of traditional functions in
 new forms, 47–51
 foreign collecting of, viii, 33–40,
 43–44, 61–67, 91–112, 141–156,
 160–162
 foreign influences on, vii, 18–19,
 104–119
 and nationalism, 2, 73, 141,
 156–160
 preservation of, 59–90, 154–156
 theft of, 8, 33–40, 60–64, 70, 74–75,
 161–162
 traditional beliefs about, 7, 14–18,
 22–25, 32, 112, 125–126,
 129–131, 146–147. *See also names*
 of peoples (Dayak, Lamaholot,
 Toraja, etc.)
international market in, 2, 6, 8–11,
 13–14, 22–25, 43–44, 51–55, 91–119,
 149–150
"primitive art," 6, 10, 91, 119 n 1,
 140–142, 150–151
scholarship, effect on peoples studied, 8,
 13–14
"sustainable yield" of, 10, 116–119
Arung Pulacca (Bugis ruler), 31–32
ASEAN (Association of South East Asian
 Nations), 72, 88
Aspelin, P., 100, 119
Atauro, 106, 108
authenticity, 101. *See also* art, faking

Bali
 as art marketplace, 68, 111, 161
 arts of, 6, 127–128
Bali Museum, 72, 87